Solidarity
and
Mercy

Solidarity
and
Mercy

THE POWER OF CHRISTIAN

HUMANITARIAN EFFORTS

IN UKRAINE

Chris
Herlinger

Portions of this book originally appeared, in different form, in Global Sisters Report and *National Catholic Reporter.*

The Scripture quotations are from the New Revised Standard Version Bible, copyright © 1989 by the Division of Christian Education of the National Council of Churches of Christ in the U.S.A. Used by permission. All rights reserved.

Morehouse Publishing
19 East 34th Street
New York, NY 10016

Morehouse Publishing is an imprint of Church Publishing Incorporated.

Library of Congress Cataloging-in-Publication Data

Names: Herlinger, Chris, author.
Title: Solidarity and mercy : the power of Christian humanitarian efforts in Ukraine / Chris Herlinger.
Description: New York : Morehouse Publishing, 2024. | Includes bibliographical references.
Identifiers: LCCN 2024024473 | ISBN 9781640657502 (hardback) | ISBN 9781640657526 (epub)
Subjects: LCSH: Herlinger, Chris, author. | Russo-Ukrainian War, 2014– — Press coverage. | Russian Invasion of Ukraine, 2022—Press coverage. | Humanitarianism—Religious aspects—Christianity. | Humanitarian assistance—Ukraine. Classification: LCC DK5503.H47 2024 | DDC 947.7086—dc23/eng/20240603
LC record available at https://lccn.loc.gov/2024024473

To the sisters, forever faithful

Contents

Acknowledgments

The very first word of thanks goes to the sisters, priests, and those in the Ukrainian religious and humanitarian community who helped me at every stage of what turned out to be a two-year reporting project. They are the heroes of this book, and their stories, insights, and help—particularly in Lviv, Kyiv, Zaporizhzhia, Kraków, and Warsaw—inform every page here. They are named in the text that follows, and I owe them all a debt of gratitude. But I owe a special word of thanks in particular to the Sisters of the Order of St. Basil the Great, who—from the start of the Russian full-scale invasion and onward—were good sources and, later, good hosts and, now, I hope, good friends.

Another word of thanks is owed to several translators and drivers, in both Poland and Ukraine, including Dominick Zięba, Natalia Kommodova, Iryna Chernikova, Stas Nepokrytyi, and Ilona Molyavchyk. They are living proof that no journalist ever works alone.

At home, a word of thanks goes to my Global Sisters Report and *National Catholic Reporter* colleagues—particularly *National Catholic Reporter* (*NCR*) publisher Joe Ferullo, Global Sisters Report (GSR) editor Gail DeGeorge, and GSR managing editors Stephanie Yeagle and Pam Hackenmiller—for their full and generous support and

fine editing. A word of thanks is also due to the *NCR* development team for their help in securing funding for the first-anniversary assignment, and to Sr. Jane Houtman for her support. I took the 2023 assignment with my friend Gregg Brekke, who was, and remains, the ideal colleague and traveling companion.

A word of funding thanks is also owed to the more than 50 friends and family from different phases of my life—Denver, Minnesota (particularly friends and classmates from Macalester College), and New York—who made financial contributions to a GoFundMe campaign that, in addition to funding from *NCR*/GSR, made an early 2024 assignment back to Ukraine possible. Also contributing were several friends of Gregg Brekke and a few anonymous donors. I thank them all.

The donors are: Alan Zemek, Daniel Spencer, James Spellman, Julie Mattsson, John Kurey, Maria Seep, Shirley Struchen, Gail DeGeorge, Tamara Hogan, Maurice Bloem, Alfred Lee, Irene Korenfield, Susan Schneider, Marco Grimaldo, Kevin Shanley, Barbara Gacek, Jean Loh, Arthur Guetter, Pat Teiken, Patricia Walkup, Martha Eidmann-Hicks, Sue Erickson, James Hahn, Charles Sanford, Joseph Ferullo, Sandra Newton, Thomas Roberts, Mike Dovey, Catherine Leimbach, David Bonior, Barry Shade, David Dillon, Julie Stroud, William Westphal, Richard Nelson, James Stretz, Rebecca Ganzel Thompson, Matthew Chin, Bruce Whitacre, Catherine Kurtz, Johnny and Deb Wray, Stephanie Angelo, George Muir, Janet Cifuni Kenig, Dutch Barhydt, Kathy Lewis, Kim Andresky, Mac King, Tom Hampson, Charles Graham, Daniel Hellerman, Jeanne Mate, Edward Mate, Rebecca L Herlinger, Lynn Dovey and Judith Dovey, Anne Perzeszty, Elizabeth Woodard, and Walter Beeker.

I began work on this book while a visiting writer at the Writers' Colony at Dairy Hollow in Eureka Springs, Arkansas, in November 2023 (accompanied by my writing pal Aileen Basis) and finished much of the writing during Holy Week in March 2024 while a guest with the Sisters of St. Joseph of Brentwood, New York. Staff and residents in those respective locales were gracious and kind. The Columbia University School of Social Work Library and the New York Society Library were also congenial spaces for writing, with courteous and helpful staffs.

I overcame a number of challenges with the help of Roma Maitlall and Airié Stuart of Church Publishing. They believed in this project from the start, and I thank them. I particularly want to thank Roma for her fine editing and suggestions for the manuscript that ultimately strengthened it in many places.

A final thanks to Juanca and Becky, and to Micheal and Rebecca Thompson for their friendship and support. And, as always, missing David, Lynn, and Matt.

Author's Note

*M*uch of this book is based on reporting from assignments to Ukraine and Poland in 2022 and 2023 for *National Catholic Reporter* (*NCR*) and Global Sisters Report (GSR), *NCR*'s project focused on the ministry and work of Catholic sisters. It has been supplemented by other reporting through 2024—all written while the war was still underway, making *Solidarity and Mercy* nowhere near definitive or comprehensive. It is a partial account. There are gaps; my contacts have largely been based in the world of the Ukrainian Greek Catholic and Roman Catholic Churches in Ukraine and Poland. My contacts did not, alas, extend to the Orthodox world.

I make these caveats clear because *Solidarity and Mercy* is based on one journalist's impressions—partial, imperfect, and produced in a specific time and place, under deadline—of people faced with a huge challenge who, rather remarkably and against considerable odds, bravely responded to an invasion built on triumphalism, imperial hubris, and "great power" fantasies. In the face of that, they demonstrated that evil need not to have the last word; that in a global environment and a historical time marked by cynicism, nihilism, and the erosion of faith in institutions all over the world, solidarity and mercy—not to mention idealism, unity, and hope—still counted for something. They certainly did in Ukraine.

Preface

On a February evening in 2024, two years into a war that no Ukrainian sought or desired, late-afternoon darkness descended on the village of Velykomykhajlivka in southeastern Ukraine. All streetlights were blacked out—so as to prevent drone attacks—and the windows of a triage center for wounded soldiers near the front lines were boarded up. The village's unpaved streets were muddy, but Fr. Aleksandr Bohomoz and Sr. Lucia Murashko, having recited the rosary on the way to their destination, bounded out of a car with the sacred vessels needed for Mass, or as the Ukrainians call it, the Divine Liturgy. They carried with them wine, hosts, a chalice, a small crucifix in the Byzantine style, two candles, two altar cloths, and a prayer book.

Once inside, the two carefully placed everything on a medical table in a dimly lit public space. The triage center, a renovated clinic and hospital, was hushed and quiet. Fr. Aleksandr read a passage from Matthew 22:37–40 in which a lawyer asks Jesus what is the greatest commandment. Jesus responds,

He said to him, "You shall love the Lord your God with all your heart and with all your soul and with all your mind." This is the greatest and first commandment. And a second is like it: "You shall love your

neighbor as yourself." On these two commandments hang all the Law
and the Prophets.

*On this particular night, only one soldier, a young man named
Sasha, attended the half-hour service—the numbers of weekly attendees
have varied over the past two years, from only a few to more than
a dozen. But neither Fr. Aleksandr nor Sr. Lucia, both members of
Ukraine's Greek Catholic Church, were put off by the small turnout.
What was important was being a witness and participant in the
miracle that, for Catholics and other Christians, transcends immediate
tragedies and lightens a community's burdens and cares—in this
case, a medical team's worry about drones, a Russian attack, and the
possible influx, at any moment, of the wounded or sick. Or the fear
of war's irrational violence—a force well known to Ukrainians for
two years now, with hospitals, schools and theaters, churches, homes
and apartment buildings all fallen to Russian bombardments and
shelling. For a few brief moments, the dimly lit workaday medical
space was altered and transformed by tradition, the belief in miracle
and resurrection, transcendence and an abiding sense of hope—for
the future of Ukraine and its people, no matter what their religious
affiliation.*

*The ride back to the city of Zaporizhzhia through a darkened, un-
welcoming, and barren landscape took just over an hour—the front
line may have become more distant but was never fully out of mind or
thought. Fr. Aleksandr and Sr. Lucia spoke little—they were quiet and
reflective. I later asked Sr. Lucia if it bothered her that only one soldier
had participated in the service.*

*No, she said, the act of witnessing on a dark, quiet Sunday evening
in a war zone was more than enough.*

"Now it is so," she told me. "It can be just one. I think we do what we have to do. We pray in that place for all those people. Our prayers are protection for all of these locations. God hears our prayers there even when medical staff or soldiers do not always understand the value of the prayers."

Introduction

*T*raversing Europe's second largest nation is not for the fainthearted, even in peacetime. At 233,030 square miles, Ukraine—an immense country of rolling plains, grasslands, and steppes—is just slightly smaller than Texas, and traveling from the country's far western to eastern areas can be daunting. By car, a journey from Mukachevo, a city of about 86,000 residents not far from the border with Slovakia, to eastern cities such as Kharkiv or Mykolaiv can take 15 hours without stops; to Kramatorsk about 20 hours.

But the distances mean little to Catholic sisters like Sr. Lydia Timkova, who have committed to regular trips across the country to shepherd food, medical supplies, and other items to civilians living near the Ukraine-Russian front. Twice in 2023, Sr. Lydia journeyed east to where the battles were raging—first in February and later in May. In 2022, she made two similar trips. On all the journeys, Sr. Lydia witnessed destroyed houses, roads, cars, and, worst of all, destroyed lives.

She told me, eyes full of emotion, "It is always like a sword that pierces my heart, and it cries bloody tears." During her visit in the village of Oleksandrivka in the Mykolaiv region, Sr. Lydia sat down at a badly damaged upright piano in a village hall that had been shelled

by Russian artillery. With fallen debris all around her, she played a few notes and lamented the piano's condition.

"Nothing," she said wistfully. "It's so scary."

Sr. Lydia, 56, a Slovakian sister and member of the Dominican Sisters of Blessed Imelda, like many non-Ukrainian sisters who have ministered in Ukraine for years, has fully embraced the country and its people, adopting both as her own. Though their presence in Ukraine predated the February 2022 full-scale invasion, the sisters' selfless commitment to Ukraine has, if anything, grown stronger since then. "I felt that I was going to my own people," she said following one of her 2023 visits—something she had said when I interviewed her earlier in the year while on assignment for Global Sisters Report and *National Catholic Reporter*.

"I've been here so long, my heart is here," she said. "The Slovak Republic is my native land, but here, well, I can't give up."

One reason Sr. Lydia said she can't give up is because she believes hers is a secondary role. "God is always there in the first place," she said. "He gives me power and understanding of what I should do."

That sense of empowerment undergirds a sense of duty, calling, and mission in a country under siege since Russia's full-scale invasion—though it does not take long for Ukrainians to correct a visitor on the use of the word "war." For Ukrainians, the term "war" actually means events that began with Russia's 2014 incursion into Crimea and later the eastern Donbas region. To Ukrainians, the continuity is obvious—as is a long-unsettled history between Ukraine and Russia. As Archbishop Borys Gudziak, the Metropolitan-Archbishop of the Ukrainian Catholic Archeparchy of Philadelphia, told me in February 2024 as the "full-scale invasion" grinded on into its third year: "The stories of devastation at the hands of Russians have been a part of my

family history and of virtually every Ukrainian family for generations. Ukrainians want to put a stop to Russian colonialism once and for all. This has been passed on from generation to generation, this fear of the Russians, the persecution at the hands of the Russians. We do not want to pass this on to our children and grandchildren, and for that we're willing to die. And that is kind of the rock on which Ukrainian resistance stands." Such resistance has a religious component: a larger commitment shared by Christian humanitarians who have shown courage and fortitude by demonstrating *solidarity* and *mercy*—both inside Ukraine and outside the country, offering support and succor, for example, to the millions of refugees who had arrived in neighboring countries—particularly Poland. The refugees had searing memories: the bombing of schools, theaters, and hospitals; unburied bodies in the street; children huddled with their mothers in crowded basements; rumors of Russian soldiers committing "assaults" against women, a common—and horrific—euphemism for rape.

In the face of such recollections and out of harm's way, the new arrivals found safety, comfort, and hope, as well as solace, strength, and sustenance at church, where they experienced the rhythms of prayer and ancient rite, shared singing and Communion, the recitation of the Divine Liturgy in a common language, and even the familiar and bracing whiff of incense, a reminder of services back in Ukraine.

Still, their experiences bespoke a terrible reality, borne of a war condemned by much of the world that transformed the face of Europe, increased international tensions, and caused ripples in the global economy. "Life has changed not just for Ukraine, but the whole world," said Sr. Yanuariya Isyk, a member of the Sisters of the Order of St. Basil the Great, whose ministry is based in Kyiv. "We're living

a new life now. It can't be the same as it was before the war. Life will never be the same again."

The reality has been one of displacement and confusion, loss and death. Ukrainian hospitals, schools, and neighborhoods were targeted in particularly brutal acts that outraged the world. Oxfam International said on the second anniversary of the full-scale invasion that more than 10,500 civilians had been killed since February 2022.[*] In May 2024, UNICEF said that it had been able to verify that nearly 2,000 children had been killed or injured in the full-scale invasion, but that the figure is likely to be higher.[†]

This is part of a wider picture, of course. On the eve of the second anniversary of the full-scale invasion, the head of the Catholic charity Aid to the Church in Need (ACN) in Spain, announced a campaign to help Ukraine, reminding supporters that the war remained the "greatest humanitarian catastrophe since the Second World War" in Europe and that 80 percent of Ukrainians had suffered some kind of physical or psychological wounds. Moreover, said José María Gallardo, director of ACN Spain, the full-scale invasion had resulted in uprooting 6.3 million refugees and more than 5 million displaced persons within the country. And, tellingly, nearly half of the population in Ukraine—40 percent—depended on humanitarian aid for subsistence.[‡]

[*] Oxfam International, "UKRAINE: 42 Civilian Causalities Every Day in Two Years of War," press release, February 22, 2024, https://www.oxfam.org/en/press-releases /ukraine-42-civilian-causalities-every-day-two-years-war#:~:text=As%20of%2022%20 February%202024,the%20conflict%2C%20including%20587%20children.

[†] UN News, "Nearly 2,000 Children Killed or Injured in Ukraine War: UNICEF," May 13, 2023, https://news.un.org/en/story/2024/05/1149661.

[‡] Loreto Rios, "Aid to the Church in Need Launches Campaign to Help Ukraine," *Omnes,* February 20, 2024, https://omnesmag.com/en/newsroom/acn-bell-ukraine/.

On the ground, that means grim realities prevail. Even in locales far from the front, life is always on edge, with blackouts and electrical outages—Russia has targeted the country's power grid—and air-raid sirens interrupting an afternoon idyll. During my travels in Ukraine in early February 2024 I became accustomed, both in visits to Kyiv and Zaporizhzhia, to the constant din of sirens. People told me the warnings had become like background noise.

"War is not stable," said Basilian Fr. Peter Kushka, when I spoke to him in Warsaw in November 2022. "Everything becomes unstable. One day, you are secure; the next, you are poor."

For that reason and others, Ukrainians landing in Poland found solace at church—looking "to God for help," Kushka said.

What they experienced at Kushka's church and others, such as the Ukrainian Greek Catholic parish of the Exaltation of the Holy Cross in Kraków, not far from the city's old center, was a combination of *solidarity*—of finding unity in a common experience of displacement amid war—and *mercy*—finding compassion rooted in the Gospel mandate to comfort the afflicted, feed the hungry, offer shelter to those who have lost their homes.[*]

One of those who experienced such welcome was Ludmyla Opanasuk, who arrived in Kraków shortly after Russia's full-scale invasion. Accompanied by her thirteen-year-old son and sister-in-law, Ludmyla told me she felt welcomed and loved at the parish: "You feel good when everybody is supporting you," she said. "We feel grateful."

[*] I have used both the terms "Ukrainian Greek Catholic Church" and "Ukrainian Catholic Church" in this book. They are interchangeable. They mean the same thing. As a US-based church official explained to me, the former is used in Ukraine because that is the official registered name, owing to the church's eastern roots. But because of possible confusion in the United States—"One cannot be Greek and Ukrainian at the same time," the official said—the name used in the United States is the Ukrainian Catholic Church.

The expressed gratitude was something the church's staff modestly accepted but didn't dwell on: the parish had a responsibility to welcome the newcomers, and besides, there was too much work to do. But all knew—priests, sisters, congregants, recent newcomers—that the nexus of solidarity and mercy evident in places like the Kraków church was an evocation of something elemental, evocative, all-embracing. When Ukrainians arrived in Kraków, they were bound for church because they knew what it did and what it symbolized—help, comfort, succor, a link to Ukraine itself. "It's precious because you've left something precious," Ukrainian Sr. Evphrosynia Senyk, a member of the Congregation of the St. Joseph Sisters of the Ukrainian Greek Catholic Church, said during my first visit to the parish.

Mercy and solidarity were evident in other ways. The church became important not only as a needed place of worship and respite but also as a kind of community center where the arrivals came seeking news and contacts and to pick up donated food and clothing. A theme all the refugees spoke of was how little time there was to prepare to leave home and how little they carried with them, usually just one piece of luggage, if even that. (Some were in such a hurry that they even forgot their passports.)

The very initial focus of the global community was the displacement out of Ukraine. But as the full-scale invasion continued, it was important to note the toll within Ukraine—after all, most Ukrainians stayed and found themselves struggling in the midst of violence, brutality, uncertainty, and trauma.

This is something Sr. Lydia knows firsthand—she said it was difficult to see the dashed hopes of displaced families as they returned home to their communities, only to find their homes destroyed. "They have nowhere to live now," she said.

What particularly has stuck in her memory are the encounters with children. "They helped us carry things and ran around us," Sr. Lydia recalled. "When we were leaving, the children were crying and asking me if I was coming back. One girl said to me, 'I'll be waiting for you!'"

If she had the opportunity, Sr. Lydia would return again. "Children's pure eyes in tears, or old people homeless under the bare sky. All this is in me, deep in my heart, and it hurts."

It does hurt. As is the case with Anastasia and Alexander Tomchuk, a young couple from the southeastern city of Zaporizhzhia who, in 2023, found refuge through a Dominican program called the Christian Center of St. Martin de Porres in Fastiv, not far from the capital of Kyiv. (The Fastiv program is not directly related to Sr. Lydia's congregation.)

With six children to care for, including a newborn, the couple were preoccupied by what would come next: schools, another separation of the parents—the father was only visiting for one day, having to return to Zaporizhzhia because of his work; and where to settle if they did not return permanently to Zaporizhzhia.

"The most important thing are the kids," Anastasia said, adding, though, that plans can be quickly altered. "Every moment can turn into something new."

In saving their children from harm, the Tomchuks acted out of necessity—but also out of courage, something many people did. Some did not of course—that always happens in war—and many were recipients of the mercy demonstrated by humanitarian groups, churches, synagogues, clergy, sisters like Sr. Lydia, and others motivated by religious faith (and others not). But even those who were still able to proceed with life with some normality did so with a sense of

collective identity, a distinct kind of Ukrainian solidarity that, to an outsider, was remarkable for its idealism and unity, hope, and clarity of moral purpose.

An unanimity of resolve—the utter confidence that, ultimately, Ukrainians would be victors in the war—was, and is, striking, even when it was apparent that the war would not be won quickly or easily. (And it must be said, many Ukrainians I met—though not all—tended to be bitter about Vladimir Putin and the state of Russian politics and corruption but generally not about Russians themselves—though one Ukrainian friend said crude Russian stereotypes about Ukrainians amount to "typical behavior of a folk who are humiliating another nation." One Ukrainian sister I met in Kraków said she was praying for Russia and its people because they are being blinded by government lies. But she remained confident Ukraine will ultimately preserve its independence, declaring: "We will win.")

Still, though confident of the ultimate outcome, Ukrainians knew from their history and from a deep-seated religious faith and spirituality that nothing can be accomplished without a struggle. Their past had taught them that, as an introduction to *In the Hour of War: Poetry from Ukraine,* a 2023 anthology of Ukrainian war poetry eloquently and pointedly put it: "The war has been going on since 2014, but it wasn't until the full-scale invasion of February 2022 that the world started paying attention. . . . (The) war began long before 2014 by way of colonial imperial politics, suppression, of language cultures, mass hunger, and terror."*

That history has to be explained, even briefly, in any study of Ukraine, and with it the attendant legacies of hunger, terror,

* Carolyn Forché and Ilya Kaminsky, eds., *In the Hour of War: Poetry from Ukraine* (Medford, MA: Arrowsmith Press, 2023), ii.

oppression, and imperial politics. But if solidarity and mercy are the governing themes here, the testimonies of struggles and triumphs of ordinary people (and of ordinary religious and humanitarian workers doing extraordinary things) are at the core of this book. So is the fact that, in the face of a country that had become one big conflict zone, the war galvanized religious communities in Ukraine, Poland, other European countries, and elsewhere, including the United States, to open their doors to those who had been displaced and to lead various humanitarian missions. Such efforts were undergirded by the mandate prescribed in Matthew 25:35–37:

> "For I was hungry and you gave me food, I was thirsty and you gave me something to drink, I was a stranger and you welcomed me, I was naked and you gave me clothing, I was sick and you took care of me, I was in prison and you visited me." Then the righteous will answer him, "Lord, when was it that we saw you hungry and gave you food, or thirsty and gave you something to drink?"

As a veteran humanitarian journalist, I have seen this mandate fulfilled elsewhere, including in locales—like Afghanistan, Haiti, and South Sudan—where needs were perhaps more dire than in Ukraine and conditions more perilous because the existing life was poorer and more desperate. Even so, Ukraine is a poor country in many ways, and the damage it has sustained is not to be minimized. As Archbishop Borys noted, the "suffering, the torture" that Ukrainians have experienced is "bloodcurdling."

"The one trillion dollars' worth of infrastructure damage," he said, and "the fourteen million people that were displaced from their homes [are] very devastating. It's exhausting. It's traumatizing. But the

people understand that they need to be resilient, because otherwise they won't exist."

It was this existential awareness that was so apparent, even as the full-scale war passed the two-year mark and Ukrainians were aware that morale was sagging, military defeats were becoming more common, and support from the United States became bogged down in US domestic politics.

Yet even with those setbacks, the determination to win remained unchecked, and ministries to help the displaced and those most affected by war—including assistance (like food and clothing) to soldiers—continued unabated. I don't think I have seen the biblical mandate as heartfelt, visceral, and fulfilled as it has been in Ukraine and Poland. A deep spirituality is at work in these places—a spirituality grounded in the knowing experience of the ruins of war in what a Catholic sister called "a dark and cold time" but able, miraculously, to overcome its attendant pain.

That is a reality known well to faith-based humanitarians. At the end of an assignment to Ukraine in February 2024, Tetiana Stawnychy, the president of Caritas Ukraine based in Kyiv, told me that "the war has gone through different dynamics over the two years"—from initial shock (few expected the invasion to happen) to hope (taking heart in Ukraine's initial success in fending off large parts of the invasion, such as in and around Kyiv) to recognition that barring a miracle, the war could be protracted—a hoped-for counteroffensive was not sustained into 2024.

Yet through it all, people throughout the world responded generously—whether they were volunteers coming to the Polish-Ukrainian border from a variety of countries (the United States, Portugal, Norway), or members of churches and convents opening

their doors to refugees, or those in distant lands making online donations to humanitarian groups. At a sour moment in the world—with so much political malice, discord, and division—people responded in ways that were courageous, merciful, and done with a sense of human solidarity.

Of course, the international response was far from perfect—nothing in the humanitarian world is. It is important to note, even briefly, the frequent criticisms of the international aid industry—or perhaps more diplomatically as Nicholas Noe and Hardin Lang call it, "the traditional international aid architecture." In a September 2023 reflection in the journal *Forced Migration Review*,* both humanitarians, associated with the secular agency Refugees International, said that "localizing" the humanitarian response "would improve the sustainability and reach of the overall response—and set a valuable precedent."

What they meant was empowering local responders. After the full-scale Russian invasion began, Ukrainian civil society groups launched a successful countrywide relief effort. However, as is so often the case, aid agencies "subsequently ramped up the traditional international aid architecture and, donors channeled billions of dollars through the United Nations and international NGOs."

The result, Noe and Lang wrote, is that this "bypassed a large set of Ukrainian responders while turning others into sub-implementing partners for their foreign counterparts." The numbers are telling: by early 2023, they noted, the "number of aid organizations working in Ukraine had increased five-fold since the beginning of the invasion.

* Nicholas Noe and Hardin Lang, "Breaking the Cycle: Local Humanitarian Aid in Ukraine," *Forced Migration Review* 72 (September 2023), https://www.fmreview.org/ukraine/noe-lang.

More than 60% of these organizations are Ukrainian. Yet less than 1% of the $3.9 billion tracked by the UN in 2022 went directly to local actors." This is all according to data from the UN Office for the Coordination of Humanitarian Affairs (OCHA).

Noe and Lang called this trend "unfortunate" because Ukraine offered "an ideal context" to further a moment that would give local groups more say and power in the distribution of humanitarian aid.

Overall, I think the "small-scale" localized work of sister congregations—whether it be providing aid to soldiers, or assistance like food and household and cleaning supplies to communities near the front lines or to those displaced—has been effective precisely *because* the sisters work within a scale and have connections to those they assist. I am sometimes asked who should people support during humanitarian crises? I always reply: sister congregations. The money will be spent wisely and prudently and will reach those who need assistance—because the sisters are closest to such people.

In this, humanity is affirmed and restored. Tetiana of Caritas sees deeper meaning in this, saying, "When we're able to help somebody around us, that creates hope in and of itself, somehow, because it's restoring humanity, what it means to be human, and that's hopeful."

She went on to say: "You need the material aid, and that's a piece of it. But it's not the main piece. The main piece is this humanity, it's this need for doing." In the case of her own organization, which is actually a confederation of local groups, a feeling of community governs—that "it's not just giving them a material thing, you're not just dropping off supplies."

"The piece that Caritas does, the value added," Tetiana said, "is that we have that moment of human encounter; it's that spirituality

of encounter of the other, of being able to restore humanity, that sense of humanity that war destroys."

That human element is important to the faith-based groups responding in Ukraine: "This way that we have of seeing the other person as an integrated person, and we see all the aspects of what it means to be human in them—this ability to see the individual in front of you as a human being. Not that other groups don't do this, but I just think there's a special emphasis in faith-based groups where it's naturally in our DNA that we do it this way."

"This way" is the cornerstone of *Solidarity and Mercy.*

One

Stepping into a War Zone

The Start of a Journey

*J*ust days before the full-scale invasion began, I was visiting Hamburg, Germany, and feeling uneasy. I had been there on vacation to work on a private writing project focused on the 1943 Allied firebombing of the city. But I had been worried about the possibility of a Russian invasion in Ukraine for weeks and prayed that it would not happen. In between touring the city's war sites, I monitored my phone to read the day's daily developments. It still did not seem possible that, in the year 2022, Europe was facing the possibility of another land war. More broadly, I knew from my work in covering the work of Catholic sisters at the United Nations that the last thing a world coping with climate change, economic disparities, and social displacement needed was a wholly unnecessary—and likely protracted—war.

Ukrainians I met later in both Poland and Ukraine expressed the same incredulity; even they, who had experienced the 2014 Russian annexation of Crimea and the invasion of the Donbas region and

had every reason to be suspicious of Russian policy, still believed the threat of invasion was something of a bluff. But in waking up on the morning of February 24, the world knew the Russians were not bluffing: a full-scale invasion had begun. I don't read or speak German, but the next day's Hamburg newspapers didn't require much translation: one tabloid boldly stated in a red-colored headline: "Putins Blut"—*Putin's Blood.*

Since I was already in Europe, my editors and I agreed I would eventually make my way to Poland to begin covering the quickly developing refugee crisis there. In the meantime, the days in Hamburg made an impression: one night, a concert in the city's old Laeiszhalle was overshadowed by news of Putin's threat of using nuclear weapons. Is this the "last night of the world?" I asked myself to the searing strains of the music of Gustav Mahler, both baffled and anxious. The next day, I asked a taxi driver what he thought of developments.

"He's the next Hitler," the driver said of Putin.

Whatever you think of the truth of that statement, coming from a 40-year-old German whose family had lived through World War II, it was poignant. So was visiting the most visible and intact symbol of the war in Hamburg: the St. Nikolai Memorial, located on the site of the St. Nikolai Cathedral, which was largely destroyed during the 1943 Allied firebombing.

"No to war," a visitor from Greece wrote in a memorial guestbook. "Yes to peace."

For several days I worked on a first story in my Hamburg hotel room. I was immensely saddened by the turn of events in Ukraine but also felt a bit of a "journalist's rush" as a major global story unfolded, and I knew that the Church would become a major player in the humanitarian response. One of the first emails I received on

February 24 was from Sr. Anna Andrusiv of the Sisters of the Order of St. Basil the Great, who would become both a trusted source and a friend in the coming two years. Writing from Lviv, a historical city in western Ukraine that has a strong Catholic identity given its proximity to Poland (and which was once itself *in* Poland), she said those in her congregation's main convent, where 27 sisters live, were fine. But she noted that, already, the city was in a war mode: residents withdrawing cash from banks, stocking up on gasoline, and buying medical supplies from local pharmacies. Anna told me that people were frightened. The possibility of an invasion had been looming for months—and not totally surprising, given the 2014 events. Yet, when it finally came, the latest invasion was still something of a shock. But she said there was a sense of steely resolve, with reports of "soldiers fighting back" and suspicions already emerging about misinformation being spread by the "Russian aggressor." She told me her fellow Ukrainian sisters also needed to affirm a sense of calm and not panic—calm in order to make sense of what was happening, and stillness in order to pray in the midst of uncertainty and fear.

That fear was no abstraction: a group of the Basilian sisters, including Sr. Anna, had just returned safely to the Lviv convent from a peace pilgrimage by the religious of the Ukrainian Catholic Church to the city of Zaporizhzhia, which is only about 120 miles from the Russia-occupied area of Donetsk. Their return from eastern Ukraine was a relief—though never in any personal danger, the sisters had left just as the Russian invasion began.

"Russia began to bomb us," Sr. Anna said, using the plural pronoun—something I would hear often in the coming months. A sense of collective identity was important to Ukrainians at this moment of crisis. "Can you imagine it?" she wrote.

This collective mentality (or identity) was important in other ways—already congregations were issuing statements that, while grounded in sorrow, also expressed anger at the February 24 invasion: "This illegal, unprovoked invasion is a terrible violation of human rights and threatens to lead to unfathomable bloodshed and prolonged conflict," Sr. Joann Sosler, the Pennsylvania-based provincial superior of the Sisters of the Order of St. Basil the Great, said in her statement, issued the same day.

"We stand in solidarity with our brothers and sisters in Ukraine and call upon all people of goodwill to support Ukraine during this crisis in whatever way they can: prayer, finances, volunteering, anything. We join with our Sisters of St. Basil in Ukraine in praying for the people of Ukraine, and we call upon our government to support the freedom of the Ukrainian people with whatever means are available and necessary."

The statement was telling; it capsulized how the press of events would be framed: what had had happened was a violation against a sovereign country and would lead, as it did, to bloodshed and unwarranted and prolonged conflict. The only proper response was to stand in solidarity together and to ask "all people of goodwill, wherever they might be, to support Ukraine however they could."

"Anything," she emphasized: prayer, volunteering, financial support, direct response. Put another way, from the start the response was framed in terms of solidarity and acting in mercy for the cause of Ukraine's freedom and independence.

In her email, Sr. Anna elaborated on those themes, noting the importance of felt prayers from other sisters and supporters internationally. She was not afraid to speak of Ukraine's vulnerable situation, noting the difficulties the country faced with an oncoming war and

the need for prayers at that difficult moment. "Every day we live but we don't know what is going to happen," she told me. "A lot of us are confused and uncertain."

I remember being struck by the poignant acknowledgment of confusion but also by the steely resolve she expressed—that Ukrainians "are ready to give our life for our country, for our beliefs and for God. We are afraid, but we are also strong and we are waiting [for] what tomorrow will bring to us."

Of course Ukrainians wanted to embrace peace. But the experience of Ukrainians was grounded in a knowledge of Russia and its perilous relationship with Ukraine. Peace that acquiesced to Russia—in other words, surrender—was antithetical to Ukrainians, a theme I would hear repeated in the next two years.

"[We] know our neighbor, and we know what he can do," she said, noting that while this was a full-scale invasion of the country, eastern Ukraine had been in a state of war with Russia since 2014. "We never forget about it in our prayers, for the soldiers who are fighting there and protecting our country, our Ukraine. We are one nation; we are Ukrainian people."

Another St. Basil sister, Sr. Ann Laszok, a Ukrainian American whose ministry is based in Pittsburgh, wrote similarly, noting the very grounded sense of history—that Vladimir Putin's "imperial goals" dated back some time, and lamented Ukraine's past suffering. War is brutal, she told me, "but Ukrainians will fight to keep their dignity, sovereignty, and religious freedom."

While the conveyed messages gave a sense of the sudden shock, sisters also said that in the days prior to the war, when it still seemed that Putin might be bluffing, they recognized that a full-scale invasion might be possible. "We are slowly preparing for the war—the war

we do not want," Sr. Januaria Isyk, based in Kyiv, wrote to her fellow Basil sister, Sr. Teodozija Myroslava Mostepaniuk, a Ukrainian by birth who ministered in Croatia. Sr. Teodozija shared that sentiment with me. "Nobody in Ukraine wants this war, but people are ready to stay there until the end," she said of Ukrainian resolve.

Sr. Teodozija told me, as the other sisters had, that the Russian invasion was an extension of a long and tragic history that Ukrainians feel has been "full of violence and colonial domination of Russia [over] Ukraine." This includes the genocidal 1932–1933 famine known as the Holodomor, in which millions of Ukrainians were starved under Soviet rule. But it was the recent history that been most felt, with Russia occupying the long-contested territory of Crimea and eastern regions. Despite "this hard situation, now it is a possibility for Ukraine to speak about itself, about its history and identity. For millennia Ukraine has been an active participant of world history," Sr. Teodozija said. She believed, like every other Ukrainian I would speak to in the next two years, that the essential truth about the war—that Ukraine had been gravely violated by this act of Russian aggression—undergirded Ukraine's resistance; that the need for military protection and assistance was based not on any act of hostility on its part, but simply that Ukrainians sought to protect their homeland. And would.

The Power of Prayer

In the midst of this tragic turn of history, prayer proved sustaining to the sisters I contacted. Sr. Ann Laszok said prayer was centering her life as she watched events unfold from the United States and that knowing that people were praying for Ukraine and for peace from

throughout the world proved sustaining. "These days I usually pray the Psalms and meditate on the Book of Isaiah," she said.

Ukrainians also expressed thanks for international solidarity—whether it be through diplomatic efforts to prevent the invasion or through the words of support from sisters who surveyed events with growing alarm. Humanitarian groups, whether faith-based or secular, as well as governments and international groupings like the United Nations began accepting donations to fund efforts to provide aid—such as medicine, housing, food—to those fleeing Ukraine and those not able to leave the country. Because of the many layers of assistance and its disparate sources, it is almost impossible to say, even as of early 2024, how much the world provided to Ukraine. It is in the billions—and this is not even counting the military assistance the United States and its allies provided.

Some of the prayers came from the sisters representing their congregations at the United Nations in New York, who watched events unfolding with alarm and even incredulity, with one sister noting that the invasion showed the apparent impotence of the global organization. Sr. Teresa Kotturan, who then represented the Sisters of Charity Federation at the United Nations, told me: "I am forced to look at this flawed organization devoid of any powers to protect 'We the Peoples of Ukraine,' who are confronted with the military might of President Putin and his ambitions for empire building." She said Ukraine was now being sacrificed for this goal—an effort "to erase boundaries and annihilate their identity. It is unconscionable. Where is our humanity and solidarity?"

That question would be answered in the coming days and months—solidarity and its attendant quality mercy undergirding the humanitarian response. Still, Sr. Teresa's anger was heartfelt and

deeply empathetic to the Ukrainians: "I am angry, dismayed, and saddened, in fact powerless, for advocacy has no room in the face of arrogant military power. Instead, in solidarity with the people of Ukraine, I lift my heart in prayer, begging God to intervene. Miracles can still happen, in the guise of diplomacy."

Unfortunately, miracles did not happen by means of diplomacy. But they did in other ways—though the challenges were always apparent. Early in the crisis, Sean Callahan, the president and CEO of the US humanitarian organization Catholic Relief Services, said it and its partner, Caritas Ukraine, stood "in solidarity with the Ukrainian people and are preparing to provide assistance to civilians affected by an escalating conflict."

Callahan warned, however, that a potential "humanitarian crisis resulting from an invasion of Ukraine would completely overwhelm the capacity of the aid agencies in the region. The freezing winter temperatures, likely damage to health facilities and other vital infrastructure, and the enormity of the civilian population in harm's way, could lead to suffering on a scale we have not seen in Europe in our lifetimes," he said.

That was true—within weeks, the extent of what happened in and around Ukraine became both alarming and staggering, with Europe experiencing its largest refugee crisis since World War II. Callahan noted that in less than two weeks, more than two million Ukrainians had fled the country, nearly all of them women and children, with a million more displaced within Ukraine. Children, Callahan said, are "dragging bulky luggage, their faces wet from tears," with crowds in Poland and neighboring countries "huddling inside bus terminals for shelter, knee-deep in their belongings."

I got a sense of this hardship in the coming weeks.

Two

Crossing Borders, Breaking Boundaries

Arriving in Poland

Within a few days I arrived in Poland, and with the help of my able driver, Dominick Zięba, I criss-crossed the southeastern part of the country and stopped at several "welcome sites" near the border with Ukraine—for the most part, empty, cavernous and shuttered shopping malls that had been rapidly converted into places of brief respite and rest for the refugees. Having visited refugee and displacement camps in Africa and the Middle East that were sometimes ragged at best, I was surprised and heartened to find that the situation in Poland was not at all chaotic—the welcome centers were orderly and clean. They were crowded, certainly, with each housing hundreds of arrivals, but they were organized, with cots set up in an orderly fashion.

Volunteers served the arrivals hot meals from food trucks outside the complex. I still recall the long lines of hundreds of exhausted and

dazed arrivals awaiting meals from groups like World Central Kitchen and from local Polish volunteers. In the train station at Przemyśl, the Ukrainians lined up for hot, freshly prepared cabbage-and-potato soup ladled from large cauldrons. Similar lines emerged inside the welcome centers, where specialized services also popped up—including medical care and help for those who had brought pets with them—a surprisingly high number, something I had not seen in other locales, like Africa.

So many of the refugees had family or friends in Poland and elsewhere in Europe, and volunteers and humanitarian workers worked to assist the arrivals with transport to their destinations. Smartphones were ubiquitous; apps like WhatsApp and Telegram made it easier for the arrivals to communicate with friends and family in Poland and other countries, as well as staying in touch with those remaining in Ukraine. The stereotype of refugees as victims and not as capable survivors with agency—an always unfair portrayal anyway—was certainly undermined in Poland.

At the same time, the refugees clearly faced challenges—though biting winds and frigid temperatures at the border were not unusual for the Ukrainian arrivals, they did not make the situation any easier. One of the first refugees I spoke to was Maryna Zozuliak, a young Ukrainian who stood dazed in a crowded parking lot of the Przemyśl welcome center—but who was warmly dressed and prepared for the cold weather.

Maryna was by turns anxious and relieved, trying to get her bearings but happy that she had successfully crossed the border in a car with her godfather and her sister, Elisabeth. Their journey had taken them from Vinnytsia, about 300 miles due east from Przemyśl. Maryna had a single piece of pink-colored luggage with her and said,

despite it all, she felt safe and protected. She expressed hatred for Russian president Vladimir Putin. Tearing up, she said, "I am very bitter." But she almost immediately recovered, focusing her thoughts on what was ahead—boarding a bus that would take them first to Wrocław, a city in western Poland, then bound for the Netherlands to stay with an aunt there.

Like all refugees I met, Maryna hoped that the war would be short and that she and her sister would be able to return quickly to Ukraine. Some did return—but many, two years after the full-scale invasion, had not, and the war's tragic grind forced many of the refugees to make an uneasy accommodation with new lives in exile.

The Human in Humanitarianism

"There's immense suffering and there's a huge humanitarian need and a crisis that is evolving daily," Tetiana Stawnychy, president of Caritas Ukraine, told me by Zoom, saying the crisis required both an obvious material response but also "a heart response and a prayer response."

The material aid—shelter, food, medicine, and hygiene items—came relatively quickly, supplied by European donors who had quick access to such things. Just as Poles opened their homes and kitchens to shelter and feed their Ukrainian neighbors, I saw vehicles carrying supplies along the Polish highways from a number of European countries, including Germany, the Scandinavian nations, and the United Kingdom. They carried supplies ranging from bandages to insulin, from crutches to wheelchairs. It was a notable display of solidarity.

But what Tetiana called the "heart response" took longer and required patience. After all, providing "psychosocial" support for those who are traumatized takes time. At the welcome centers run by Caritas, many people were "just sitting and in shock and kind of just sitting with their phones, and needing to talk," she said. That was needed within Ukraine itself, of course, but the succor and comfort were also needed once people arrived in safer spaces in neighboring countries like Poland.

On the same afternoon I spoke to Maryna on that windswept parking lot in Przemyśl, a 32-year-old volunteer from Norway manning a Caritas "comfort station" spoke of the shock experienced by the refugees, who had left everything behind, recalling one girl who walked nearly 12 hours to escape a war zone, and had traveled to Przemyśl by herself. At the Caritas station, she had found a place to sit, rest, and savor a cup of hot tea. (The volunteer did not want to be identified by name because he believed the focus of any story about Ukraine should be on the refugees and not volunteers like himself—a selflessness that is evident among the many humanitarian workers I encountered.)

Though Tetiana spoke of what was happening in Ukraine itself, she could also been speaking of what I witnessed in Poland: large-sale mobilization of nongovernmental groups and volunteers who worked together with local governments to help ease the immense suffering. "Everybody's pitching in in the best way that they know how," Tetiana told me. "I think what's been really important in these first weeks is that it's been this huge outpouring of generosity of the local population that stayed, that hasn't left."

Tetiana added that the "overwhelming outpouring" of help for the refugees had been moving to see. "Suddenly somebody's there to

catch them and hold them as they move on," she said. But it was also moving to hear as she related stories of rural regions where people in church parishes were taking people in.

A few times in our conversation Tetiana began crying a bit. I could not help but do the same when she told me that the very act of helping was obviously healing for those needing help, for those who had fled for their lives and been displaced, and for those who had taken people into their homes. "This act of helping another person is a restorative act in itself—it's restoring something in the person that's being helped and it's restoring something in the person who's helping."

She added: "It's like a restoration of a sense of this human face of human dignity of love and kindness and mercy. That's such a key part of who we are and how we're made."

The idea of human dignity, of course, is central to Catholic social teaching. As the United States Conference of Catholic Bishops puts it: "The Catholic Church proclaims that human life is sacred and that the dignity of the human person is the foundation of a moral vision for society." It adds: "We believe that every person is precious, that people are more important than things, and that the measure of every institution is whether it threatens or enhances the life and dignity of the human person."[*] Such a belief undergirds and intertwines with the principles of humanitarianism, which is simply the promotion of human welfare, the belief that humans ought to help or even save

[*] United States Conference of Catholic Bishops, "Seven Themes of Catholic Social Teaching," accessed June 16, 2024, https://www.usccb.org/beliefs-and-teachings/what -we-believe/catholic-social-teaching/seven-themes-of-catholic-social-teaching#:~:text =The%20Catholic%20tradition%20teaches%20that,things%20required%20for%20 human%20decency.

other humans who are suffering. These complimentary concepts are a foundational and bedrock reason Catholic sisters, for example, and other humanitarian workers, feel that it is their duty to become engaged and help the oppressed, the forsaken, and the displaced.

Love Thy Neighbor:
Poland Welcomes Ukrainian Refugees

Of course, the solidarity and mercy being shown by volunteers stood in stark contrast to what prompted the need for a response in the first place—something articulated by volunteers working at a refugee reception center on the outskirts of Korczowa near the Polish-Ukrainian border. The shuttered shopping mall on the outskirts of the city that served as the reception center was filled to near capacity on the day I saw it, with cots row to row.

"You have the best of humanity here, and across the border, the worst," said Ukrainian American volunteer Lev Ivanov of Chicago, referring to the humanitarian response near the border and the war raging within Ukraine. He was one of many expats and those of Ukrainian descent living oversees who came and joined the humanitarian effort—highlighting the strength and power of Ukrainian identity.

He expressed exasperation at the crisis. "It's a war started out of nothing, out of lunacy," said Lev, a musician and orchestra conductor who works in the Chicago area and was raised in Kyiv.

The cycles resulting from war that later turn into humanitarian crises can change rapidly. The crowded one-time shopping mall filled to capacity when I first visited felt dramatically depleted when I visited four days later, with about two-thirds of those in the public

space dubbed "Kyiv Hall," the Ukrainian arrivals having gone to their destination points. But the numbers could change again, said volunteer Anastasiya Vaynraukh, an IT worker from Portugal. "It's like a wave."

Outside the center, mounds of donated clothing piled up—always an unfortunate side effect of any humanitarian response. The clothing seemed to be better suited for the summer than a late winter that had been cold, windy, and even snowy.

At first, the large, cavernous halls housing people were crowded with Ukrainians—predominantly women, children, and the elderly, as men of conscription age were not being permitted to leave the country. The arrivals napped during the day, covered with blankets. Others texted families and friends back in Ukraine or in their hoped-for destinations.

In the transit site in Korczowa, many of the displaced, who were from heavily bombed Kharkiv, Ukraine's second-largest city, rested, took stock, and contemplated their next moves. While they uniformly praised the Polish hospitality they encountered, they also acknowledged what the Caritas volunteer from Norway had spoken of—being suddenly uprooted by a European land war in 2022.

"You think we live in a civilized time," said the bearded, middle-aged volunteer, wearing warm winter-outdoor gear, shaking his head disbelievingly. "No one expected this. It's surreal to think we are experiencing a war like this in our time."

As they finished their breakfast of rolls, snack bars, and tea, two Kharkiv residents, 51-year-old Inga and her 30-year-old daughter, Maryna, said the situation in their city had become too dire to stay; it took them three days to arrive in Korczowa, mostly by train. "Fear, fear," said Inga, an information technology worker who, like a number

of those at the center, did not want to give out her full name. "It was a terrible situation."

The two were not sure where they might go next, and both spoke of the hope—often expressed—that they would not have to stay in Poland long. "We just can't be sure how long we will be here," Maryna said.

Most of the arrivals left the welcome sites within weeks, if not days—finding ways to travel to other locales in Poland or elsewhere in Europe. Before the invasion, for example, more than one million Ukrainians lived in Poland, and so many refugees had family connections outside of Ukraine. This contrasted strikingly with what I saw in crises in Africa or the Middle East, where temporary locales with displaced persons often expanded into tent cities that soon became semipermanent, or even permanent, settlements.

Down the way, another group of Kharkiv residents sat on cots, eating Knoppers, a Polish brand of nut bars that volunteers distributed. Two women had arrived the day before and said they had no other choice but to leave. "We were scared, and especially scared for the child's sake," said Anastasia, cradling her one-year-old son, Nikita, who slept peacefully, and not fussily, in her arms. Both Anastasia and another Kharkiv woman, Olga, said they were headed to Warsaw, where both women have families. Anastasia said it would be a relief to reach her destination and be reunited with her husband, Sergey, who worked in Warsaw. Both women appeared calm and friendly, enduring what would be a singular, frightening, and poignant experience for anyone. For Anastasia, in particular, the hope of being reunited with her husband was the salve sustaining her.

The women were fortunate—they had already established ties in Poland. Others were not as lucky. Upon immediately arriving in

Korczowa, Irin Sautina, another resident who fled Kharkiv, had to take her disabled husband, Alexi, to the hospital. When I spoke to Irin, Alexi was still hospitalized and Irin had to watch over the couple's three cats, Angel, Bonay, and Cugank, and two medium-size dogs, Lira and Laylay. Irin told me what happens next was yet unknown—the couple (and their family of pets) faced an uncertain future.

That was a common burden: the decision to stay in Poland or go to another country was the first decision families had to make. A spokesman for UNHCR, the United Nations refugee agency, told me that Ukrainians could legally stay in Poland to live and work for up to 18 months without seeking official refugee status. Those seeking international protection could formally apply for refugee status later—a process that is never easy anywhere. Still, at the transit center, Irin told me she had everything she needed for now, including hot meals and pet supplies provided by volunteers.

"It's normal—or as normal as could be," Irin said, laughing. "Polish people are good."

Poles, through older family members, were also acquainted with the underlying realities of war—though personal historical memory was bit by bit becoming lost. Polish Jesuit Fr. Wojciech Mikulski, 53, said that he had come from a postwar generation that had only known war from the movies—and movies tended to focus on the battlefields and not on their aftereffects. (His parents and grandparents also tended to speak little of their wartime experiences—a reticence I heard expressed again and again in Germany, Poland, and Ukraine.)

But in his work at the European Institute of Communication and Culture, a Jesuit-run training and conference center in Warsaw that welcomed and housed refugees, Fr. Wojciech saw a different face of war. Refugees often brought only one suitcase—if even that—when

they arrived at the center's door. "For three weeks now, I have seen that the victims of this war are women, children, and old people, defenseless people, who came to us," he told me in an email. "With uncertainty they run away and do not know where they will go," he said of people departing from Ukraine. Some people have an idea of what to do next. Others run as far as possible from the war."

Fr. Wojciech recalled one family—a young woman named Irina, her twin children, and her grandmother, carrying "only small suitcases" with them—who had left the center and got onto a bus bound for Spain. "Nobody knows Spanish. They don't know what will happen to them there. They found good and kind people who helped them get to Spain," Fr. Wojciech said. "What to do next is unknown. When I went on the bus with them, the grandmother asked Irina if she knew whether their house was still standing."

That would be a frequent question heard among Ukrainians in the next two years—as Tetiana of Caritas explained to me.

"When you see the numbers," she said, "it's easy to slip into statistics, but behind every statistic is a face. A face, a human life."

One such face was that of refugee Maryna Zozuliak, the young Ukrainian I met in the parking lot—suddenly bound for a new country, an uncertain future, and the ache for what was left behind: a home and a seemingly secure life. Multiply Maryna Zozuliak's experience by nearly three million people, and you get a sense of what convulsed Europe in a few short weeks in the winter of 2022.

Three

A Complex Brotherhood

The Historical Ties Between Ukraine and Poland

The welcome for Ukrainians along the border—in the hundreds of thousands within a few short days—was warm and fraternal. It was hopeful. It was concrete. It gave new meaning to words like "solidarity" and "mercy." I knew this from the Ukrainian refugees I had met at the transit centers. But it came on a land that had been soiled with decades of bloodletting, tragedy, and horrors. These are part of the "bloodlands," as described by Yale University historian Timothy Snyder,[*] a place of immense sorrow, where 14 million perished between 1933 and 1945. That sorrow still felt immanent in my various visits to the border areas in 2022 and 2023—perhaps best described when I visited the memorial site of the Belzec extermination camp, about a 90-minute drive from

[*] Timothy Snyder, *Bloodlands: Europe Between Hitler and Stalin* (New York: Basic Books, 2010).

the Ukrainian border, on a bitterly cold, overcast rainy day. That was a site where the tensions between Poland and Ukraine could be evinced—Ukrainian guards were common at the camp, as they were at other sites (like Treblinka), representing one thorn in a history that was not always easy or comfortable for either country.

While it is true that, as Fr. Wojciech noted, direct experience of the calamities of mid-century Europe are becoming fainter, memories of World War II are still evoked in Poland and Ukraine, with both nations claiming victimhood in an ongoing debate about the massacres in the border regions of Volhynia and Eastern Galicia in what is now Ukraine. The European Network Remembrance and Solidarity has described the events as "anti-Polish genocidal ethnic cleansings conducted by Ukrainian nationalists"*—and the Polish government has described them as genocide. Then there is also the matter of the Holocaust. Some Ukrainians resisted the Nazis, while others welcomed German occupation, partly as a reaction to Soviet rule. (This fact, as well as massacres in Babi Yar and elsewhere, as well as pogroms in prewar Ukraine, are one reason that a Jewish friend of mine in New York once told me that she was unable to muster much enthusiasm for supporting Ukraine in the current war against Russia. At the same time, though, as we will see later, a Ukrianian American Jewish scholar I interviewed praised Ukraine for its commitment to pluralism and even electing a Jewish president.)

And yet in the reality of the postwar world—and then later in the post–Cold War era—two countries with distinct cultures and histories, and not always enjoying easy relations as neighbors, could find common

* European Network Remembrance and Solidarity, "Volhynian Massacre," accessed March 22, 2024, https://enrs.eu/news/volhynian-massacre.

ground because of their shared experience of Soviet domination and influence. In other words, the relations between the countries were poignant—like siblings who had grown up at odds but as adults had discovered they shared similar experiences and even fraternity.

This became clearer to me in the following days when I met Ukrainians in Kraków. One of the first I met was Sr. Evphrosynia Senyk, a member of the Congregation of the St. Joseph's Sisters.

When I first met her in the quiet space of a small chapel at a Ukrainian Greek Catholic Church in Kraków, Sr. Evphrosynia admitted to still being tired and a bit weary after a long and difficult journey earlier in the week from western Ukraine. But her somber expression transformed into a beaming smile when I asked about the welcome she and other Ukrainians had received in Poland. "We were moved to tears, to be welcomed by the Poles," she said. "How they welcomed us, with such warm and open hearts. Here in Poland, it feels like they are our brothers and sisters."

It has to be said that Poland's recent history with immigrants has been marked by what some say is a double standard based on race and religion. In 2016, thousands of Poles protested a decision to welcome refugees from predominantly Muslim nations in Africa and the Middle East. But Poles who said the country should welcome immigrants took to the streets in 2021 to protest what they said was cruel treatment of migrants by Polish authorities at the border of Poland and Belarus.

Nonetheless, as the 2022 crisis unfolded, religious leaders praised Poland for doing right by the Ukrainian arrivals. One of them was Sr. Dolores Dorota Zok, the provincial leader of the Mission Congregation of the Servants of the Holy Spirit in Poland and president of the Conference of Major Superiors of Religious Orders in Poland. She noted that Poland likes being a haven for others. "We are good to

different kinds of people," she said. In doing that, Sr. Dolores evoked other aspects of World War II and historical memory—with Poles remembering what it is like to experience poverty, hardship, and what it means "to be alone and in a new country."

Dominican Sr. Marjolein Bruine, the secretary general of the Union of the European Conferences of Religious Major Superiors, also evoked that history and common ties, saying that "Many Poles know the experience of fleeing, because they had to do it themselves, often." But there were also pragmatic reasons for the Poles' welcome: even before 2022, Ukrainians already constituted the largest non-Polish minority in Poland, so "many Ukrainians have relatives in Poland, whom they now call on, in the belief that they can soon return home or what is left of it," Sr. Marjolein told me. There were also the obvious geopolitical realities. "Countries west of Russia are 'solidarizing' with each other against Putin out of fear that it will soon be their turn," she said.

And then there were the ties of faith, of religions—always a strong bond. While Poles are overwhelmingly Roman Catholic, and most Ukrainians are Orthodox Christians, the significant minority of Ukrainian Greek Catholics "worship with a Byzantine liturgy similar to that of the Orthodox but are loyal to the pope," noted an Associated Press story.* Given all of these factors, Christianity, in a moment of crisis, helped unite "the people of Poland and Ukraine," Sr. Marjolein said. Still, when Ukrainian Orthodox Christians found a spiritual home

* Peter Smith, "Explainer: How Is Russia-Ukraine War Linked to Religion?," Associated Press, February 27, 2022, https://apnews.com/article/russia-ukraine-vladimir-putin -kyiv-europe-nationalism-ff22c6c17784674a5eaad0f0a1ff17ca#:~:text=Surveys%20 estimate%20a%20large%20majority,of%20Protestants%2C%20Jews%20and%20 Muslims.

and shelter—even temporarily—in Ukrainian Catholic churches in Poland, they did so in places of worship with some differences. The Ukrainian Greek Catholic Church is still loyal to Rome, for example. But the language, prayers, and rituals are similar—not to mention an abiding sense of solidarity, comfort, and hope.

The ties between Poland and Ukraine were one reason that Sr. Evphrosynia, a native of Chernelytsia in the Ivano-Frankivsk region in western Ukraine, journeyed three days from the border city of Lviv, where her congregation has a convent, to Kraków, where she had been assigned to work at the Greek Catholic parish of the Exaltation of the Holy Cross. That parish, formerly the Church of St. Norbert, is not far from Kraków's old center, and helped minister to the burgeoning Ukrainian refugee community. Her experience was not unlike those of refugee families: for part of the journey, Sr. Evphrosynia was accompanied by her sister, two other women, and three small children, who were bound for other locales. She was responsible for getting the women and children to their destinations safely—and while traveling, looking after the group: "Holding one child in my arms or on my knees, looking after bags, tickets, and travel documents," she recalled.

Sr. Evphrosynia's eventual goal—to return to her congregation's health and nursing-home mission in Saskatoon, Canada, where she worked from 2019 to 2021—eventually happened in early 2023. But in March 2022, she said she was happy to be in Kraków, working among fellow Ukrainians. "I'm safe here," she said, "and I feel I am doing God's will."

A few days later, Sr. Evphrosynia introduced me to two recent Ukrainian arrivals. Ludmyla Opanasuk, 45, and her sister-in-law, also named Ludmyla. They said they were relieved to be in Kraków, a city they said was blessedly quiet after the bombings and chaos

they had experienced in and around the Ukrainian capital of Kyiv. The women, accompanied by Opanasuk's 13-year-old son, stayed in Kraków with a Polish American couple who volunteered to take them in. Bound by trauma and seeking spiritual solace, the women expressed relief that they were in a safe space. "We are overwhelmed," Opanasuk said, "by the support of the Polish people." She added, "You feel good when everybody is supporting you. We feel grateful."

Though the family, who had lived outside the capital of Kyiv, were brought up in the Orthodox tradition, differences between Orthodox and Catholic traditions and theologies meant little if anything in the context of displacement and trauma. What mattered most to Opanasuk was that she and her family were safely in Kraków, finding some solace as they contemplated next moves and tried to make sense of their fate—and their country's.

The larger questions were never far from the surface: Opanasuk's sister-in-law also said she felt enormous anger over the Russian invasion and being uprooted. "Bitter," she said. "Bitter. We were afraid for our lives."

My time with these women was too short: they needed to visit the church's priest and inquire about future plans. But my time with Sr. Evphrosynia as a key contact continued through the days and months ahead, and I was forever thankful that she introduced me to Svitlana Kruchynska, 57, a one-time librarian and a recent arrival from the eastern city of Melitopol, a city renowned for its fruit trees and verdant gardens and parks. The city, with a population of 150,000, lies near the border with the disputed Crimean Peninsula, and many Ukrainians there still speak Russian.

Svitlana's story was, in many ways, typical of many who fled Ukraine, and it began on that fateful day of February 24, when she

stepped outside her home to walk her two dogs early in the morning despite bracing, below-freezing temperatures. That was part of her normal morning ritual—and in the weeks leading up to the Russian invasion, Melitopol residents had become accustomed to hearing blasts that were part of Ukrainian military exercises. So, on that day, Svitlana and her 23-year-old daughter, Ruslana, tried to think of the best—that perhaps what they were hearing was a kind of new normal.

Of course, something of the wider context is helpful: though war always comes as a shock when it finally arrives, Ruslana said that those living in cities like Melitopol were perhaps better braced for that, given that Russian and Ukrainian forces had been engaged in battle since 2014 over Crimea and disputed parts of eastern Ukraine.

"Those who live far from that border still can't believe this is happening," Ruslana told me. But for those living closer to the border, it was not quite a totally new situation. "That background is important."

But even some mental preparation doesn't fully prepare a person for war: when Svitlana saw warplanes overhead, she realized that the full-scale Russian invasion—threatened for weeks and a prospect for years—had begun. With the escalating din of bombings, shootings, and shattered glass, Svitlana and her daughter realized they had to flee.

"We'd be under the gun," Ruslana told me in an interview along with her mother in a park near Kraków's old city on a bright sunny Sunday afternoon, just weeks after they fled Ukraine. Yet fleeing was not an easy thing, and at first Svitlana hesitated. Where would they go? she asked her daughter. But Ruslana convinced her mother that it was best to leave, a hunch that proved correct given that Russian tanks entered Melitopol the next day.

Ruslana's concern for her and her mother's safety stemmed from her family's support of Ukrainian nationalism: the collection

of blue-and-yellow Ukrainian flags throughout the family home identified them as nationalists and could put the family at risk. The family might be targeted, Ruslana warned her mother. Another factor: the family and others had prepared gift packages of food and other supplies for Ukrainian soldiers fighting at the border for years.

And so, the two women fled in the family car, with neither Svitlana nor her daughter packing suitcases or even passports. They were motivated by fear and the need to be out of harm's way; they had no thoughts at the time that they would be leaving their lives indefinitely. All they had with them were the clothes they were wearing and their national identity cards. They left almost immediately, accompanied by the two dogs, and saw few cars on the road, though they did see some wreckage of burned-out vehicles along the way. Luckily, once out of Melitopol, the two women did not hear further explosions.

The women decided to meet up with the mother of Ruslana's boyfriend, who lived in Zaporizhzhia, about 80 miles north. They stayed there three days, but after that city's airport was targeted and bombed by Russian forces, the women decided to head west, accompanied by the boyfriend's mother. Without a change of clothes, the women continued their journey, dogs in tow, and drove nearly 400 miles to spend one night in the city of Khmelnytskyi and eventually ended up, as had many in the first months, in the western border city of Lviv. After three nights in Lviv, the women crossed the border into Poland on March 1. After a few short hours of sleep in the car, they arrived in Kraków a day later. They were exhausted from the days-long journey—by turns grueling and terrifying, driving hundreds of miles—and turned their thoughts to what

came next. Would they be in limbo? What would happen to them? Who would take them in?

Due to the efforts of a Caritas volunteer at the border, they found shelter at a convent of Dominican sisters, located on the outskirts of Kraków. At the time, the sisters, some 40 in all, welcomed about 20 arrivals—children, women, and one elderly man. Though the space for the women and the dogs was tight, Svitlana said the welcome had been warm and heartfelt. "We've been welcomed very well by the Dominican sisters," Svitlana said, adding that "the sisters are all good." She also noted that two Polish sisters at the convent had served in Ukraine and spoke Ukrainian, while another sister from Belarus spoke Russian. The overall welcome by Poles and by Ukrainians already living in Poland, she continued, had been warm and appreciated. As one example, officials at a consulate office in Kraków—where the arrivals had to wait in long lines to receive the papers allowing them to stay in Poland—provided food and words of comfort. That proved an overwhelming relief for the women, who were grateful for such hospitality.

At the time I spoke to Svitlana and Ruslana, the women expected their time in Poland would be short. "But we so want to be home, and for this war to be over." Svitlana paused, then continued, "We are not going to stay in Poland"—a statement that reflected the women's steely determination to return to Ukraine as quickly as possible.

"We're praying for peace, praying for peace in Ukraine," she said, and added that she was grateful that Pope Francis and churches around the world were doing the same.

At her mention of Pope Francis, I asked, "What should he do for Ukraine?"

Svitlana did not hesitate: "Pray." Throughout the interview, the women spoke about the severity of the injustice facing Ukrainians, with Svitlana telling me she felt bitterness toward Putin and his government. Yet she said she did not feel such anger toward "ordinary Russians," explaining that she did not believe that they truly understood what was happening in Ukraine. But while proud of the global support and solidarity shown Ukraine—including military volunteers from other countries coming to fight for the country—Svitlana said she did not want to focus on what could make her angry. But at the same time, she said it was difficult to ignore the cost—even the physical cost—of the effects of war. Svitlana stiffened at the memory of sirens in war-besieged Zaporizhzhia.

"We heard them all the time," she recalled, a crease in her brow. Though such were not heard in Kraków, Svitlana said she still panicked momentarily when hearing the occasional siren. And even in moments of silence, like at the convent, "we hear sirens in our heads."

The war's effects were felt in other ways. While in Zaporizhzhia, the three women lost all appetite. And after arriving at the convent near Kraków, all they could manage to take in were tea and some cookies.

"Nothing tasted good," Svitlana said.

A constant worry for the women was the fate of men back at home—the daughter's boyfriend, Svitlana's 80-year-old father, and her 34-year-old son, a volunteer bringing supplies, clothing, and food to Ukrainian soldiers. The women stayed in touch with the men via texts and phone calls. When I spoke to them, Svitlana and Ruslana said the men were all right, a reality, however, that could easily change. But still, the women expressed hope.

What It Means to Be Ukrainian

Throughout the interview, Svitlana nodded at Ruslana, the circles under her bloodshot gray-blue eyes attesting to weeks of anxiety and exhaustion. But her face brightened when I asked her what it means to be Ukrainian.

"It means freedom, it means beauty, it means identity," she said, beaming. "We want to be an independent country." She paused, suddenly crying quietly.

"We are a joyous people," she added between tears, and repeated her hope that the family would be reunited in Ukraine shortly—both as a homecoming and also to welcome visitors to a country she and her family dearly love. "We are waiting to return. We don't know when, but we hope it won't be long."

After an hour's conversation, Svitlana said she would rather dwell on fond memories, recalling the pride of Melitopol: its gardens, parks, and fruit trees. "Our city's emblem is the cherry tree," she said, tearing up at the memory. She extended her hand to me, and I took it. "Come," she said. "Come visit. It will be cherry time."

Svitlana's invitation and description of the cherry trees, their flower blossoms pink and full and fragrant, still move me two years later. Luckily, I was able to see Svitlana two more times on repeat assignments: once in November 2022 and then again in January 2023. Both times I visited Svitlana at her new residence: a small studio apartment in the building owned by the Dominican sisters outside of Kraków. Every time I met Svitlana, she was gracious, welcoming and upbeat—though not afraid to discuss her fears and vulnerabilities. She was certainly not afraid to cry. She said she still sorely missed her family, friends, and former life in Melitopol, and she teared up a bit

when I reminded her of her invitation for me to visit her city known for its charm and beauty.

It was good to see Svitlana. Despite the continued uncertainty of her life, she had grown accustomed to that, I guess. Svitlana said she realized now that the idea she expressed earlier that year of returning to Ukraine had been naive. ("It will be over in ten days," she recalled thinking at the time.) Still, she remained hopeful about the eventual liberation of Ukraine and Melitopol.

But then again, she told me that she did not think there would be a war—and there was still a feeling of incredulity about it all. "I can't understand why the war broke out," Svitlana told me, shaking her head in disbelief, something others also expressed repeatedly.

"It's beyond what I can comprehend." Even more poignantly, she told me that "I was once a princess, like Cinderella." But now she called herself a Cinderella in reverse. "The Russians took everything away from me," she lamented.

Despite that painful admission, she seemed mostly upbeat and focused on her new situation: working as a teacher's assistant at a Montessori school with Ukrainian students and also teaching religious education. Ruslana, meanwhile, feeling torn about being in Poland while her country remained at war, eventually returned to Ukraine to continue her military service. "It was hard for her to be here while the war continued," Svitlana said. "She wanted to go back." Mother and daughter remained in touch with daily calls and frequent texting. Svitlana cried a bit when she spoke of this.

The residence in Kraków—located across the street from the Dominican sisters' convent—was a handsome space, and at the height of the initial influx of refugees in 2022, thirty-one people lived at the residence. With some bound for other destinations and others

returning to Ukraine, those numbers had declined to 10 people in early 2023.

Sharing the small, simple studio residence with her dogs, Oscar and Jack, Svitlana said she was making peace with her new life—learning Polish, working in Kraków as a housekeeper two to three times a week and, as mentioned earlier, as a teacher's assistant. But what had become the center of her life in many ways was teaching religious education and continuing her own theological studies, taking online courses.

"In God," Svitlana, a Ukrainian Greek Catholic, said of her theological studies, "there is hope and help."

As for life in Kraków, Svitlana said she liked the city and had made some friends. She certainly appreciated the support of her Dominican hosts. ("We're being good neighbors," Sr. Margaret Lekan said modestly of the overall Polish response to welcoming Ukrainian refugees.) But, of course, Svitlana said Poland will never quite be home. "It's not the same," she said.

When I returned to Kraków in February 2024 after my third visit to Ukraine, and almost two years after I first met Svitlana, Sr. Margaret, whose ministry had since taken her to the United States, said that Svitlana had left the convent and was living elsewhere in Kraków. I took that as a positive sign—that Svitlana's life was perhaps becoming more stable in her adopted city. But having just been in eastern Ukraine and traveling across the country, I was slightly better aware of the physical and psychological distance she had experienced.

I still hope to meet Svitlana in Melitopol someday and breathe in the sweet scent of the cherry trees she so wistfully described to me.

The Ghosts of Ukraine's Past

Exploring the History of a Hard-Pressed Nation

One of the saddest moments in the first month of the war came the news of Russian force commiting alleged war crimes against civilians in Bucha, outside of Kyiv, prompting international condemnation. When I contacted Sr. Anna Andrusiv of the Sisters of St. Basil the Great, she expressed incredulity—but not surprise. "We are fine," Andrusiv told me in an April 6 WhatsApp exchange about the Bucha events and Russian bombardments that hit western Ukraine. "But we are also terrified, too. Deep inside, all of us knew [this] would happen: murders, raping, this kind of horror."

This fear was based on the ghosts of history—ghosts that start to reveal themselves when asking Ukrainians about the past, and then bears down by reading and reflecting on Ukraine's past. Though Ukraine is not the only area of the former Soviet Union where Russia has targeted civilians—most famously it happened in such locales as the province of Chechnya, which sought independence from

Russia—Sr. Anna noted that Ukrainians have special reason to be concerned about events like Bucha, with fear based on historical realities. One was a war after the 1917 Russian Revolution, in which, up against Bolshevik forces, Ukrainians lost their attempt at national independence. Equally tragic, however, was, as I have mentioned before, the 1932–1933 famine, in which policies instigated by the Soviet government led by Joseph Stalin targeted Ukrainian farmers for opposing a massive farm collectivization program.

In her landmark study of the famine, *Red Famine: Stalin's War on Ukraine,*[*] Anne Applebaum noted that the result was catastrophic: at least five million people perished, she wrote, "of hunger between 1931 and 1934 all across the Soviet Union. Among them were more than 3.9 million Ukrainians. In acknowledgment of its scale, the famine of 1932–3 was described in émigré publications at the time and later as the Holodomor, a term derived from the Ukrainian words for hunger—holod—and extermination—mor."[†]

This tragedy was no accident. Applebaum wrote that the Soviet Politburo "took a series of decisions that widened and deepened the famine in the Ukrainian countryside and at the same time prevented peasants from leaving the republic in search of food."[‡] Incredibly, she wrote, organized teams of police officers and party activists, "motivated by hunger, fear, and a decade of hateful and conspiratorial rhetoric, entered peasant households and took everything edible: potatoes, beets, squash, beans, peas, anything in the oven and anything in the cupboard, farm animals, and pets."[§]

[*] Anne Applebaum, *Red Famine: Stalin's War on Ukraine* (New York: Anchor, 2018).
[†] Ibid., xxix.
[‡] Ibid., xxviii.
[§] Ibid., xxvii–xxxix.

That was not the only tragedy: Soviet repression against the church throughout the twentieth century was also common, particularly against the Ukrainian Greek Catholic Church. Sr. Anna knows this personally: her great-grandfather, a priest, was exiled to Siberia and later died there, and other family members were also exiled to Siberia. (Many of the Eastern rite churches, like in Ukraine, follow the common Orthodox practice that a man can become a priest after being married, but a priest who is already ordained cannot then become married. And bishops must always be celibate.)

Sr. Anna later told me that the Ukranian Greek Catholic Church was a particular target because it was seen as a tool of the Vatican—"They were afraid of the church," she said—and also enjoyed a tradition of intellectual freedom that threatened the established order. "We are a free people,"she said of those in her denomination. In the particular case of Sr. Anna's great-grandfather, who refused to convert to the Orthodox tradition and said he would not reveal his parishioners' confessions. Given that history, Sr. Anna told me, the news of Russian forces killing civilians was "not something new for us. That's why we've been afraid." But such fear prompted defiance, and that defiance was rooted in people's lived experiences. As Archbishop Borys Gudziak told me in a February 2024 interview, he cannot view the current war without the wider context of centuries and decades of oppression, particularly the oppression experienced in World War II. "I'm a son of Ukrainian war refugees who actually lived through a much worse war. The casualties now are in the hundreds of thousands. My parents were victims, and my extended family was a victim of a war in which seven million inhabitants of Ukrainian lands were killed, including 1.5 million Jews during the Holocaust. So, the bottom-line conviction is that a culture, a country, a church, a

nation can survive incredible challenges and great devastation. What it can't survive is a total genocide. It can't survive if its freedom and God-given dignity is completely crushed. It can't survive, it will no longer be itself, if it is forced to be something else, particularly if that something else is counterfactual and an inversion of one's identity."

Archbishop Borys continued, if you talk to Ukrainian soldiers and probe their motivation, "They will not tell you that they're protecting the Zelensky government, that they are ready to sacrifice their life for a political system. They say, 'We have been dealing with Russian imperialism for centuries. Our whole nation, the people, our families are in mortal danger. We will defend them.'"

He mentioned this theme, too, in his introduction to theologian Henri Nouwen's diary of visits to Ukraine in the early 1990s.* As Archbishop Borys wrote, "Ukrainians resist. Bravely, selflessly. Solidarity, prayer, mutual trust, volunteer work, and community charity, sacrifice, faith, and a belief in eternity all are present in a way in society." Why is this? Archbishop Borys argues that Ukrainian resistance is rooted in a belief that "the truth will prevail and that evil will be defeated. There is a shared moral inspiration. No one is giving up or is ready to compromise the defense of God-given dignity."†

There is both a secular and religious component here. In secular terms, Archbishop Borys wrote, "Ukrainians today are saying, '[W]e will never again be colonial subjects of the Russians'"‡—something he believes Nouwen sensed in his 1990 travels. Framed in religious terms, Archbishop Borys believes Nouwen, whose love of the Ukrainian

* Henri J. M. Nouwen, *Ukraine Diary* (Maryknoll, NY: Orbis, 2023).
† Borys Gudziak, introduction to *Ukraine Diary,* by Henri J. M. Nouwen, xvii.
‡ Ibid., xxxii.

people is heartfelt and palpable in *Ukraine Diary,* "would have appreciated the transfiguration occurring, on in which Jesus is leading his people on a way of the Cross to a new life."[*]

But the new life is still rooted in old times and experiences, and memories of the Soviet era are often twinged with pain—even seemingly innocent things were never fully free of menace.

Take, for example, the stories of sisters talking about life during the Soviet era. When I visited Zaporizhzhia in February 2024, Sr. Romana Hutnyk told me of growing up in a Catholic family but having to celebrate Mass at night in her small village not far from the Polish border. She remembered her father swearing her to secrecy and not to say anything about it with anyone. "He'd have been in prison if I had said anything," she recalled.

Things were so worrisome that "we had to cover the windows," she said.

Even sartorial choices were suspect. Sr. Romana recalled her mother telling her not to wear a yellow blouse and blue skirt—the national colors of Ukraine—"because your father would get into trouble."

"Imagine," she told me, "our families could be blamed for something so innocent."

Similarly, Sr. Lucia Murashko. recalled showing a painting she created in art class to her father—the colors, again, were blue and yellow—and he warned her to be careful. She had never even seen a Ukrainian flag.

These incidents all occurred in a context of imperial control, a dynamic in which Russia could never seem to view Ukraine as anything apart from itself. Vitaliy, an artist friend in Kyiv—who, as a

[*] Gudziak, introduction to *Ukraine Diary,* xxxv.

member of a Protestant church, has been a volunteer in transporting
medical supplies to military hospitals—grew up in the Soviet time and
said Russians have long viewed Ukraine as a "temporary country" that
will eventually collapse. His interactions with Russians during travels
to Russia convinced him that Russians continue to have prejudiced
views of Ukrainians: that Russians view Ukrainian culture (and the
culture of other former non-Russian Soviet republics) as second-rate,
while Russians are endowed with a "great culture." Vitaliy further
explained that the stereotype seems to center on Ukrainians being
"rural, uneducated, uninitiative, cunning and unintelligent, incapable
of building an independent state."

But in fact, he said, recent history proves otherwise. "Imagine if
Ukraine became a successful democratic country under the European
Union—it could be a model for Russia. But if Ukraine is destroyed
as an independent state—Putin's expressed aim—it would not be in
competition with Russia."

This dynamic goes back decades. Vitaliy believes Joseph Stalin
was simply afraid of Ukrainians—which is why he killed off so
many Ukrainian intellectuals and had so many Ukrainians exiled to
Siberia. Vitaliy's views are supported by respected historians. Anne
Applebaum noted, for example, that Soviet and Russian leadership
had long feared Ukrainians even before they resisted the large-scale
collectivization efforts in the 1930s. Why? Stalin, she said, "spoke
obsessively about loss of control in Ukraine."[*]

And then there is the memory of the Holodomor, the great trauma
of the 1930s. Vitaliy said his grandparents told stories about the fam-
ine and collectivism programs. He recalled his grandmother saying

[*] Applebaum, *Red Famine*, 428.

they had to hide food with their neighbors. Though his grandparents survived, millions did not, and that trauma, as a number of historians have noted, continues to undergird much of Ukrainian reality—a reality that Nouwen sensed was akin to brokenness, a brokenness that contributed to the "very melancholy soul of Ukraine."*

Is it any wonder, Nouwen wrote, that the "spirituality of Eastern Christianity is marked by long-suffering. The people who have experienced so few victories in the secular domain have come to see the Christian faith as a call to follow the crucified Christ as the way to a joy and peace that cannot be reached in this world."† Described in Christian imagery, it might be said that Ukraine is a crucified country, seeking its resurrection.

But even shorn of religious imagery, Ukrainian determination and resistance makes perfect sense. In his 2023 history of recent events, *The Russo-Ukrainian War: The Return of History*, Harvard historian Serhii Plokhy calls the 2022 full-scale invasion "an old-fashioned imperial war conducted by Russian elites who see themselves as heirs and continuators of the great-power expansionist traditions of the Russian Empire and the Soviet Union."‡ He continued that, for Ukraine, however, the conflict is a "war of independence, a desperate attempt on behalf of a new nation that emerged from the ruins of the Soviet collapse to defend its right to existence."§

One reason for Russian obsession about Ukraine: its own fear of democracy.

* Nouwen, *Ukraine Diary,* 114.

† Ibid., 86.

‡ Serhii Plokhy, *The Russo-Ukrainian War: The Return of History* (New York: W. W. Norton, 2023), xxi.

§ Ibid.

Plokhy, amplifying what my artist friend Vitaliy said, helps explain why Ukraine has been such an obsession for Russians in the post-Soviet landscape. The simple embrace of democracy itself, he argues, threatens Russia's autocratic order, and makes it more challenging for Russia to ever dominate Ukraine again.

Plokhy also makes clear—and this is important for Westerners who largely ignored the events of 2014—that the "eight years of hybrid warfare that Russia had waged against Ukraine in the Donbas," had "turned Ukraine into a different country and society from those of 2014. A country divided by issues of history, culture, and identity when the Crimea was annexed was now united by the desire to defend its sovereignty, democratic order, and way of life at almost any price."[*]

The result, Plokhy said, was a uniting "across ethnic, linguistic, religious, and cultural lines"—promoting a "popular identification with the Ukrainian language and culture."[†] Plokhy noted that many Ukrainians who spoke Russian but also knew Ukrainian began to favor the latter as an act of defiance against Putin's official rationale for invading Ukraine—which was the defense of Russian speakers.

That is why, more than two years later, I still marvel and puzzle over why Putin ultimately did what he did. It didn't seem to take into account the changes—and welcome changes—that had transformed Ukraine since its independence in 1991. But as Plokhy argued: "Putin and his 'special military operation' fell victim to the Russian president's distorted view of history and complete lack of understanding of Ukrainian society and its democratic foundations." It also, though,

[*] Plokhy, *Russo-Ukrainian War,* 132.
[†] Ibid., 133.

"destroyed the last vestiges of the belief that Ukrainians and Russians were fraternal peoples, to say nothing about their being one and same people."[*]

A Unique People, Culture, and Land

In fact, as Applebaum noted in her history of the 1932–1933 famine, Ukraine had long had a distinct identity even before it became a sovereign country, stretching back to the Middle Ages. Even then, she wrote, there was already "a distinct Ukrainian language, with Slavic roots, related to but distinct from both Polish and Russian, much as Italian is related to but distinct from Spanish or French."[†] Moreover, "Ukrainians had their own food, their own customs and local traditions, their own villains, heroes, and legends," and like other European nations, that sense of distinct identity "sharpened during the eighteenth and nineteenth centuries."[‡] However, like Ireland or Slovakia, Applebaum wrote, Ukraine for much of its history was a colony.

It had a brief moment as an independent nation, known as the Ukrainian People's Republic, in 1917. But, as Applebaum noted, anyone "who had promoted the Ukrainian language or Ukrainian history, anyone with an independent literary or artistic career, was liable to be publicly vilified, jailed, sent to a labor camp or executed."[§] This included both priests and theologians, but also Ukrainian political

[*] Plokhy, *Russo-Ukrainian War*, 163.
[†] Applebaum, *Red Famine*, 2.
[‡] Ibid.
[§] Ibid., xxix.

leaders "as well as intellectuals, professors, museum curators, writers, artists . . . public officials and bureaucrats."

This all brought what Applebaum calls "the Sovietalization of Ukraine, the destruction of the Ukrainian national idea, and the neutering of any Ukrainian challenge to Soviet unity."[*] That is, until 1991, when Ukrainians went to the polls and overwhelmingly opted to become an independent nation.

The legacy of Ukraine's tragic twentieth-century history is difficult to underestimate. The fear of Ukrainian independence—and a Ukrainian embrace of Europe and not Russia—led Russia to initiate a constant drumbeat about Russia fighting fascists and Nazis, which as Applebaum noted, became part of the strategy during the 2014 Crimea and eastern Ukrainian invasion. "As in 1932, the constant talk of 'war' and 'enemies' also remains useful to Russian leaders who cannot explain stagnant living standards or justify their own privileges."[†]

Applebaum concluded her study by noting that while the history of the 1932–1933 famine was an obvious tragedy, "the history of Ukraine is not a tragedy. Millions of people were murdered, but the nation remains on the map. Memory was suppressed but Ukrainians today discuss and debate their past." Moreover, she wrote, Ukrainian history "offers hope as well as tragedy."[‡]

Why? "Ukraine was not destroyed," Applebaum wrote—nor did the Ukrainian language and the desire for independence and democracy. "Ukraine, as the national anthem proclaims, did not die."

[*] Applebaum, *Red Famine*, xxix.
[†] Ibid., 428–29.
[‡] Ibid., 428.

When I spoke to Ukrainian American scholar Victoria Khiterer about these threads of history, she agreed with Applebaum that there is a mixture of tragic and hopefulness bounded together in the Ukrainian narrative. All are rooted in the nation's experience but such dynamics are also common to relatively young countries such as, say, Israel. "First we can say there are some periods that we can call period of great hopes, romanticism, then some disappointment because not everything is going as great as people want," said Victoria, professor of history at Millersville University of Pennsylvania and who also teaches a course on the history of the Holodomor at Gratz College.

Victoria, who was born and grew up in Ukraine, told me a telling anecdote: a friend of hers in the 1980s visited his family's village, and his grandmother pointed out a hill to him. She said that was the spot where half the village was buried during the Holodomor.

"If half of your village died during the war, it is a big tragedy for those who survived because they knew these people, their relatives and friends. It affected basically in the same ways that Holocaust affected the life of Jewish people," said Victoria, who is Jewish.

"If Jewish people all live in the shadow of the Holocaust, Ukrainian people all live in [the] shadow of the Holodomor, because so many grandparents or great-grandparents, or some relatives, perished." Given that difficult history, I asked Victoria how to assess the various false claims Putin has made about the Ukrainian government and Ukrainian cause, equating them with Nazism. Victoria thinks a sound term for what is happening in Russia and with Putin's ideology, such as it is, is "historical schizophrenia," a

term she first heard on Ukrainian television. It means, she said, that Putin has "denied that Ukrainians are a separate nation from Russians—that Russians and Ukrainians are one people." But at the same time, she said, he sent in troops to kill Ukrainian people.

"Needless to say," she told me, "that's a very strange treatment for 'one people.'"

As someone who grew up in Ukraine and remembers Soviet anti-Semitism herself, Victoria finds the Ukrainian landscape encouragingly altered. She recalls being taunted with anti-Jewish slurs and being confronted by "state anti-Semitism and by anti-Israeli propaganda" in the Soviet press because "almost every day Soviet newspapers published some information that Israeli aggressor did this, Israeli aggressor did that. And I was attacked as a child at school because I somehow became a child responsible for all 'Israeli aggressors.'"

That environment has changed, Victoria said—and not only because former classmates later apologized to her for their anti-Semitic taunts. "I remember that I was crying, and I did not understand what my classmates wanted from me and what was my responsibility in this story. But it all was Soviet state propaganda. When I graduated from school, my classmates apologized to me and said it was of the time—garbage of the time. They said, 'We are very sorry.'" Victoria explained that her former bullies told her that they were under the influence of Soviet propaganda, having been inundated by anti-Semitism every day on television and in newspapers.

By contrast, she said, Ukraine now has a Jewish president, something that Victoria never thought would ever be possible. "I was wrong, They elected Zelensky by seventy-five percent of the votes. At point, I understood that the country really had changed after years of independence—that the state anti-Semitism that existed in

the Soviet time was gone, together with the Soviet system. It is now an absolutely different democratic country."

One telling example of the change, Victoria said, was witnessing, in person, the eightieth anniversary commemoration of the Nazi execution of nearly 34,000 Jews at Babi Yar, then just outside of Kyiv. The massacre was a seminal event in the history of World War II, and the participation of Volodymyr Zelensky, as well as presidents of Germany and Israel, and family members of those killed was a milestone in recent Ukrainian history. This type of ceremony, she noted, would never happen under a Nazi state—"whatever Putin says," Victoria noted.

In fact, Victoria argued, Putin has created a new form of Russian fascism that has "poisoned the minds of common people." But not just common people. Some Russian scholars Victoria has known for 30 years, from her days of graduate study in Moscow, have also embraced Russian state fictions and ideology. When she has tried to persuade these colleagues of a different point of view, Victoria said they have replied, "You have one set of information, we have another."

She added: "I think the information and the minds of people are really poisoned. This is really very dangerous because I believe that their society is very sick." Unfortunately, Victoria said, "seventy to eighty percent of Russian society support Putin in his aggressive imperialist plans," putting Putin in a tradition not unlike fascists like Hitler and Mussolini—a tradition which has "destroyed life for a peaceful people."

Victoria recalled two incidents from a conference of historians she attended in Russia in 2019. One was a Russian scholar telling her that she could not afford to pay for an extra night's hotel room because her salary was so low—she planned to sleep in the hotel lobby. (Victoria

invited the woman to stay in her room for the night.) The scholar told her: "We have nothing. We still live in these tiny apartments that were built fifty years ago. We don't have cars."

"I just felt sorry for her," said Victoria.

The other experience stemmed from Victoria's departure from Russia after the conference and she was detained by border officials for two to three hours and interrogated about why she had been in Russia, who she met with, and if she, as a holder of an American passport, was an American spy. Victoria had a mug shot taken and she almost missed her flight to visit her parents in Israel. "After this experience," she recalled, "I said I would never return to Russia again as long as the Putin regime was still in power."

By contrast, Victoria said, pre-2022 Ukraine was notable for her friends enjoying moments in overcrowded restaurants because they were starting to earn decent salaries. "Finally, life was improving," her friends told her. But then the 2022 full-scale invasion began, and their lives were upturned again.

Victoria said she and Ukrainians who grew up in the Soviet era would never return to the days of small apartments, long lines, and food shortages. Or to the lives of her parents, who, as engineers, worked eight to nine hours a day but then had stand in line "after work two, three hours to buy meat or cheese or something because people need to eat something every day. Everything was lines—and lots of anti-Semitism."

Though not writing of that directly, Nouwen in his 1990s travels noted that there was probably never a time when Ukrainians did not experience some kind of oppression and exploitation. On the outside, it seems, they had always been at the mercy of some foreign power. And yet that awareness has created a certain kind of resilience, meaning

that the Ukrainian people "have always been waiting people, waiting not just for the oppressors to leave their country but also waiting for the fulfillment of the divine promise of eternal joy and peace."[*]

Joy and peace—this is what all Ukrainians—whether Jewish, Catholic, Orthodox, Protestant, those of no organized faith—have sought and desired. But in so seeking it, Ukrainians are mindful of Russian domination and devastation, which, as Archbishop Borys Gudziak noted, has been part of family histories, including his own, for generations.

"The current war is bleak—but Ukrainians have known even worse. I've seen it. My family's lived it. My church has lived it. And I think that is consciously or subconsciously in the minds of millions of Ukrainians."

[*] Nouwen, *Ukraine Diary,* 14.

Five

A Glimpse into My Journal
My First Experience in Ukraine

*I*n some ways, my first experience in Ukraine—a brief two-day visit to western Ukraine in November 2022, just as Advent began—was a distillation of everything I would experience later in the country. My hosts, a group of four Polish Dominican sisters living in a convent in Zhovkva, near the border with Poland, had lived as missionaries for years—though they resided in an area that had once been part of Poland, and the heritage and history of the place was a mixture of Catholic, Orthodox and, pre-Holocaust, Jewish. If there was a theme to the visit, it was the need to find light—both metaphorically (it was the beginning of Advent) but also literally; darkness had become the norm in Ukraine because Russian bombardments had affected the power grid throughout Ukraine, cutting off electricity in many parts of the country, even in places like Zhovkva that are far from the front lines of war in the east.

"We're on a mission for light," Dominican Sr. Margaret Lekan told me shortly before we crossed the Poland-Ukraine border on what was

Thanksgiving Day back home in the United States. Sr. Margaret had invited me only two days earlier to join her and volunteer Malgorzata Porebska on a two-day mission to meet the four Polish Dominican sisters living and working in Zhovkva, a city of about 14,000 in western Ukraine and a center for a surrounding agricultural district.

A mission for light was literally true: The cargo area of Sr. Margaret's congregation's brown Škoda Fabia hatchback was filled with dozens of boxes of flashlights and candles, bound for the convent in Zhovkva. The small candles—Sr. Margaret brought 30 boxes in all, enough for about 460 families for about four days—were a particular godsend. Candles then were scarce and costly—more than a loaf of bread, and bread is not cheap in Ukraine.

Our day began at 5:30 in the morning with stops to buy candles, flashlights, and fresh bread—the bread would be a welcome "taste of home" for our hosts, said Sr. Margaret, 46, who studied and worked in the United States for nine years, from 2000 to 2004 and 2005 to 2010. When I met her, Sr. Margaret's ministry in Kraków focused on vocations, preaching, and evangelization, particularly to women.

It took about six hours of travel from Kraków across southeastern Poland, including an hour at the border crossing, to arrive in Zhovkva. (Our return to Poland two days later was not as easy. It required about 12 hours of travel, seven of them stuck in a slow-moving line at another border crossing. At that point of the war, it was next to impossible to predict the pace of border crossings, especially back to Poland.)

Along the way, Sr. Margaret and Malgorzata alternated as drivers, and during our travels, Sr. Margaret prayed the rosary, reciting in English with the help from an app on her smartphone. As we made progress on our journey—for example, as we crossed the border—she would quietly say, "Thank you, Jesus."

The spirit of the sisters in Zhovkva was all-embracing, welcoming, and warm—they greeted us effusively and apologized for any discomfort or inconvenience we might experience at the sisters' convent, a comfortable but crowded two-story residence located on an unpaved side street in Zhovkva. Their warmth was a comfort in a war-torn country experiencing bracingly cold temperatures and fog-filled skies enveloping snow-covered flatlands that reminded me of my years as a young newspaper reporter in Minnesota.

Sr. Mateusza Trynda, the local superior of the house and a resident of Zhovkva for 28 years, apologized for the spotty electricity and said this was the first day with sustained power outages. "We just have to deal with things as they are," she said with a shrug, welcoming us—in spite of their troubles—to a midday candlelit meal of pierogis, borscht, and stewed apricots, traditional regional cuisine.

The sisters said they were able to make due with a backup generator for heating. But they also noted the inherent challenges and dangers of life without electricity—for example, the uncertainty faced by hospital patients and those needing dialysis treatment.

"It can be a life-or-death situation for some," Sr. Mateusza told me as we sat down for our midday supper in the convent that had been turned into an all-purpose sister-run community humanitarian center.

Yet the experience of war is always a bundle of things: and the Russian invasion had, ironically perhaps, brought families together "to read old stories like fairy tales" over candlelight, said Sr. Juwencja Dziedzic, who had been in Zhovkva for 19 years. Zhovkva is about 25 miles from a military base that the Russians had hit with missiles in the first month of the war. Thankfully, the city itself had not yet been a Russian target, though residents had seen or heard bombs fly over the town, said Sr. Sarah Lakoma. Alarms became common—perhaps

as many as four a day, Sr. Sarah added, though during the two days
I was in Zhovkva, I didn't hear a single alarm. (I would hear alarms
during a later assignment a few months later.) A kind of normality had
set in, with residents, including the sisters, pausing for just a moment.

"When we do hear the alarms, we will pray but just continue what
we're doing," Sr. Sarah said. This became a necessary way of coping
with the situation. Otherwise, she said, "you just become overcome
with fear and tension."

That is a kind of "everyday protest" against Putin and Russian
forces, she said. "Once the alarms finish, people go back to their normal
lives." In other words, normality had become an act of resistance.

One reason life goes on almost seamlessly is that there was work
to do. Sisters began distributing the candles and flashlights the next
day, also the day that three heavily stocked vans full of foods and
medicine arrived courtesy of Caritas, shepherded by a group of Polish
priests, arrived at the convent. The sisters spoke proudly of their
residence becoming a trusted community resource, one of the few
places in town—I heard this from others, too—that offered assistance
people can count on. But they also said, in the spirit of solidarity
and mercy, that whatever they do, they do only in partnership with
others, not only Caritas but also networks of Dominican sisters, groups
like US-based Sisters Rising Worldwide, World Central Kitchen,
the Polish Red Cross, and others that had provided the sisters with
material aid or cash.

One other partner and major resource in Zhovkva at the time
was a humanitarian center housed at a civic theater in the center of
town. Srs. Margaret and Mateusza accompanied me there in the late
afternoon—just as the sunlight was dying and as the faint trace of
woodburning fires filled the air of the small city. We needed flashlights

to make our way through the complex, ending up in a large side room filled with used clothing that had been sorted smartly and neatly. I was lucky to be with the sisters: the first thing volunteer Natalia Szymkowicz, a librarian, told me was how much that residents respected and valued the sisters as real community leaders, which was appreciated now more than ever. "We always thank the sisters for their work," she said. "There are only four nuns assisting in this entire city. They are like our bright suns."

This was no lark. The Dominican sisters' work before the war—whether as teachers or in providing food or medicines to those in need—had made a quiet but permanent mark, Natalia said. Zhovkva is not a prosperous place, and the gloom of the war seemed to accentuate the city's drabness. I was told that when the sisters arrived in Zhovkva in the mid-1990s, following the collapse of the Soviet Union, they owned only the second car in the town.

Helping boost the community had long been part of the sisters' ministry. Zhovkva resident Liana Blikharska, 24, who worked with the sisters on humanitarian efforts, said their community-based work was nothing new: "They coordinated the work of volunteers for years." Though characteristically modest about the sisters' work, Sr. Mateusza acknowledged that the sisters had been networking and building relationships with people in the community well before the war.

Looking more broadly, Sr. Mateusza said she believed a new sense has developed in Ukraine since the 1990s of becoming closer to Europe than Russia. "They have a quality of a free person now," she said. "The Soviet person couldn't think on their own. They wouldn't take responsibility for their actions." This was a theme I would hear later a number of times, and it pointed to one key reason why Ukrainians were wary of a Russian-dominated past: many Ukrainians' firsthand

experiences as onetime Soviet citizens were key reasons people remained committed to an independent Ukraine—people do not want to return to a seemingly unprosperous future.

But yet an irony: Sr. Margaret said Zhovkva's underdevelopment actually might have become an asset, since the current deprivations could be more painfully felt in a more prosperous place. (It also might have spared Zhovkva from being a target for the Russians.) Still, that has not made life any easier in the current context. Though not a major destination for those displaced in other parts of the country, the people of Zhovkva had been hard-pressed to find apartments for any new arrivals. There just were not that many, Natalia said. Hundreds of families did arrive at first, many stopping for a day or two before heading to Poland. The numbers of those arriving had declined since the immediate onslaught of the full-scale invasion. As of late 2022, perhaps only about a dozen families arrived daily.

Despite the hardships and deprivations, volunteers in the town were doing their best to help, not only with material assistance but also with maintaining cultural life. The city tried to keep residents engaged and happy, whether through informal concerts, plays, poetry readings, and embroidery classes—all by candlelight, if needed.

"It's very important to keep culture going," said volunteer Kateryna Plechii, the daughter of another volunteer, Hala Lozij, who worked alongside Natalia in registering new arrivals to the city. "We are fighting the war by building culture."

Still, the reality of war itself was never far away. The auditorium of the building housing the humanitarian center had become a vast storage area for medical supplies going to the war's front lines. After three hesitant flickers of light, the electricity returned, and it was

possible to see that many of the auditorium's seats had been taken out, the area groaning with boxes of donated medicine, bandages, and other supplies, like crutches.

"We have a strange new life now," said welder and medical coordinator Vadym Voronin. "But, as you can see, we have a lot of friends in Poland, in the United States."

Vadym, who worked at the nearby Yavoriv military base, coordinated the distribution of medical supplies through the volunteer group iCare Ministry but had also worked with the sisters as they provided medical supplies.

Sr. Mateusza stood next to Vadym, attired in military camouflage gear, and smiled as he said that this "strange new life" of Ukrainians was a necessity for now.

"It's our country," he said. "We must protect our way of life."

I asked Vadym why analysts, at that point, believed Russia was losing the war. He said in contrast to a war-aroused and united Ukraine, Russian soldiers "don't have the motivation. They've been surprised by how fiercely Ukrainians are fighting for our country, and they've also been surprised by the international support."

Ukrainian spirits were boosted by the many social media apps that allow civilians to keep in touch and track war developments. One such app allows users to see where a launched Russian missile might be headed.

"We have a new age of war," Vadym said. Even so, Zhovkva resident Liana Blikharska, who worked with iCare, as well as the sisters, said later in the day at dinner with the sisters that not everything can be determined with an app or new technology.

"You can't schedule a day. Everything changes every day. We're getting used to the new circumstances," she said over a dinner of

cheese, sausages, and bread—a simple meal, the only thing the sisters could muster under the circumstances, but satisfying.

I asked Liana when the worries over bombs and alarms became most frequent.

"They love Monday mornings," she said to laughter from the sisters. "And Saturdays."

The laughter died down as one sister recalled the many stories making the rounds, like that of a mother who left her children for a few days without telling them she was going east to bury their soldier father.

Liana believed the war was transforming national life. People in eastern Ukraine, who often grew up speaking Russian as a first language, were embracing a distinct Ukrainian identity, she said. "People are united." And yet still, even amid all of the changes underway, some normalcy continued—indeed, had to continue.

As the meal ended, the sisters and visitors shared cell phone photos of celebratory events.

"War or no war, birthdays continue," Sr. Sarah said, smiling.

The next day, Sr. Sarah showed me the classroom where she teaches Polish and religion to students ages 7 to 17. (Zhovkva, like the nearby Lviv, was once Polish, and familial and social ties to Poland are close. Parents also believe learning Polish may help "open up work possibilities," Sr. Sarah said.) Up to 30 students fit in the small space where she teaches Saturday classes—down from twice-a-week classes before the war. Despite the challenges of limited space and time, Sr. Sarah beamed when she spoke of her students and her calling as a teacher.

"Even with everything, we're happy here," she said. "I've accepted that this is the place where God wants me to be."

The acceptance of a call in the midst of war is not always easy, however, as I found out in speaking to Kostiantyn Sklifus. Kostiantyn,

63, doesn't carry the burden of war lightly. A career military man first with the Soviet army—where he served in Afghanistan and Chechnya, among other locales—and later with Ukrainian forces, he was volunteering with Caritas and assisting in the three visiting Catholic priests' delivery of goods from Poland to Zhovkva.

After morning Mass with the sisters and the visiting priests in the convent's small icon-filled chapel, Kostiantyn spoke to me about the war and the undercurrents of Ukrainian nationalism. "There's too strong a Ukrainian identity" for the Russians to win the war, he told me, and that stems in part from the 2004–2005 Orange Revolution and later 2013 street protests in which Ukrainians rejected pro-Russian rule. Kostiantyn and his family traveled to the capital of Kyiv and participated in the 2013 street protests—a seminal event for them and thousands of others.

Kostiantyn's own identity as Ukrainian stems from those events as well as disillusionment with Russian culture and politics and even with the Russian Orthodox Church—he is a Catholic convert. "It's a corrupted place," Kostiantyn said of contemporary Russia. "Everything is upside-down."

He added: "What we're fighting for is a better society," framing the war as a clash of civilizations.

I witnessed that deep love of country with others, too. Andrij Nevyniak, 38, a local construction worker, is the father of five children ages 6 to 16, which allowed him to remain with his family in Zhovkva and not be drafted into the Ukrainian armed forces. (Fathers with three or more children are exempt from conscription.) While the family could have left for Poland, they made a "categorical decision" to stay in Zhovkva.

"I was born here, I live here," he said. "This is my homeland."

When they can, the family volunteers with the Dominican sisters' humanitarian efforts. "We're always available to help the sisters," Andrij said, which meant unloading pallets of canned food. "The sisters are like godmothers to us. We'll do whatever is needed."

By early afternoon, it was time to leave. As we departed, Zhovkva residents began to line up for the candles we had brought with us the day before. Though patient and orderly, they looked anxious, tired, and wan. I didn't have the heart to ask them any questions.

But as we got into Sr. Margaret's car, I asked Sr. Mateusza a final question: "What sustains you?"

"Faith," she said, outstretching her arms. "Faith. Otherwise, I couldn't stay here."

Six

Lightning and Thunder
in a Clear Sky

Finding Spiritual Comfort
in Prayer and Church

Recall the testimonies of the two Ludmylas at the Kraków parish, the Greek Catholic parish of the Exaltation of the Holy Cross. They said that being at the church—which dates from the first half of the seventeenth century and became property of Greek Catholics in 1808—was a balm even for a few minutes during the week, to pray, sit in quiet contemplation, and speak to the church staff.

"It's a relief, pleasant," said Ludmyla Opanasuk. "The church gives us hope."

It also gave people beauty and inspiration with its striking and rich artwork of icons and front iconostasis. And when it is sunny, as it was on the Sunday morning I attended services there, with morning light streaming in and illuminating the interior, it was easy to feel a real sense of uplift. But the boost was also discernable in a service that was

by turns somber yet hopeful: aisles were filled with standing attendees, the whiff of incense filled the air, and the rhythms of prayer and ancient rite declared hope and resurrection. A hymn sung in remembrance of the war dead brought tears to both church members and visitors alike.

When I met with Ludmyla Opanasuk, she mentioned that she felt at one with other Ukrainian arrivals like herself, saying, "We feel we are among brothers and sisters."

Those brothers and sisters were increasing in number: Fr. Peter Pawliszcse, one of two priests at the church, told me there were about 400 members or attendees at the church before the February 24 invasion, a number that had increased by at least 100 since.

"People are looking for peace. They are looking for prayer," Fr. Peter, 49, said, noting the need for solace in facing a true shock—an imperial invasion in twenty-first-century Europe. "People thought this kind of war was something in the past, behind us." Those arriving in Kraków "are depressed; they don't recognize fully what has happened."

Asked how he was doing, Fr. Peter—who looked worn-out himself—smiled wanly and replied, "I'm good, yes, but this has been a very stressful time for everyone."

Sr. Lubomira Chaban, a Ukrainian St. Joseph sister who had worked in Kraków since 2011, echoed Fr. Peter's sentiments about how the arrivals were struggling with the enormity of what had happened to them and their families. As she evocatively noted, "This has been like lightning and thunder in a clear sky." She continued that she and longtime Ukrainian residents in Kraków "did not expect events would go this way," and they were still staggered by the unfolding tragedy in their native country.

When I spoke to Sr. Lubomira, she said that she was doing "all that is needed" to help both new arrivals and established church

members. That meant everything from cleaning the church, teaching catechism, serving "as a bridge of communication between the priests and the people," and welcoming guests and refugees.

But several times she observed that the arrivals were asking for spiritual sustenance and help. For her, that meant affirming anything from shared prayer to kind words of encouragement. Certainly, shared experience was important: the unity among the arrivals and the established Ukrainians in Kraków was real and palpable because all were feeling the war's menace.

"They are glad to be here, far from hell," she said.

Coming from "hell" is not easy. But both Fr. Peter and Sr. Evphrosynia said that while most Ukrainians are Orthodox Christians, the new arrivals felt accepted at the Greek Catholic parish thanks to the warm welcome they received and good word-of-mouth in the refugee community. It became a home for them.

"They feel this is a kind of home for them," Sr. Evphrosynia said, and why not?

The church emanated a sense of peace, a sense underlined when Sr. Lubomira said she derived her own spiritual strength from contemplation and prayer, particularly in a small chapel within the church where a tabernacle rests.

"When we hear stories of bombings and the experiences people have had," she said, "we want to share the peace of this church with them."

The Thorny History of Church Relations

This points to an important element that needs a bit of examination and explanation. Throughout my travels within the Ukrainian Greek

Catholic world, both in Ukraine and Poland, I met Orthodox Ukrainians who found a "home" in Ukrainian Greek Catholic churches, with some fully embracing a new tradition out of need or desire to do so, while others simply found comfort in churches that, while not Orthodox, felt similar enough to their old tradition.

Whatever the reason, the war had produced changes altering the profile of Ukrainian religious practice and affiliation. A study conducted by the Kyiv International Institute of Sociology in July 2022 and based on a survey of 2,000 respondents, found the numbers of those identifying with the Ukraine-based Orthodox Church of Ukraine had increased from 42 percent to 54 percent since 2021, while affiliation with Russia-identified Ukrainian Orthodox Church decreased from 18 percent to 4 percent.[*] (The percentage of those identifying with the Greek Catholic Church remained roughly steady, decreasing only one percentage point in a year, from 9 percent in 2021 to 8 percent in 2022. Only 1 percent of the respondents identified as Roman Catholic, while identification as Protestant and other Christian denominations combined came to about 4 percent.)

It is not difficult to conclude why so fewer Ukrainians identified with the Russia-identified Ukrainian Orthodox Church. As Aidan Houston of the United States Institute of Peace wrote in a 2022 analysis, a spiritual and religious component was inevitably part of the saga of the full-scale invasion. Russia's Patriarch Kirill clearly aligned himself and his church with President Putin, framing events as part of a spiritual battle, and as a necessity for Russia's "eternal

[*] Anton Hrushetskyi, "Dynamics of Religious Self-Identification of the Population of Ukraine: Results of a Telephone Survey Conducted on July 6–20, 2022," Kyiv International Institute of Sociology, August 5, 2022, https://www.kiis.com.ua/?lang=eng&cat=reports&id=1129&page=1.

salvation."* (Houston noted that both ecumenical Orthodox Patriarch of Constantinople Bartholomew I and Pope Francis immediately condemned the Russian invasion.)

Given Kirill's use of such celebratory language—and because of historic divisions between Ukrainians and Russians over their Orthodox origins—it is hardly a surprise that many Ukrainians would turn away from a church identified with Russia. Controversy is no stranger to Kirill's church. An Associated Press piece by Peter Smith that appeared in *National Catholic Reporter* in October 2023 noted that while the church insisted it had become independent of Moscow and had condemned Russia's aggression, many Ukrainians remained suspicious of the denomination, prompting the Ukrainian parliament to move to effectively ban the church.† The parliament's move, the AP reported, would, in effect, prohibit activities of religious groups "that are affiliated with the centers of influence of a religious organization, the management center of which is located outside of Ukraine in a state that carries out armed aggression against Ukraine."

Within the Greek Catholic circles I traveled in for my assignments, the Orthodox controversy did not appear to be discussed much. However, one Catholic sister I met in Zaporizhzhia, speaking of ministering to those who had once lived in Russian-occupied zones, observed that many who had personal experience with the Orthodox church there often left disillusioned. The Orthodox clerics they

* Peter Mandaville, "The Role of Religion in Russia's War on Ukraine," United States Institute of Peace, March 17, 2022, https://www.usip.org/publications/2022/03/role -religion-russias-war-ukraine.

† Peter Smith, "Ukraine's Parliament Advances Bill Seen as Targeting Orthodox Church with Historic Ties to Moscow," *National Catholic Reporter,* October 20, 2023, https://www.ncronline.org/news/ukraines-parliament-advances-bill-seen-targeting -orthodox-church-historic-ties-moscow.

knew "were more like businessmen" than spiritually minded priests, she told me, and that they had not experienced "God's love." This is obviously only one sister's perspective. It is not impartial. But it is a telling snapshot of how elements of the Orthodox church in Ukraine are perceived right now.

At Advent, Singularly Grateful but Still in Exile

Even during a time of regional and global tension, the promise of peace can feel closer during the celebrations of Advent and Christmas—despite the December cold and the shortened days and longer nights in Central and Eastern Europe. In the Polish capital of Warsaw, Christmas outdoor lights and lit trees offered some comfort to all—Poles and Ukrainians, established residents and newcomers both.

And yet for Ukrainians living in Poland, any joy of the season was also inevitably mixed with heartache and loss, longing and grief. As exiles, they thought of Christmases past and are mindful of the consequences of war: illness and hunger, deprivation and death.

"Ukraine has no electricity," Sr. Nazaria Mykhayliuk, another Ukrainian sister of the Order of St. Basil the Great, told me as the 2022 Advent season began.

"We are losing our best," she said of war's casualties. She reached up and touched her heart. "It is a cold and dark time."

Yet even in cold and dark times, if I have learned anything from my reporting on humanitarian crises, it is that humans are amazingly durable and adaptable—as when I met four refugee women from different parts of Ukraine in Warsaw who were thrown together by the sad fate of war but ended the turbulent year of 2022 safe, secure, and calm—though still uneasily in exile.

"I'm happy to be here," said Kateryna "Katya" Zelinska, 27, in the offices of Jesuit Refugee Service (JRS) in Warsaw, near a Jesuit seminary residence in the Polish capital, where the four resided. "I feel safe. I'm not nervous." But, she stressed, the current living situation "is only for now." And the term "now," Katya and the other women acknowledged in several interviews, had taken on weighted meanings as the conflict stretched well beyond what either they or the war's Russian perpetrators expected.

Each of the women said they could not have imagined a year ago living in Warsaw, residing in the midst of a Jesuit community.

"No, no, no," said Yanya Vasyk, 37. "We never thought there would be war, even with the Russian threats. And we certainly thought it would end soon." She paused and recalled shared news of relatives and friends back in Ukraine through texts, social media, and phone calls.

"Bombs landing every day, from the first day until now," Yanya said. "It's just very, very hard. But here, at least, we are safe. We're not afraid."

Of course, the women, who in addition to Katya and Yanya included Lubov Kadura, 67, and Nadia Zhihalko, 46, were all hoping to return to Ukraine.

"Naturally, I want to go back. That's where my life is. Everything I know . . ." Nadia said, her voice trailing off. "Home is home. Going back home is the important thing." But the women remained resolute that ending the war cannot be accomplished at the expense of ceding any territory to Russia.

"No!" they said in unison at the JRS offices, which adjoin the Catholic Academy in Warsaw—Collegium Bobolanum, whose campus includes a Jesuit seminary and the St. Andrew Bobola Sanctuary.

"There's no other option," Yanya said, shaking her head. "Ukraine must win. Why should we give up land? We only want peace, but as it was before 2014."

With that, the women said they remained singularly grateful for the welcome accorded them and their families by Poles and by the Jesuits in particular. They said they had heard of the growing unease by a small minority of Poles about the economic and social pressures welcoming 1.5 million refugees had placed on a country of nearly 38 million. But they said they had not experienced discrimination or flashes of anger or prejudice themselves. What they had experienced is the challenge of learning the Polish language, which has an entirely different script than Ukrainian, as well as having to take low-paying jobs, like cleaning houses—a common experience for many Ukrainian refugees who, as a group, are predominately female; most Ukrainian men can't leave the country because of the possibility of being conscripted into military service.

Sebastian Lelek, one of the Jesuit seminarians hosting the refugees, told me the women—several of whom had children living with them—had adapted well to their new surroundings, with both the refugee families and the Jesuits enjoying tea, parties, and occasional meals together. Sebastian, 34, said the families would be able to stay indefinitely and that his religious order did not find it particularly remarkable or unusual that they were offering space to the Ukrainians.

"This is nothing special for Christian people. It's obvious we have to welcome them," he said. "It's in the Bible. It's humanitarian. It's natural."

Sebastian took a wide view of the Polish response since the Russian invasion. "Everyone wanted to give something at first," he said, and the

overwhelming initial response was perhaps a bit ad hoc. He recalled that his grandmother, who lives in Rzeszów, located in the southeast Polish region of Podkarpackie, near Ukraine, took in arrivals as part of a welcome from her local parish. At one point, she welcomed as many as 20 people—as well as two dogs—but only for a few days. The last of the guests left after about three weeks, and Sebastian's grandmother was no longer hosting anyone. More broadly, as the numbers declined since the first months of the war, more coordination by government bodies and humanitarian groups about housing and assisting new arrivals had improved.

Despite World War II's Uneasy Shadows, "We Live Together"

Broader historical dynamics were at play. As mentioned earlier, relations between Poland and Ukraine have not always been cordial, with uneasy shadows from World War II still lurking. Poland gave up territory to Ukraine, then part of the Soviet Union, after the war, and both bearing grudges over civilian deaths perpetuated by the other before and during the war. Poland and Ukraine have also each claimed victimhood in ongoing debates centering on genocide and wartime massacres that occurred in border regions.

Yet both Poland and Ukraine now view Russia as a common enemy, and Sebastian viewed the welcome from Poland as a way to restart relations from a better, more hopeful place.

"It's important to me that we live together. In the past, things were not easy. What's happened [in Poland] is a good step. We want good things for Ukraine," he said. "I think the situation of war has made us think about the relations between our countries."

Even so, the situation was evolving, said Sr. Urszula Krajewska, an attorney and member of the Society of the Sacred Heart of Jesus who works for Jesuit Refugee Service in Warsaw.

"The warm welcome now is probably not as enthusiastic as it was initially—people generally got used to having Ukrainian refugees around," Sr. Urszula said in November 2022 and whose work also included coordinating Polish language courses for refugees.

As the situation "normalized," new pressures emerged—with hundreds of thousands of children requiring schooling, with mothers needing work, and Ukrainian families wanting long-term housing, given that it was far from clear how long the war in Ukraine would last. (As a sign of changing realities, the Polish government said in November 2022 that refugees, many of whom had been receiving public assistance, should start paying for some of their food and housing costs.)

If Ukraine faces a huge task of rebuilding and reconstruction, Poland faced not only the burdens and pressures of more people within its borders but also worsening inflation and spiraling energy and gas costs, all due to the fallout from the war and reductions in Russian energy imports. This led to inevitable tensions, said Sr. Urszula.

"Ukrainians are tired. Poles are tired. The war is tiring. It's a tiring situation for everybody," she told me. And yet, like Sebastian, she believes the war had drawn both Poland and Ukraine closer together.

In the end, she said, "it connects us, and doesn't divide us. Everybody understands who is to blame for this. Everyone knows what the situation is. The fact that Ukrainians are welcome hasn't changed."

But the "how"—how to house the arrivals in more permanent housing, for example—had changed, Sr. Urszula added. Nearly a year on, she said, "it's harder now for people to house others in their homes—they prefer to help them in other ways."

And despite the fact that dozens of religious communities in Poland—both of men and women—had opened space to the refugees, much of the housing had been provided by private citizens, opening their homes—like Sebastian's grandmother.

"It's not a typical situation to welcome strangers literally into your home," Sr. Urszula said, and how that plays out in the coming years was far from clear. And yet Poles, she said, "are working to give them [the Ukrainians] some hope."

Certainly I felt hope when meeting the four Ukrainian women, all of whom are Orthodox Christian and celebrate Christmas by the Julian calendar but planned to observe Christmas in some way with their Jesuit hosts. They told me that they would cook together in their Jesuit kitchen space—possibly kutia (a sweet grain dish), potato dumplings, braised cabbage, fish, and mushrooms. They also hoped to toast the holiday with some red wine.

That would cure some of the nostalgia and heartache, though not all. It is common in Ukraine to make the rounds to visit friends and relatives and sing carols. "Those things in our home are very special," Nadia said. "People visiting, neighbors, guests. Normal life."

That was an important element to Christmas in 2022. But in the face of the war's many perils and snares, Sr. Urszula held out hope for a deeper holiday experience—for both Ukrainians who had arrived and for the Poles hosting them. "You can find God in this situation," she said. "God is present in this very difficult time—waiting for Christ to come. At this time of year, we know the true king will come and practice mercy and justice." That mirrored what Sr. Nazaria said,

that this was an opportunity for the Ukrainian refugee community in Poland to encounter something new and possibly deeper amid the privations.

"This year will be a real Advent," she said. "It's not a time for presents or lights." She added: "Jesus was born in a poor place. It's time for Jesus's life. The real meaning is Jesus Christ."

Iconography as a Form of Spiritual Therapy

When I met her, Sr. Nazaria, 51, had been reflecting for eight months on Jesus's life and the mysteries of faith amid the current conflict. Based at Dormishin Mother of God, a Ukrainian Catholic parish near Warsaw's Old Town, Sr. Nazaria led prayer and retreats and taught catechism and night courses on iconography, a particular love she believed helped arrivals from Ukraine heal and recover in their uncertain state of exile. "It's a way to stay in peace," she said. "Iconography is a way of prayer. It leads to freedom, a feeling of freedom."

On a November night, Sr. Nazaria's two-hour class included the history of iconography, preparing the assembled students—12 in all, 11 women and 1 man—to create their own icons over the coming months. Sr. Nazaria stressed attention to detail, noting that in iconic art, "everything has its own meaning," and patience and respect for the unpredictable ways of creating art is required. "The one you want to make is not necessarily the one you will make," she said.

Those words echoed the overall experiences of the Ukrainian refugees in the class: I later spoke to one of Sr. Nazaria's iconography students: Irena Atamaniuk, 52, who arrived in Warsaw in March 2022 with her husband, Ihor, and their 15-year-old son, Andrii. Their situation was perhaps not as dire as others: Irena's husband had

worked before the war at the Warsaw University of Life Sciences as a mathematics instructor, and the college had provided the family dormitory housing.

Even so, before they left the southern Ukrainian city of Mykolaiv, the city came under siege from Russian forces. The family once spent the better part of a day at a bomb shelter with hundreds of others, waiting to see what would happen, fearful of both the bombardments and other threats, like looters. The family ultimately decided to take the risk and leave. They drove to the city of Odesa, where they stayed briefly, then crossed the border into Moldova before, ultimately by plane, they arrived in Warsaw.

Their days in Poland, though free from war, were never free from anxiety—Irena always appeared worried and anxious when I spoke to her. Irena was a government manager back in Mykolaiv, but, as 2022 ended, was working as a house cleaner. She wished better jobs were available, but her prospects were limited given her rudimentary Polish—though she was attending language classes twice a week.

"People are kind and helpful," Irena told me, but acknowledged that Poles see her and others as temporary visitors. She did, too, hoping to return to Ukraine but realizing that the time in Poland would stretch out much longer than she and others had expected.

An abiding worry and concern for Irena was keeping up with fellow congregants of her church back home, the historic Church of Zakaria and Elizabeth. The prewar renovation and restoration work of the church was Irena's driving passion. Though the church had not been damaged—yet—it sits near a military hospital, and Irena, who is Ukrainian Orthodox, said she remained constantly anxious about the church building and its remaining parishioners.

"I miss my religious community," she said, tearing up.

Taking Sr. Nazaria's iconography course proved to be a spiritual salve, helping Irena through anxious days full of fear about the possible threats to the church and even a potential nuclear strike against Ukraine, another constant worry. Though looking forward to what she hoped would be a better Christmas the following year, she said she took solace in prayer, a constant comfort. "I pray to God and do feel God is here with us."

The Refugee Experience
A Search for Safety, Protection, and Home

Being uprooted means facing uncertainty and fear. Most fleeing Ukraine, like Svitlana, left the country with very little—not even their passports, making their future plans even in welcoming countries like Poland all the more uncertain and challenging. As Basilian Fr. Peter Kushka told me in Warsaw in late 2022, the future remained difficult to discern. The war raged on, and many refugees were reluctant to return to Ukraine permanently—though some began to visit periodically. Still, "so much just isn't clear," he said.

And while the welcome afforded them in Poland was deep and substantial, the pressures of welcoming more than 1.5 million refugees into the country were beginning to show: a cross word here, an angry glance there.

"The Polish people are tired," Sr. Nazaria acknowledged.

Maria Shumska, 45, who is from the Lviv area in western Ukraine, spoke to me in the basement of the Warsaw church were Sr. Nazaria ministered. She found "cold reactions" while looking for work in the

Warsaw area. She recalled a Polish landlord telling her he would not rent to her family because of fears that "Ukrainians will damage the apartment." She also had to be persistent about claiming the small amount of government assistance the family was entitled to.

"I have to help Poles first and Ukrainians next," one local official told her in a heated discussion. Yet Maria would not give up.

"Everyone knows me," she said, laughing. Such resolve was hardly surprising: Maria believed Ukraine will ultimately win the war because its people are committed, united, and strong. "Ukrainians have a deep faith and love of their land."

Maria, 45, has similar faith and optimism but was also clear-eyed about her present situation. She and her husband, Yuri, have five children, ages 8 to 15, and had ties to Warsaw before the war. Yuri worked in construction, and the family had stayed in Warsaw intermittently because one of the children, an 11-year-old son, required medical treatment for a physical disability. At the time I met her, Maria and her family lived in Jozefow, a community about 10 miles southeast of Warsaw. The family was "coping," Maria said.

They resided in a home called a "summer kitchen," a small one-room space with an adjoining kitchen. "It's not a lot of space," she said. Maria was working as a health aide, but admitted having trouble with the Polish language. The children were adapting better—"Change is not a problem for them," she said. Her thoughts during the holiday season were turning nostalgically to Christmases past in Ukraine. But as an Eastern Catholic, she was also thankful for "being in a church environment" during the holiday season.

Relative proximity to Lviv, which is close to the Polish-Ukrainian border, also helped. Maria had returned to Ukraine about once a month to see her ailing father and hoped to return, if even briefly, to see family

for the holiday. Maria had been reflecting on her past association with the Sister Servants of Mary Immaculate, who work in both Poland and Ukraine. The sisters educated Maria, and she entered their convent at age 20 to prepare for religious life. But after five years, she decided to leave, eventually marrying Yuri and raising their family.

The current war and the work of sisters prompted occasional thoughts about a return to religious life. "Maybe when the children are grown," Maria said, laughing.

What of her husband?

"He might say, 'Do what you want,'" she said, laughing again.

Kidding aside, the mark of the sisters remained.

"The sisters taught me to be persistent and have a strict plan," she said. "They had a great influence on me, on how to bear problems and manage my life." Maria, like Sr. Nazaria, said that amid the uncertainties and vicissitudes of the first year, her religious faith remained her bedrock—it was the foundation that had helped her overcome struggle, and biblical narratives like the Christmas story are examples of such.

"Nobody expected to have a wartime Christmas," she said. "It's sad. But Christ was born, and that's the main thing. That gives us hope."

Profound Displays of Solidarity and Mercy

When Beatitude Sviatoslav, the Major Archbishop of Kyiv–Galicia and Primate of the Ukrainian Greek Catholic Church, spoke to the faithful at St. Patrick's Cathedral in New York in March 2024, to praise the acts of solidarity New Yorkers had provided the people of Ukraine, he spoke about the need for hope—but also about how

much solidarity and aid from throughout the world had meant to Ukrainians since 2022.

Speaking to a packed cathedral where families held Ukrainian flags and dressed small children in traditional Ukrainian clothing, Beatitude Sviatoslav delivered a very personal sermon, thanking Timothy Cardinal Dolan for being the first US bishop to visit Ukraine after the full-scale invasion in what was a "profound display of solidarity." He also thanked New Yorkers and groups like Aid to the Church in Need, a Catholic charity serving Christian communities suffering persecution, "for the support we experience every day." The charity's focus in Ukraine since February 2022 was supporting some 600 humanitarian projects. These included constructing 11 centers to provide displaced persons and others with spiritual and psychological support, a heating system for church-run institutions, and summer camps for children.*

"The humanitarian aid you provide feeds, warms, and heals millions," he said. "We thank you for your prayers, advocacy, and aid. By God's grace we stand. Thanks to God and to you, Ukraine fights for freedom, peace, and justice, and, be sure, Ukraine will prevail."

That struggle always had an international component, dating from the first months of the full-scale invasion. Quiet, and in many ways unacknowledged, acts of solidarity came from other religious congregations scattered throughout the world. Prayer became ubiquitous as when, for example, six weeks after the full-scale invasion began, 13 members of St. Clare's Adoration Monastery prayed for an end to the war at the sisters' monastery in Gobindapur, Dinajpur, Bangladesh.

* Amy Balog, "UKRAINE: Families Still Enduring Constant 'Psychological Torture,'" Aide to the Church in Need, February 16, 2024, https://acnuk.org/news/ukraine-families -still-enduring-constant-psychological-torture/.

According to Sr. Mary Petra, mother superior of the monastery, sisters had extended their commemoration with a nine-day-long novena, praying for an end to hostilities so that the people of Ukraine could live there with peace.

If that was notable for its solidarity, an act of mercy came when the International Union of Superiors General (UISG)—the largest grouping of women religious leaders in the world, with 1,900 members in 97 countries—began distributing $1 million in grant money by the Conrad N. Hilton Foundation to assist women's religious communities in eastern Europe, which were providing care and accommodation to the Ukrainian refugees as they determined where to go next. Most of the monies went to Ukraine, Poland, Hungary, Romania, and Slovakia to cover the costs of essentials that were still needed—such as food and clothing—but also basics that were not always readily available for those in transit, such as basic hygiene items, baby diapers, medicines, phone cards and mobile phones. Monies were also provided for covering the costs of legal, medical, and psychological services. (When I began covering humanitarian emergencies in the late 1990s, the need for support to pay for phones was still in its infancy. Now, the need for refugees to stay in touch with families back in Ukraine through phones is taken for granted—as is the need for funding such efforts.)

Sr. Patricia Murray, who heads UISG, cited the encyclical *Fratelli Tutti* in discussing the support and noted that Pope Francis had referenced the "openness of heart which St. Francis experienced from the Sultan Malik-el-Kamil in Egypt."

She said, "Despite differences of language, culture, and religion, they were able to connect across borders. Now we, too, in these dark days of war, are being called to reach out in hospitality and welcome those who seek refuge and safety."

One of Murray's UISG colleagues told me while I was in Rome in May 2022 to cover the UISG plenary in Rome, that the grants were an almost unprecedented show of international solidarity to help Ukrainian refugees. "There is great trauma for these people," said Sr. Jolanta Kafka, UISG president and general superior of the Claretian Missionary Sisters and who is Polish. "We are pained by what is happening in the world."

In responding to that, sisters literally opened their doors—something I witnessed on two continents.

In Brentwood, New York—a hamlet in Suffolk County, Long Island—the Sisters of St. Joseph, Brentwood, began welcoming Ukrainians as part of a larger effort to house nearly 50 people from three countries—Afghanistan, Pakistan, as well as Ukraine—on a large 211-acre campus with more than a dozen buildings. Three buildings—including a small wing of an older dormitory-style building and several smaller residential houses—accommodated the arrivals. As Sr. Tesa Fitzgerald, the congregation's president, told me: "It's a sin not to do it."

She added: "We have space and resources." The 293-member congregation had been unanimous in its welcome. "Not a single sister has said anything negative about this. That's a miracle," said Sr. Annelle Fitzpatrick, who oversees the program, and believed the initiative is applying the Gospel mandate to welcome the newcomer.

"For me," Sr. Annelle said, "it's front and center of what God asks of us."

In several interviews I conducted in nearly a year in Brentwood, the refugees said they believed they were in a safe place—with hope for the future animating their lives while also mindful of the many challenges they face. In contrast to the refugees from Afghanistan

and Pakistan, who tended to be shy and reserved and also struggled more with English, the Ukrainians were more at ease with the new language, and seemed outwardly confident and outgoing.

"It's definitely peaceful," Oleksandr "Alex" Somin, one of the Ukrainian arrivals, told me—and that made it easier to focus on acquiring work, settling down, and having new aspirations. But, Alex added, immigrants always face challenges.

"It's a completely different culture," said Alex, a tall, lanky man given to wearing fashionable T-shirts and sports jackets. "Different rules. You have to adjust to the culture."

And feeling caught between two cultures can be a challenge. Children of refugees want to learn English but parents also want their children to remain grounded in their home culture and language.

"If you lose your culture, you lose yourself," said one parent whose children are learning Ukrainian online while attending English-language schools in Brentwood.

As I noted, the Ukrainian adults I met had acquired better English language skills than Afghan refugees—but in either case, English is often not an easy language to learn, especially for adults. That is one challenge. There are others. "Many refugees suffer from post-traumatic stress disorder, depression and a lack of hope," Sr. Karen Burke told me. She also noted the challenges the refugees faced in even getting to the United States. One family, for example, journeyed from Ukraine to Moldova, then Poland, Turkey, and Mexico before arriving in the United States.

If learning English is at the top of priorities, so are completing vocational training programs and advancing children in school. Also important: establishing a modest savings account and eventually gaining mastery of job skills and, of course, securing a steady job

with benefits. And all of these have to be done in complying with federal immigration rules. Even so, Alex sees more opportunities in the United States than in Ukraine, where, he said, even before 2022, it was "difficult to get the right job, to get what you want." Yet at the same time, he said, the war itself has caused him and others to feel that a chapter had turned, perhaps irrevocably, with people having left Ukraine and friendships within the country now harder to sustain.

"We miss Ukraine a lot. We miss our previous life," Alex said. "But I don't think we can rebuild that." (In March 2024, I learned that Alex and his family had decided to move from Long Island and settle in Florida.)

When I last saw the Ukrainian refugees in Brentwood, two families were sharing a two-story residence on the sisters' campus. The latest arrival, in June 2023, was Igor Konovalova, whose wife, Anna, had been living in the United States since June 2022 with the couple's two children, a son aged five, and a daughter aged nine. That was a difficult year, Anna said, recalling the constant worry about her husband's safety. Igor had worked as a commercial director at a large bread factory in the central Ukrainian city of Dnipro and had volunteered to work close to the war's front lines, helping distribute bread—an experience he described "as scary." Though happily reunited with her husband and now residing in the security of Brentwood, Anna still looked like she carried the burdens of war in her sad eyes.

In an interview just weeks after Igor arrived in the United States, the couple expressed happiness in being reunited but also spoke of the uncertainties ahead of whether to remain in the United States when the war ends or to return to Ukraine, which will eventually need massive reconstruction assistance. Both have family remaining in Ukraine.

"It's our country," Anna said of Ukraine's experiences of the first 18 months and the dismay and disruption caused by Russia's full-scale invasion.

"We had a normal life," she added wistfully.

In Brentwood, both were employed—Anna, hardworking and professional, had found a job in the high-tech sector, while Igor worked laying cable for a local business. Of the two, Igor, though not doing what he did in Ukraine, seemed more intent on making a go of things in their new country. His face radiated ease and happiness. "We have an opportunity to live in the U.S., to work, for the children to go to school," he said. "I'm happy with it."

Still, Ukraine and the war were never far from their minds. Though Anna's parents are about 200 miles from the war front, she worried about their safety. As for Igor, he said he no longer checked the news from Ukraine constantly—once a day is enough, he said.

In Europe, the experience of the Ouchynnikova family, who had settled in the coastal city of Split, Croatia, shows the diversity of experiences by refugee families. Unlike the lives of the refugees on Long Island, access to Ukraine—to some families, even just temporarily, for short trips—is possible, since they are closer to the country.

The Ouchynnikovas' story has some similarities with the Ukrainians in Brentwood, principally in the fact that the family was being hosted by sisters—and that the family seemed confident and at ease in their new surroundings. Maria, 37, left Ukraine with daughters, 16-year-old Sofia and 8-year-old Anastasia, and arrived in Croatia a month after the full-scale invasion began. When I saw them in

December 2023, they were being accommodated in available space by a community of sisters belonging to the congregation of the Sisters of Charity of Zagreb.

Maxim, Maria's husband and Sofia's and Anastasia's father, had remained in Kharkov in northwest Ukraine to continue his work at a military factory. Mother and daughters visited Maxim at the end of 2023 for two weeks and said that saying goodbye and returning to Croatia proved difficult. But Maria, with long blond hair and dressed informally but smartly, told me "it is still better to be here . . . it's still not really safe to be in Kharkov," which is often the target of Russian bombardments.

She added: "We thought we'd be here two months, but it's been nearly two years now."

Both daughters were attending school and learning Croatian and Sofia had won accolades for her performance on a high school swim team. Meanwhile, Maria, once a lawyer in Ukraine, was working as a restaurant chef—something she said she actually enjoyed. Still, as in the United States, adjusting to a new life has not been easy, though the family said the sisters had welcomed them warmly.

"They're like a second family," said Maria, as she stroked Anastasia's hair and Sr. M. Franka Odrljin and Provincial Superior Sr. M. Andrijana Mirčeta looked on, beaming. "We love them so much."

Unlike the United States, the face of Croatia—once part of the former Yugoslavia—and other countries once in the orbit of the Soviet Union has altered due to the Ukrainian refugee crisis. It is believed that more than 22,000 Ukrainians had entered Croatia by the end of 2022—though it is possible that many left the country for other destinations, said Stanko Perica. He is the regional director for Jesuit Refugee Service based in the Croatian capital of Zagreb and estimates

that perhaps 10,000 Ukrainians remain in Croatia. He told me the history of the wars in the former Yugoslavia helps explain some of the context for Croatia's welcome to the Ukrainians—a welcome, he said, is proof that Croatia "could help many more people, and in the Ukrainian crisis we showed that we are ready and capable to do it."

Sr. Andrijana, 69, and Sr. Marija Blaga Bunčuga, a former general superior, 71, said the sisters in Spilt had been motivated by several factors. When the Croatian Bishops' Conference asked for the country's religious communities to open their doors to arriving refugees, it made for an easy decision—the congregation had the space in its Split convent, and members prayed and discerned that this was something that St. Vincent de Paul, whose charism the congregation follows, would surely want.

But the sisters also said their own experiences in the Croatian war of independence in the 1990s were a factor. Both lived in the war-hit community of Zadar at the time; Sr. Andrijana helped deliver aid to shelters of displaced persons and Sr. Marija recalled such terrors as a Serbian-launched bomb hitting their convent.

"It was an awful experience," she said, remembering fleeing the building, adding that her immediate thoughts flashed to praying for Croatia's enemies. "That was very important."

Sr. Andrijana said that, given those experiences, there was no question of helping people in a "desperate situation," adding there is a "very close connection between us and the Ukrainian people."

"We were fighting, and they are fighting now, for liberation," she said. "So, we know what that's like."

If that shared experience, legacy and awareness of the wages of war is part of the global narrative of solidarity, there are other elements to the global story that were confounding. This was because as events

unfolded, I was surer than ever about one of my first thoughts about Russia's invasion: that an old-fashioned imperial war of this type was the last thing that a world facing multiple challenges—climate change, the aftermath of the COVID-19 pandemic, continued economic disparities—needed.

The Three Cs: Conflict, Climate Change, and COVID-19

Two months after the war, I reported that Baltimore-based Catholic Relief Services (CRS), the international aid agency of the US Catholic Church, had warned that the war in Ukraine was starting to have serious effects on global hunger—that it was compounding already-existing problems.

"After decades of progress, global hunger has steadily risen for seven consecutive years. The 'three Cs'—conflict, climate change, and COVID-19—are exacerbating chronic and severe food insecurity for people living in highly vulnerable and fragile contexts," said Bill O'Keefe, the agency's executive vice president for mission, mobilization and advocacy, in congressional testimony. Given these preexisting problems, he said, the Ukraine conflict was "having an undeniable impact on the state of global food security within Ukraine and around the world."

Noting that Ukraine is a top exporter of wheat and sunflower oil, "accounting for forty percent and sixty percent of the global supply, respectively," Bill said that countries in north and east Africa and the Middle East were "already feeling the effects of food price spikes and global supply shortages." Also a concern: the global supply of fertilizer had "taken a massive hit" because Russia, after facing global sanctions, was the lead global supplier of potash, ammonia, and other

soil nutrients. As a result, countries already "on the brink of famine, like South Sudan, Yemen, and in the Horn of Africa, are particularly vulnerable to the worsening impacts of the ongoing war in Ukraine, with an unfortunate likelihood of new hotspots arising in places like Lebanon, Egypt, and Jordan," Bill said.

"While there is great uncertainty as to how significantly food prices and availability will be impacted over the next four to six months, it is clear that the worst is yet to come," he noted forebodingly.

Through 2022, that warning proved to be prescient. When I spoke to Sr. Mary Lilly Driciru, a member of the Missionary Sisters of Mary Mother of the Church in Uganda, she saw grave problems in her country: high inflation affecting food and fuel prices—sometimes doubling in only a few weeks—as well as unpredictable weather that varied between drought and flooding, all at a moment when Ugandans were hoping for better times after two years of COVID-19-related lockdowns and economic downturns.

"It's hope against hope," said Sr. Mary Lilly, saying she heard a stream of despondency and stress and of people working day and night to try to stay ahead in poor areas of Uganda's capital of Kampala.

"Many people live on the bare minimum, and others are literally going hungry," she told me.

Was all of this due to the war in Ukraine? No—but Sr. Mary Lilly told me that the war exacerbated already-existing problems, creating a kind of "perfect storm" in which the war rattled international economic markets and disrupted grain exports to many parts of the world.

Luckily, when I reported this in October 2022, some things had improved over the course of eight months. Russia had eased its blockage of grain shipments from Ukrainian ports, with a resulting lowering of global food prices. United Nations trade chief Rebeca Grynspan said

the drop had eased pressure for the 1.6 billion people in the world who had struggled with inflation, particularly due to the rise in food prices. But Grynspan acknowledged that such price drops were not yet reflected in local domestic markets like the ones in Uganda. As a result, developing countries still struggled with high food prices, inflation, and currency devaluations, the UN news agency reported. And other challenges loomed—including drought and poor weather throughout the world.

Still, it was the war in Ukraine that, through 2022, remained the most visible symbol of the challenges for the global food supply. Its impact "rests heavy on the continent of Africa," said Sr. Mary Lilly, a journalist and communicator by training who serves as communications and as a faith and justice coordinator for the Association of Religious in Uganda. She said the real problem for African countries like Uganda was not so much the initial grain blockage but the way the war had hurt the global economy in other ways, with a reduction in trade that wreaked havoc on foreign exchange.

"Given the fact that Africa is still recovering from the COVID-19 pandemic with its negative effects of unemployment and declining business trends, the Russian war on Ukraine is yet a new blow on the African economy," she wrote in a reflection she shared with me. "The conflict is poised to drive up already soaring food prices across the globe. Ukraine and Russia, which is under heavy economic sanctions for invading its neighbor, account for one-third of global grain exports," Sr. Mary Lilly wrote. "The economic challenges that are bound to affect the world also affect Africa as part of the global community."

The problems were also felt elsewhere. Lola Castro, the World Food Program's regional representative for Latin America and the Caribbean, told me in an interview that at the beginning of 2022,

there were about 8.3 million people in the region who were "severely food insecure," lacking access to a regular source of food. But by the fall of 2022, those numbers had increased by about 15 percent. In all, 74 million people faced moderate to severe food insecurity, which corresponded to about 40 percent of the population of the 11 countries and territories considered, said World Food Program spokesperson Norha Restrepo. The inflation numbers in some countries were telling, Lola added that Colombia had 2 percent food inflation in 2019—but a more critical 25 percent in 2022.

As in Africa, one way to look at the problem was to see it in all its different component parts, particularly coming so soon on the heels of the global pandemic. "COVID-19 brought a huge economic downturn and increase of poverty and loss of middle-class and development gains," which had been made over nearly three decades, Lola told me. "While we should not forget the poorest of the poor that are the ones suffering the most, COVID brought the middle class of Latin America down to almost poverty levels in not having a cushion." Another troubling dynamic: climate change, with several powerful hurricanes affecting parts of Latin America in 2022. Add the war in Ukraine, and "it's compounding crises, one after another, and the resilience of the people is eroded, basically. They cannot cope anymore. I mean, you are a family, a woman farming in the dry corridor of Honduras, and you got the [2020] Eta hurricane," Lola said. "On top [of that], you got COVID-19, where you couldn't plant or couldn't move your harvest. And then you get that everything you buy is double in price."

All of these problems, said Shaun Ferris, the senior technical adviser for agriculture for CRS, meant a larger burden for humanitarian groups and ministries. That is a challenge—and so is the pressure to overcome

the dynamic of an overall loss of confidence in struggling countries. "When millions of people lose hope for the future, that's not good for any society," he said—something also noted by Sr. Monica Moeketsi, a member of the Servants of the Immaculate Heart of Mary, also known as the Good Shepherd Sisters of Quebec, and secretary-general of the Catholic Leadership Conference of Consecrated Life in the southern African country of Lesotho. She told me that religious congregations felt frustrated in an uncertain environment in which political leaders perceived as corrupt were not doing enough to meet the current crises. Her congregation was doing its best, though, to provide food to those who need it. In Uganda, Sr. Mary Lilly saw similar challenges and problems. She said government corruption was undercutting any real hope of substantive, meaningful change.

"Taking advantage of the poor is part of the order of the day," she said of the present political climate. The eight congregations that run schools in Lesotho kept their focus on helping students envision a better future—part of efforts, Sr. Monica told me, for the congregations "to go the extra mile."

Sr. Mary Lilly said that was important during a period of global and local tension and uncertainty. "It's time to be mindful of each other," she said, "just like Jesus responded to needs in his time."

Beatitude Sviatoslav's sermon at St. Patrick's had similar echoes, as in his call to "dear sisters and brothers" for solidarity and mercy in the immediate Ukrainian context. He said: "Thank you for expressing [God's] love through your prayer, action and sacrifice. Let's not give up!"

> (In) a time of pain, fear, and despair, the Lord gives us hope and promises
> us life. And this is not just a promise, it is backed up by God's action—He

gives his Only Begotten Son so that we may live. The incomprehensible sacrifice of the Son of God gives us life. God loves the world so much; He loves us so much. We are loved by God, and no enemy can overcome us. We have experienced this during these two years—mutual love, care, and protection.

A tragic war and its unfortunate fallout globally had prompted similar outpourings throughout the world. In a cynical time, that was worth celebrating.

Eight

A Hope for Resurrection

Can a Damaged Society Be Repaired?

I had not seen damage in Zhovkva during my short visit in November—it being an isolated community far from the eastern front. But when I returned to Ukraine three months later to get a sense of how the country was faring a year after the start of the full-scale invasion, I saw things that were dismaying, even shocking. To see a portion of an apartment building collapsed in the wake of a Russian missile attack, as if a giant hand had scooped away the center of the building—and with it possibly innocent civilians—was to sense the real power and weight of this brazen, senseless war.

I saw that very thing in Borodyanka—and the image of the building there seemed to symbolize what had been a horrendous—and wholly unexpected—horrible year for Ukrainians, "a year of deep darkness and crucifixion for the Ukrainian people," Sr. Yanuariya Isyk told me the same week I visited Borodyanka and other cities surrounding Kyiv. "Thousands of Ukrainian hearts were crucified, people's destinies were mutilated, cities and villages were destroyed."

In framing what had happened in terms of Gospel narrative, Sr. Yanuariya, like other Catholic religious, was hopeful about the promise of eventual victory, a kind of resurrection. But as in the Gospel narratives, the signs were not always visible.

It was true that some of the worst moments seemed to be over. In the early months of the war, Sr. Anna Andrusiv and her Basilian sisters had offered shelter in their convent in the western city of Lviv. But with fewer people now headed to Poland, the sisters had not hosted arrivals since September 2022. That was a sign of some normality returning. And yet, taken in a whole year, from February 2022 onward, the experience had been trying. "Ukraine and the Ukrainian people have experienced a long, difficult and painful year of Lent," Sr. Anna told me. "Every Ukrainian has suffered during this year one way or another."

I discovered this quickly on visits to cities like Borodyanka. On one such visit, welcomed by blue skies and bright sunlight, I and my colleagues—photographer Gregg Brekke, translator Iryna Chernikova, and driver Stas Nepokrytyi—saw the results of the early incursions the Russians had made in cities outside of Kyiv before retreating after a brutal three-week siege had ended in late March of 2022. One of our first stops was Irpin. The siege there resulted in nearly 300 civilian deaths, making Irpin, a once-tranquil community about 15 miles west of the capital of Kyiv, nearly as infamous as neighboring Bucha, the better-known site of alleged Russian war crimes. Irpin's prewar population of 70,000 had dwindled after the siege. Though many residents had returned in the following year, some remained displaced.

Two of them were the brothers Basil and Nicolai Knutarev, who surveyed the scorched high-rise apartment buildings where they had once lived, both wearing winter caps to guard against the February

cold. With their blackened, charred exteriors, the buildings evoked danger and menace, underscored by the distinct smell of leaking gas wafting in the cold air. Both brothers, with worn faces and the calloused hands of elderly men who know the hardship of factory life and manual labor, spoke quietly about their experiences. Nicolai, 76, a retired factory worker, lived in a nearby town with other relatives but occasionally came by Irpin to check on things, including picking up potatoes in a rented garage serving as a temporary storage cooler. Basil, 71, who also relocated nearby, looked up at the hulk of his vacant apartment building and shrugged.

"No progress," Basil, a security guard and retired factory worker, said of his destroyed sixth-floor apartment, despite promises of reconstruction from local officials. "No one knows the future . . ." His voice trailed off. "Just promises. We lost everything."

"We lost everything" was a common sentiment I heard during this assignment, a sentiment shared by millions of Ukrainians uprooted and displaced during a year of war. And yet, as Sr. Yanuariya, like Sr. Anna, a member of the Sisters of the Order of St. Basil the Great but whose ministry is based in Kyiv, said, "We've had to think less of ourselves and more about everybody else." She spoke to me in an interview in the small apartment monastery she shares with two other sisters in a building damaged when Russian saboteurs engaged with Ukrainian forces early in the war.

Like many St. Basil sisters, Sr. Yanuariya's primary ministry had been as an educator—specifically a Christian educator in parishes. But though that work had continued and remained paramount, Sr. Yanuariya has also been called into direct humanitarian response, including deliveries of food—flour, pasta, canned fish and meat, rice, and milk—and medical supplies to those in need. Among

those in need were the survivors of the assault on Bucha. Two months after that event, Sr. Yanuariya and other Catholic volunteers visited the community to meet with residents and pray at the mass grave of the slain civilians who had perished in the Russian assault.

She recalled that it was a hazy, cloud-filled day, somehow capturing the mood of the town, where residents remained silent as Sr. Yanuariya and others unloaded the food and other supplies. Quickly, though, Bucha residents began crying as they recounted their experiences of horror but also resiliance. "They told us how they survived and were grateful they could speak to someone about that," she said. "It was important to hear their stories, to ease their pain and to comfort them."

Those small moments of mercy were a salve and came as a needed relief. Yet nothing is ever settled in the disruption caused by war— especially a war that showed no sign of ending soon. "Right now, things are stable, but everything is still on the table," Dominican Fr. Mikhailo Romaniv said of the situation in Fastiv, a community of 45,000 about 45 miles southwest of Kyiv. Fr. Mikhailo, who looked like he had not slept in days, was in charge of the Christian Center of St. Martin de Porres, a Dominican ministry that provided assistance to mothers and children with various needs in addition to those who have been displaced or are experiencing homelessness. Though permanent stability was still elusive, any peace and quiet that marked a February afternoon in Fastiv was apparent and welcome to Dasha Habovska, 24, and her one-year-old son, Christian, who, thanks to the Dominican ministry, were living in a converted hospital on the city's outskirts as part of the Dominican ministry. When we visited, the residence housed seven families, 18 people in all.

Dasha and her son welcomed the quiet of the residence. They had fled the then-occupied city of Kherson in September 2022, leaving

behind Dasha's partner and Christian's father, Daniel, who at the time I met the family was serving in defense work along the Ukraine-Belarus border. In some ways, the decision to leave was easy because the family's home was near an area of bombardment. Still, Dasha spoke of the separation as difficult and painful, for both mother and child.

"It's hard for Christian, being away from his father," Dasha said, adding that as the boy's mother, it was challenging to raise an infant alone in a new environment. And there were constant worries—about family back in Kherson, about Daniel, about the course of the war. Dasha told me she was confident of the war's ultimate outcome—"Of course, we will win," she said—but she could not be sure how the war's next phase would turn.

"We're prepared for everything," she said. "It's so disturbing." Still, Dasha told me she felt enormously grateful for the Dominican care and housing she and her son were receiving.

"They are providing so much help," she said, "and [it's] help that you cannot find on any corner."

That was a testament to the enduring strength of ministries in Ukraine, which had resumed once some sense of normalcy had returned in parts of the country where the Russian forces had retreated. Sr. Damiana Monica Miac, a Polish sister and one of five Dominican Sisters of Jesus and Mary who lived and worked in Fastiv, spoke of a welcome return of routine at the school where she teaches kindergarten. Like several of the Polish sisters I had met in Kharkov, Sr. Damiana was a longtime resident of Ukraine—30 years in all, 24 of them in Fastiv.

She spoke of the early months of the invasion as nerve-racking and trying, with Russian units stationed nearby. Food was scarce, and life felt like it was under siege. "It was a hard time for everyone,"

she recalled. "At first, I couldn't pray at all." But in the intervening months, she eventually found solace and strength in her community and in her resumed teaching, though the demographics of her students had changed some: there were 35 kindergarten students at her school, about half of them from permanent Fastiv residents and the rest from displaced families. As for how the experience had changed her, Sr. Damiana told me she had come to trust further in God and that her prayer life eventually returned and even deepened.

"The rosary," she said. "That helped." So has a belief that, ultimately, Ukraine would prevail. "I believe everything will be all right," she said.

Will Everything be All Right?

The belief that Ukraine will prevail was nothing novel—I heard it repeatedly—but a belief that "everything will be all right" was striking in its optimism. Yes, there were some signs of optimism—we saw houses being reconstructed in damaged areas like Bucha, for example—but the hurdles for Ukraine ahead seemed enormous. Most obvious: despite the success in driving out the Russians from Kyiv and the surrounding areas, the war had yet to be won. And there was, and remains, a terrible need for physical, cultural, and spiritual repair. Fr. Mikhailo spoke of Ukraine being now a damaged society, with one example being the separation endured by families, with women and children leaving the country and men remaining. A particular problem, he told me, had been the rise in alcohol abuse as families separate, particularly as women have migrated to other countries and men who have not been conscripted try to find meaning in their lives. "They don't know what to do," Fr. Mikhailo said of the men

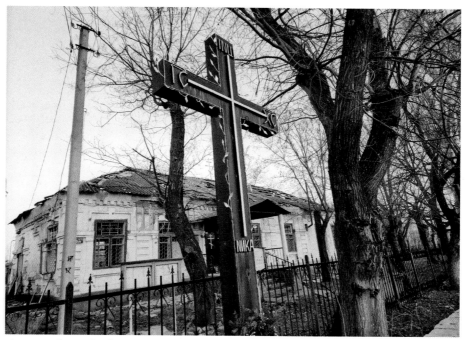

A cross in front of a damaged Orthodox church in the village of Orikhiv, in southeastern Ukraine, stands as a symbol of the strength of Christian faith amid two years of war. (Photo courtesy of Chris Herlinger)

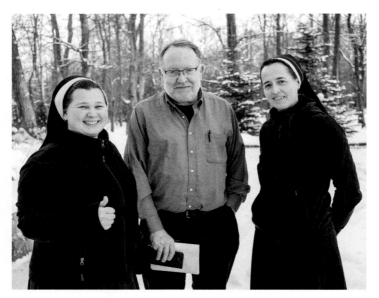

Author Chris Herlinger (center) with Srs. Anna Andrusiv of the Sisters of the Order of St. Basil the Great (left) and Sr. Veronika Yaniv, prioress of the Sisters Catechists of St. Anne monastery (right), pose outside in Lviv, Ukraine. (Photo courtesy of Chris Herlinger)

Destroyed Russian tanks and personnel carriers along the road between Kyiv and Bucha are a reminder of Russia's losses in the spring and summer of 2022. (Photo courtesy of Chris Herlinger)

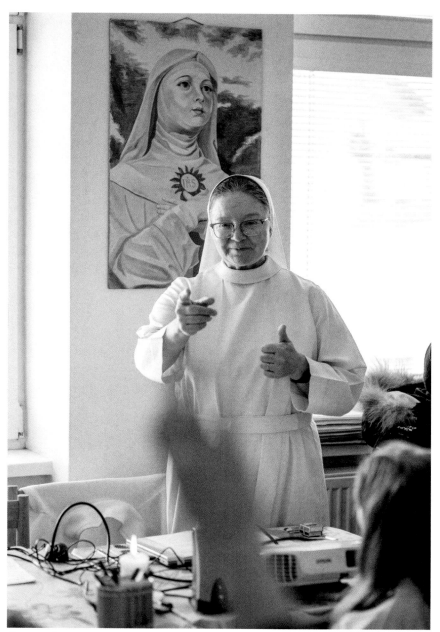

Despite the ongoing war, Dominican Sr. Lydia Timkova continues to teach a catechism to a class of young children in Mukachevo, Ukraine. (Photo courtesy of Gregg Brekke)

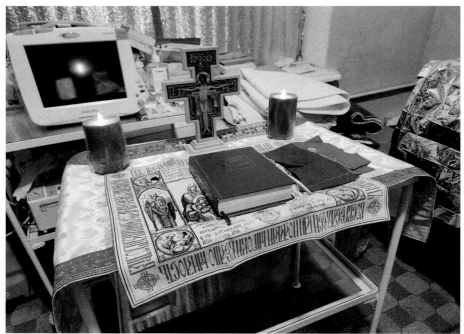

At a triage center in Velykomykhajlivka in southeastern Ukraine, Fr. Aleksandr Bohomoz and Sr. Lucia Murashko placed the sacred vessels needed for Mass, or as the Ukrainians call it, the Divine Liturgy, on a medical table. (Photo courtesy of Chris Herlinger)

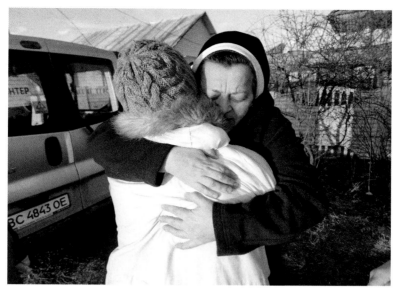

Sr. Lucia Murashko, a member of the Order of St. Basil the Great, hugs a resident of the village of Orikhiv, southeastern Ukraine, during a delivery of humanitarian supplies in February 2024. (Photo courtesy of Chris Herlinger)

The author with Sr. Lucia Murashko outside train station in Zaporizhzhia, Ukraine, in February 2024. (Photo courtesy of Chris Herlinger)

Sr. Yanuariya Isyk, a member of the Order of St. Basil the Great, stands in a chapel located near the apartment she shares with other sisters in Kyiv. Tanks rolled through her neighborhood in the early days of the invasion, and Russian soldiers went door-to-door in her building, searching for young men. (Photo courtesy of Gregg Brekke)

Outside a church in Lviv hangs a poster depicting the Archangel Michael trampling Satan, whose head has been replaced by Russian president Vladimir Putin's. The image captures the religious sentiments of the Ukrainian people, who believe God and his heavenly host are on their side. As Erik Tryggestad, president and CEO of the Christian Chronicle, told author Chris Herlinger, "God's been foiling Satan for some time, and we see that in Ukraine and among Ukrainians." (Photo courtesy of Gregg Brekke)

Sr. Evphrosynia Senyk, a member of the Congregation of the St. Joseph Sisters of the Ukrainian Catholic Church, lights a candle in the sanctuary of the Greek Catholic parish of the Exaltation of the Holy Cross, formerly the Church of St. Norbert, in Kraków, Poland, in March 2022. During the first months of Russia's full-scale invasion of Ukraine, the Ukrainian church became a haven for Ukrainians fleeing the war in Ukraine. (Photo courtesy of Chris Herlinger)

Street art adorns a wall of an apartment building that has been riddled by bullets and damaged by a mortar explosion in Irpin, Ukraine. (Photo courtesy of Gregg Brekke)

now living on their own. "They drink. And without the women with them, they lose the motivation to work."

Sr. Yanuariya underlined similar themes. "Ukraine has been damaged, and that is reflected in so many ways—schools destroyed, our heritage harmed," Sr. Yanuariya said. "It will take many years to rebuild and heal this society."

Healing will involve spiritual repair but also the challenges of physical repair. Those who had been displaced wished to return home in the spring of 2022, said Edith Dominika Shabej, a Hungarian Dominican associate and coordinator with Caritas who works with Dominican sisters in western Ukraine and eastern Slovakia. "But the problem is their homes have been destroyed. They have no place to return to."

Other grave challenges remained. In many parts of Ukraine, Edith told me, land mines left by Russian forces also posed a deadly threat. And as the human toll of the war continued to climb—with estimates of military casualties on both sides in the hundreds of thousands—Ukrainian military families needed help and solace, both now and in the future, as do returning war veterans.

Yet despite these sobering examples of societal damage, the religious I spoke to were adamant that Ukraine should not compromise with Russia and call for a ceasefire. Dominican Fr. Petro Balog, who heads the Institute of Religious Sciences of St. Thomas Aquinas in Kyiv, told us in a softly lit office that that would amount to "a compromise with evil," an acquiescence he said Christians could not and should not support. Like others, Fr. Petro, with short-cut graying hair, a trimmed beard, and dressed in a light-colored Dominican habit, spoke of Ukraine's calvary as beginning with the February 2014 annexation of Crimea and the war in the Donbas region that began

a few months later. Ukrainians believe a resurrection will be marked "when death is defeated, and the threat of death will linger as long as Putin's imperial and [Soviet-like] Russia exists."

I admired Fr. Petro's steely resolve but was a bit skeptical. Would it not be better for the country to accept some kind of end of imperfect peace, I asked, than continue with hostilities that were damaging the country?

Fr. Petro was adamant. "Our task is not an agreement with death, not a compromise," Fr. Petro told me, "but to overcome it, and that is final. I think with God's help, it is possible."

In Lviv, where the signs of war were much less visible than they were in the towns around Kyiv, that sense of commitment was no less deeply felt, and Sr. Anna told me why—the issue came down to what constituted necessary peace.

"The thing people don't understand is that Putin and Russia will not give us a real peace," she said. "If they give us two years, they will come back and kill. That will not be a real peace. . . . We know there are good people in Russia who want peace. But they aren't in the majority." As she explained, Ukraine is fighting a battle against tyranny in a war that has implications far beyond the borders of Ukraine. "Our people are dying to protect the world."

I understood the grand narrative—but I also realized that war comes down to small acts of violence, as well as resilience. When Sr. Januaria escorted us out of her apartment building, she pointed out a partially shattered stairwell window with a still-visible bullet hole. It had been almost a year since the window was shattered, but it still had not been repaired.

With the physical evidence of war in front of us, I asked her if she could ever forgive Russia.

"Maybe not now, but in the future, yes. But the war will have to end, the suffering will have to end. We're waiting for them to admit this mistake, and only then will we forgive them."

She remained firm, as the other religious had. "There will be a victory of life over death, good over evil, a celebration of victory over death, a celebration of hope and salvation, a celebration of good news after the dark night," she said quietly but firmly. "By God's grace, Ukraine will be resurrected."

Surviving Trauma

The Physical, Psychological, and Spiritual Toll of War

*S*omething that war does is pull people both outward and inward. Outward in that humans are forced to deal with horrific external circumstances—fleeing their homes, their cities or villages, and often even their countries. And that means adjusting to all sorts of new realities.

But people are also pulled inward, far deep within themselves, because they have to contend with their own personal experiences and traumas. War is trying, exhausting, and, at times, surreal. Though moments of grace and hope had been on ample display in Ukraine and elsewhere, the war's trauma seeped into the deepest part of people's souls and psyches—and that included Catholic sisters, who have experienced both the inward and outward realities.

"It's true that I don't feel the war like the people displaced," said Sr. Josafata Zapotichna, a member of the Sisters Catechists of St. Anne, whose congregation has a monastery outside of the western

city of Lviv and offered shelter for families fleeing the conflict during the first year of the war.

"But in my consciousness, I feel it all the time," she added when I spoke to her during my February 2023 assignment. "The images of the war go deep into my mind, and I even dream about them."

Experiencing the war in visceral, physical ways—ways that are felt palpably—is common, others told me. "I'm safe at the moment, so I'm trying to let go of worries so they don't build up in my body," said Katya Zelinska, one of four refugee women taken in 2022 by Jesuit seminarians in Warsaw, Poland, and interviewed in November 2022 about their new lives.

It is about coping, really. Though not inured to the news from home, Katya said, she had decided early on that it was better not to pay constant attention to headlines and reports from her country. "I feel less panicked because I don't read the news every few minutes like before, but only once a day," Katya said in a later email. When she first arrived in Warsaw in 2022, Katya felt "fear for myself and my family, for my land and my future." But over time, she said she felt new confidence and steadfastness thanks to support from her family, and from new friends in Poland.

And it is not that she ignores the news from friends and family in the western Ukrainian city of Khmelnytskyi—the news being a mixture of doggedness and resilience in the face of adversity. "Every morning, the people of Ukraine wake up to air-raid alarms," Katya said. "My relatives and friends who stayed there say that it is no longer scary; they are used to being without electricity, water, and heating."

Sr. Margaret Lekan, the sister I accompanied on the November 2022 humanitarian mission to Zhovkva, spoke of the constant news

of the war, as well, but from a different perspective: "There's not been a day without news from Ukraine. It's not been a normal situation, but we've learned to live with it."

While no end to the war is yet in sight, Sr. Margaret said, like others told me, she found solace in the fact that Poland and Ukraine—two neighboring countries with often fractured relations due to the shadows of World War II—have, at least for now, embraced a better space.

"Relations between Poland and Ukraine were not always straight, not always good." But in the first year since the full-scale invasion, both countries had come to "an understanding of neighborhood"—with both fearing Russia. In the case of Poles, she said, "We've been helping our neighbor"—doing what needs to be done.

God, Sr. Margaret said, "can take something good from this."

Even so, the fear of the war's deleterious effects remained real and tangible. Sr. Margaret recalled hearing of one Ukrainian woman's concern that "hate is entering our hearts"—hatred not only toward the Russian government and military but also hatred toward the Russian people. It is a concern that worries other Ukrainians, though they must also, realistically, focus on defending themselves against the assault on their country's sovereignty.

That trauma was relived during the one-year commemorations and reflections in early 2023.

Sr. Veronika Yaniv, prioress of the Sisters Catechists of St. Anne monastery outside Lviv, wrote a reflection on her experiences in 2022 in preparation for our interview. "At first, in the first days," she began, "we were still in a state of shock—like all people, hiding in the basements during the war sirens, which lasted often and for a long time, day and night, because no one understood when and where

the Russian missiles might arrive." But, Sr. Veronika continued, "in a few days, when the first shock passed, we realized that we would not be able to function for that long, because if we sit in the basements for long hours both day and night, then no one will be able to work or live at all."

So people began "to go to basements less often," she said, even as "war alarms lingered in the corridors of our homes." In short, some return to normalcy had become an act of defiance—and a kind of plea for peace. For a return to normal. "We're all praying for peace—but not only peace, our independence."

When I interviewed Srs. Veronika and Josafata at their monastery, midafternoon shadows darkened a common space, a still-decorated Christmas tree standing nearby, a reminder of recent celebration and joy, including that of visiting children. Their presence had enlivened the monastery, though had not altered the sisters' prayer life. "We spend time together, see them, have lunch and dinner together," Sr. Veronika said of the sisters' guests. "But we have managed to organize the time in such a way that we continue to have time set aside for the common prayer of all of the sisters."

She added: "It's been wonderful to help people."

That is the grace in a moment that placed demands on everyone in Ukraine, especially at those moments when the immediate future looks troubled and uncertain. So, a token of hope had to be found elsewhere. "The only place where I can find that confidence is in Jesus," Sr. Josafata said. "I feel confident that he's in me, that he's my safety."

That sense of safety became more apparent as the season of Lent approached—Lent in 2023 began on February 22, two days before the first-year anniversary of the full-scale invasion began, and the sisters I spoke to were in a reflective mood, contemplating both events

as somehow merged. Sr. Veronika told me, for example, that when invasion began, she had only been the superior of her community for two months and mourning the loss of her mother, who had died 12 days before.

The Russian attack came like a thunderbolt, and she and another sister scrapped plans to cross into Poland to take a formation course for nuns. "We didn't know what would happen," Sr. Veronika recalled. The sisters considered leaving and helping family members elsewhere in Ukraine or even in other countries. Ultimately, though, the St. Anne sisters opted to do what they could to help those fleeing the war, particularly travelers coming from eastern Ukraine.

Early in the war, for example, the sisters drove seriously ill and disabled children who required medical care across the border into Poland. But with so many people from eastern Ukraine fleeing their homes because of constant Russian shelling, the sisters reconsidered how to use their monastery property in Bryukhovychi, about six miles northwest of Lviv. The property—located in a serene, forested area—was built in 1991, but the sisters had remained in community in Lviv in recent years because of the monastery's rising utility bills. They used the convent primarily for organized retreats and events, such as evangelization workshops and catechesis classes.

But with the visitors arriving, four sisters decided to move back to Bryukhovychi in May 2022 to live with the new arrivals and help organize their stay in the house. The decision was made prayerfully but with a bit of trepidation. "This thing we did took some courage," Sr. Veronika said. "It was something concrete we could do, housing people here. But we didn't know how to do it." Representatives of Jesuit Refugee Services in Lviv offered to assist the congregation with logistics and financial support to help buy everything necessary for the

arrivals and their stays. Additional financial support came from the International Union of Superiors General and the US-based Sisters Rising Worldwide, which were among the groups providing assistance to congregations in Ukraine, Poland, and elsewhere in Europe that offered sanctuary to Ukrainian families seeking refuge.

With financial support came fewer worries for the sisters, and with more arrivals came "more courage and more motivation to help people," Sr. Veronika said. "We have a home for people, and it's been wonderful that we could help people." Though the monastery can house 25 people, it was home to 19 people when I visited: six mothers, seven children and six retirees. By all accounts, the presence of children and infants brightened the house, filling the monastery with cries, laughter, and the joy of the unpredictable.

"The children feel our home is filled with love," Sr. Veronika said, a smile spreading across her face.

The residents there when I visited came from different parts of eastern Ukraine, creating a rich mosaic also based in Ukraine's complex history. Sr. Veronika called the monastery "a 'peace shelter' where a community of unity in diversity is created." One of the older couples, 64-year-old Mykhailo and 63-year-old Elena, were from the Donetsk region, Russian-controlled areas in eastern Ukraine that Ukrainian forces had been struggling to reclaim. As such, the couple—with worn faces, making them look older than their age—were afraid of being identified publicly, given that some of their neighbors in the city of Slovyansk are pro-Russia. Due to those fears, they asked that their family names not be used in my reporting and that their given names be altered.

In contrast to Lviv, sometimes called the "soul" of Ukraine, Russian linguistic and cultural influences continue in the east, and with

it, fear and anxiety. Mykhailo, a retired vocational trades teacher, and Elena, a retired flower factory worker, recalled that their lives under Soviet rule were stable. (Like many people from the east, Russian is the couple's first language.) They said the initial years of Ukrainian independence were sometimes rocky, but they stressed that they do not want to return to the Soviet era and affirmed their Ukrainian identity. They opted to leave their home in early April 2022 and ended up in a whirlwind of travel across borders that included time in Poland, Italy, France, Germany, and Switzerland. After several weeks of cross-border travel, they decided to return to Ukraine: Given their ages, the couple concluded, it would be hard to start over and master the language of a new country, and in Ukraine, they would have easier access to their government pensions.

A couple they met in Zurich told them about the possibility of staying in Lviv, and they moved in with the sisters in May 2022. With two daughters and several grandchildren remaining elsewhere in Ukraine, Mykhailo and Elena still hoped to return home. But the front line had gotten closer to their home city, and the war continued its relentless, droning drumbeat—meaning the couple remained with the St. Anne sisters.

"Hope dies last," Elena said, her voice firm, unhesitating. However, though grateful for their refuge at the monastery, Mykhailo and Elena mourned what was: they own a cottage outside of Slovyansk—not far from the front lines—that was looted and essentially lost.

"Nothing is left," Elena said.

But Mykhailo said the sisters care for those at the monastery, checking in on their well-being and sharing meals with the refugees. "We feel safe here," he said, and this care has perhaps dulled the pain of their loss.

Sr. Veronika and Sr. Josafata listened to the couple's story with compassion. "Behind these stories, you can see how this war seeps into people's lives," the latter said.

Sr. Veronika added that those staying with the sisters have been a mixture of faithful and nonobservant, which had not been a concern. "For some, we are the face of God and faith, and for others, we are figures of help." Either view, Sr. Veronika said, is fine. "We accompany them in their difficult situation," she said. "They see what we do is good."

Similar feelings animate the experiences of Sr. Anna Andrusiv and her sisters, who offered short-term shelter to visitors heading west to Poland and other countries during the first six months of the war. Though Lviv, about 50 miles east of the border with Poland, was a destination for some, for most, it was a temporary transit point. The Basilian sisters opened their quarters there to visitors shortly after the war began, though most stayed just overnight. In other Basilian monasteries in western Ukraine, visitors stayed longer, up to six months. In total, three monasteries hosted hundreds of visitors in 2022. Notable at the monastery in Yavoriv: the birth of a child. Some people left because they found more permanent housing elsewhere and started a new life, Sr. Anna said. Others, like the mother with the newborn, went abroad.

In Lviv, the sisters prepared basement quarters for the visitors, a kind of bunker-like environment the sisters used as shelter when air-raid sirens went off. When Sr. Anna, carrying a flashlight, showed me and my colleague Gregg the quarters, they looked like a well-equipped, well-stocked American basement, with blankets and mattresses ready for any future visitors. The air-raid sirens continued throughout Ukraine, but as the first-year anniversary approached, the sisters and the other residents of Lviv rarely took shelter, mostly continuing their routines. (I found this to be also true during my third assignment to

Ukraine, in February 2024, when sirens in Zaporizhzhia and Kyiv barely registered a shrug.)

"Day to day, we've become used to it. People can get used to anything," Sr. Anna told me. But, she added, "we have this pressure on us. Every time you hear that siren, you feel that pressure, and it's never-ending."

The ministries continued with a particular focus on collecting and shipping food, medicine, and clothing to soldiers and others in need in the east. Both Sr. Anna and Sr. Veronika say Easter—which the Orthodox and Eastern rite churches in Ukraine usually celebrate a week later than the Western church—would be a welcome respite from the tensions of the events since 2022, though the war could never be fully out of their thoughts. Uncertainty always remained in the air—but like every religious I met in Ukraine, the narrative that most uplifted their spirits was that of the resurrection.

"Although we do not know exactly the day and hour when we will win this victory, we know for sure that this time of resurrection-victory will be, because the good always wins over evil, but it is only a matter of time, about which only the Lord knows," Sr. Veronika wrote me in the spring of 2023.

Sr. Anna shared a similar sentiment of hope. "We are waiting," she said. "Christ will rise, and Ukraine will rise. And the people of Ukraine will always fight for Ukraine to rise."

The Human Cost: The Effects of War on the Ukrainian People

What a visitor to Ukraine notices almost immediately is the way in which the war's relentless reach was evident even far from the front.

For example, while visiting Mukachevo in February 2022, not far from the border with Slovakia, Gregg and I heard air-raid sirens for the first time. While that was hardly a surprise, they were still startling and cause for unease—as were poignant moments, like seeing young soldiers on railroad platforms, headed east to the front, saying goodbye to tearful friends and family members. (I only saw male soldiers that afternoon in February 2023, but thousands of Ukrainian women have also served at the front.) Seeing the departing soldiers was a stark reminder of the costly, grave, and tragic intrusion, even domination, of war on Ukrainian lives.

"Outside of Ukraine, the war is often portrayed as 'Who's winning, who's losing,'" one Dominican sister in Mukachevo told me. "But what's forgotten is the human cost."

Some of that cost became quietly apparent near Mukachevo, in a visit to the nearby town of Serednje. There, a local priest with ties to Dominican sisters and to Caritas was overseeing a project to expand housing for a group of displaced orphans and adults from the Russian-occupied city of Mariupol. My time with this group—22 children and 9 adults, crowded into a small, darkened two-story house—was all too brief. But I sensed that the residents were deeply traumatized.

That was confirmed by Volodymyr Zavadski, an army chaplain and leader of the group who had formed a charity to help fellow displaced persons—displacement that dates back earlier than 2022 to the initial incursion of Russia in Crimea and eastern Ukraine in 2014.

Recalling the utter confusion and daily bombardments that drove him and others to leave Mariupol, Volodymyr—a bearded, somber and serious young man—spoke plainly and starkly: "I'm totally lost. I have lots of friends who died in the army at the hand of the Russians. I've seen orphans. I feel lost. And I feel big, big pain." Volodymyr's

comments felt as bracing as the biting wind from the snow-covered steppes near Serednje—air so frigid in the darkening late afternoon that my eyes watered.

Volodymyr's sober observations helped frame the nearly 10 days we traveled in Ukraine that month—as did being in once-peaceful towns near the capital of Kyiv damaged and brutalized by Russian forces early in the war and only recently recovering.

Thankfully, though, those were not the sole frames we experienced. Stark reminders of war were nearly always offset, sometimes miraculously, by the resolve and solidarity, persistence and humanity, of those both suffering and those offering succor. In an environment where an invading country's blunt, searing, and often unspeakable violence have been met with small acts of resistance and courage, the humility of sisters like Slovakian Sr. Edita Vozarova proved to be both welcome and even healing. Sr. Edita and a translator, Natalia Kommodova, herself displaced first in 2014 and then in 2022, met Gregg and me in Kosice, Slovakia, and drove us into Ukraine. There we joined other members of the congregation, the Dominican Sisters of Blessed Imelda, who had kindly offered us to stay in their convent for a few nights.

Blessed with a wry sense of humor and deep modesty—she put off an interview as long as she could—Sr. Edita, 53, recalled that in the war's first days she and others were uncertain about what to do to help the Ukrainians crossing into Slovakia. An early gesture, she said, was offering freshly baked cake to the arrivals and making coffee for Order of Malta volunteers at the border.

"We didn't know what else to do at first," she said. But in working with the volunteers as well as local parishes and Caritas, the sisters deepened their collaborations. As one example, Sr. Edita noted that

ministries both in Mukachevo and across the border in Slovakia, like establishing kindergartens for displaced Ukrainian children, were made possible by the support of Dominican networks globally. Other efforts included sending shoes and food to the front for Ukrainian soldiers; collecting clothing for the displaced and offering refugees shelter for the first six months or so of the war. (As of early 2023, most of the families had since returned to Ukraine.)

"It has changed life in our community," Sr. Edita told me of the sisters' lives at their convent in Kosice. "We are not used to children crying and laughing. But it gave us a lot of light and energy for our sisters."

For her part, Natalia, who is from the besieged city of Bakhmut in the Donetsk region of eastern Ukraine, said her family's "light and energy" came from the sisters. She, her children, ages 7 and 13, and her 83-year-old grandmother, also from Bakhmut, resided at the convent, while Natalia's husband continued working for a hydropower-generating company north of the capital of Kyiv.

"Cooperation with the sisters gave me strength at the moment when I felt the weakest in all thirty-seven years of my life," said Natalia, a journalist who assisted the sisters with their humanitarian work. "When I didn't know if I was doing the right thing by staying in a foreign country, when it was difficult for me to survive the separation from my husband and my family, when my children were having a hard time being separated from their father," she said, "the Dominican sisters took them for walks, played games together, allowing me to be alone and make important decisions." Natalia said she constantly felt the sisters' "prayers and support." In a later email, Natalia said that in "the convent of the Dominican Sisters of Blessed Imelda in Kosice, my faith became real," adding, "I don't know how

our destiny will develop, but I'm just learning to feel again and hear the voice of faith."

Natalia and Sister Edita bid us farewell on the same railroad platform where we saw the departing troops. We didn't know what to expect next in Lviv, a city with a culturally polyglot past—at times Jewish, Polish, and now Ukrainian—and a stop for those headed west to Poland and other countries during the first months of the war. Some sense of normalcy was visible in Lviv, long cherished as a charming, cobblestone-lined traveler's destination. Despite the darkened streets at night, restaurants remained open, and a nightly curfew did not seem terribly well-enforced. Yet idylls could be suddenly interrupted—and not only because of the constant hum of electrical generators heard on the city sidewalks given Russian attacks on the country. Turning a corner our first day, I ran into two Ukrainian soldiers brandishing Kalashnikov rifles.

The next day we saw a group of young—and I mean *young*—soldiers, none older than their mid-20s I would guess, grouping together in a city street. The same day we saw displays touting Ukrainian soldiers' heroism outside one of Lviv's handsome cathedrals—displays suggesting that the soldiers were blessed by saints. In a nation experiencing war, though, there are always contradictions that complicate easy narratives. An interview one afternoon with a parish priest, a Franciscan sister and a lay Christian educator veered into uncomfortable territory about the issue of conscription. The educator said that, from her Lviv parish, about two dozen young men had been conscripted. The sister and priest spoke of small numbers of young men hiding to avoid military service, and the priest said he has presided over two funerals for those who had died in battle.

The toll this cumulative anxiety was taking on society is considerable. "The psychological stress is very big," the sister said. While all are trying to avoid panic, no one could predict with any certainty what the next months would bring—though, as always, there was still a widespread belief that, ultimately, Russian forces would be defeated.

Still, the question hanging over society was a constant thrum—"What's next?" That question took on more urgency as we got closer to the front. In Kyiv, the memories of a thwarted Russian takeover of the capital in the early days of the war remained raw. Within days of the 2022 war's start, Russian tanks had entered Kyiv—a shock to residents like Sr. Yanuariya Isyk, a member of the Sisters of the Order of St. Basil the Great whose ministry is based in the capital.

"I remember praying to God and asking, 'How did they arrive so quickly in Kyiv?'" she recalled, speaking animatedly at the small monastery apartment shared with two other sisters.

Though the Russian forces were quickly repelled, it is not easy for Sister Yanuariya to forget having to seek shelter, along with hundreds of others, at an underground parking area for a day. Ultimately, it became safe to return home—though there were still Russian saboteurs in her neighborhood, causing Ukrainian troops to fire at them. At moments like that, Sr. Yanuariya said, prayer—"living with faith," "living to trust God"—proved to be both a source of comfort and a lodestar of resilience. "It was like a challenge for us, but I learned to trust in God, knowing God will help us," she said. "He will do the best for us."

Sr. Yanuariya related her experiences over plates of homemade cookies and cups of steaming tea and coffee—simple hospitality

that is the norm in Ukraine but speaks to a wider sense of generosity, kindness, and even solidarity. Something of that spirit was also apparent among those who are not avowedly religious. The last third of our assignment—in and around Kyiv—could not have been accomplished without the help of Iryna Chernikova, 33, our translator, and her husband, Stas Nepokrytyi, 42, our driver. They are both Kyiv residents and were expecting their first child in about two months. In the first year since the full-scale invasion, the young couple had to fully reorder their disrupted lives. Both lost livelihoods: Stas is an environmental attorney in a country where environmental law is not a priority now; Iryna is a furloughed flight attendant for the Ukrainian national airline. Because of the war, flights in and out of Kyiv were grounded—and remain so as of mid-2024.

Iryna and Stas spoke in a quiet and matter-of-fact way of their challenges over lunch at a restaurant in Bucha—the city just west of Kyiv best known for civilian atrocities committed by Russian troops in early 2022. In Bucha we saw families reconstructing their homes—and, by inference, rebuilding their lives. "Who knew Bucha would ever be famous?" Iryna said as we dug into bowls of hot *bograch,* a spicy Ukrainian soup.

"It's all very sad," she said, sighing. "Life changes so fast."

We pondered something several people had told us in interviews—that Ukraine was now a damaged society, physically and socially. Overcoming that challenge touched both the collective and individual. "How do you rebuild a life?" Iryna mused. She paused. "The war is showing us who is who. Most people become helpful," she said, noting the solidarity shown by volunteers, and of neighbors helping neighbors. Some people even became heroic—joining the armed forces. "But others become thieves," she said of people trying

to profit from the war. Iryna paused and repeated herself. "The war is showing us who is who."

The couple wants to be on the side of the angels—both volunteer with the Territorial Defense Forces, a kind of civilian national guard, and they are forming a charity to help war veterans and their families recover from the "moral injury" of war. "People need psychological help—they are damaged inside," Iryna said. "Every day it becomes worse and becomes a bigger problem for our society."

Stas picked up on that. "It is something we have to deal with now," he said. But it will take time. The outskirts of Kyiv were littered with the detritus of war—abandoned Russian tanks sit rusting along the sides of roads, for example. More ominously, the imposing forests outside of the capital were now studded with land mines. It could take years—perhaps as much as a decade, Iryna said—before the armaments are all removed. And searing memories are never far away. We passed the church in Irpin where the Orthodox priest who married the couple presided: Fr. Vladimir Bormashev died while helping evacuate local residents. "No one knows if it was artillery shelling or a mine that flew," Iryna said of the cleric's killing. Iryna later told me of how she and her husband were devastated by Fr. Vladimir's death. "We still don't believe that he is not with us. When we were informed about this tragedy, we were overwhelmed by emptiness and grief." The tragedy pointed to deeper dynamics. "Before the war, we had problems like getting up late for work, or the car breaking down, getting sick. But after the start of the war we were faced with existential problems, and so other issues faded far into the background."

I later saw Stas briefly during my February 2024 assignment. He and Iryna had welcomed a daughter not long after I saw them

the year before—Anna, born in May 2023—and Iryna and I later exchanged emails reflecting on the previous years. She told me more about the experiences of February 2022, noting that the day before the full-scale invasion began, she and Stas concluded the invasion would happen but probably not right away.

"So it was a shock for us to wake up on February 24 from the sounds of explosions," she said. "Our lives had been turned upside down." At first, she told me, they didn't know what to do. So they waited. "When a person finds himself in such an extraordinary situation," she wrote, "you no longer think about money or work, you think about saving the life of both your own and those of your loved ones."

As time passed, Iryna said, they took up work as volunteers, and their minds "adapted to worries and explosions, and we had to think about where to earn money to live, because both my husband and I lost our jobs. Then we found out that we were expecting a baby." She continued that they took every opportunity to make money and were able to get part-time work as a driver and translator. Since I saw them together in Kyiv, Stas had been able to find a civil service job, but Iryna stayed at home with her daughter, and contemplated starting her own business.

Life remained difficult. "There is not enough money for everything," Iryna said—and she further noted that "our experiences in the current reality cannot be described. We are afraid of the future and afraid for our lives, for the lives of our loved ones. We can't leave here."

She worries about health problems Stas faces, but he, like other men his age cannot go abroad. What sustains the couple is a belief in a better time—both for themselves and for Ukraine. "We hope for the best and trust in God."

Our last full day in Ukraine was marked by hearing air-raid sirens, and learning that rockets were bound for Kyiv, launched by Russian forces in the Black Sea. "Maybe we'll see them on the way," Iryna said casually as we headed for a morning interview south of the capital. A clear, cloudless blue sky enveloping an expanse of flatlands similar to the plains of the Upper Midwest greeted us. Fortunately, we didn't see any incoming rockets—though we did see soldiers along the highway at the ready with surface-to-air weapons.

"People are adaptable," said Slava Esmontov, a Protestant volunteer we met later that morning in the city of Bila Tserkva and who has shepherded humanitarian aid to the besieged areas of eastern Ukraine. "People get used to anything." His colleague Nita Hanson, an American Presbyterian laywoman who heads a charity that assists Ukrainians living with physical disabilities, agreed that humans are surprisingly adaptable.

"It's not normal," she said of the current situation. "But it becomes normal."

Cross-Denominational Solidarity: The Church Unites

But there are many kinds of "new normal." Nita's charity, God's Hidden Treasures, has a collaborative working style in which members of different Christian backgrounds and traditions—Catholic, Orthodox, mainline Protestant and evangelical—work together seamlessly without concern for sectarian or theological differences. (A daily staff lunch of carefully prepared Ukrainians meats, salads, and garnishes

is marked by prayer and singing. All are welcome.) Nita, a veteran advocate of interdenominational cooperation, had long hoped "to see the churches working together—and the war is doing that." Perhaps such efforts can have a positive effect on churches in Ukraine—a "kind of reformation and realization of what unites us: Jesus Christ and his love," she said.

In May 2024, I asked Nita to reflect further on these virtues. "The unity of the churches is what I consider one of the biggest miracles—all of us are joined together with one goal in mind—help alleviate the suffering, the soldiers, the internal refugees, families whose husbands, sons, or fathers have been killed in action, and wherever there is a need," she told me via email. "The usual divisions are gone."

Nita said her organization, because it is small, can "move swiftly" and "is not bogged down by bureaucracy." She described volunteers like Slava as "our arms and legs"—but also noted that in assisting front line communities affected by war, God's Hidden Treasures always asks what "specific needs there are for each area and then meeting as many as we are able." For example, the charity helped restore 17 clinics to date in previously occupied areas or those suffering damage from the war.

"In every case we asked for their specific needs," she said, "and that is exactly what we provided."

And like sisters' congregations I met, the organization has assisted Ukraine's under-supported military by providing warm clothes, medicine, and hygiene products, and even some sweet treats. The group has also provided emergency blankets needed when evacuating the wounded, solar power banks, portable water purification tubes, and tablets. Nita believes churches and humanitarian organizations like hers have been—and are—vital to responding to the war. "I don't

believe Ukraine would have survived without them," she said, citing the fact that such humanitarian groups are able to move quickly in response to needs. "Humanitarian organizations are more in touch with what is really happening and what is needed than government institutions."

What is "really happening" is often disturbing. A video recorded on a phone that Slava and chaplain Andrew Volov shared with us the day we visited puts all of this into perspective. It showed the chaotic aftereffects of a rocket attack while the men were delivering food and other humanitarian assistance to a small community in the war-affected east that is, like most of Ukraine, predominately Orthodox.

"If not us, who will do it?" Slava reflected.

Tonia Ivanova, the worship leader for the staff lunch the day we visited, said what motivates her, the chaplains, and the others of God's Hidden Treasures is "love and compassion that you share with others."

In their deliveries, the chaplains and volunteers have also provided Bibles to residents—something they say is being requested because of what Nita calls "a growing spiritual hunger." Some faith-based groups do not do that because they do not want to appear as if they are proselytizing. But Slava and Andrew believe "sharing the Gospel" is important, calling the distribution of Bibles, along with food, clothing, and medical supplies, as bundles of "spiritual bullets." They say the response by the largely Orthodox communities to their efforts have been welcomed. But it is also true that given the dangers involved, their encounters in such communities have been brief—perhaps no more than five minutes.

"You say hello, pray for them," Andrew said, "and say goodbye."

As head chaplain, Andrew organizes all the trips, and Nita said "he is absolutely fearless, going right into the front line areas." He has been told that he is now being targeted by the Russians. That takes a toll, Nita told me. "Andrew told me once that when he comes back after his trips," she said, "he often cries for a couple of days and stays alone until he can process the horrors he is seeing."

Protestantism in Ukraine: A Fellowship of Faith

The story of Protestantism in Ukraine is complex, as Erik Tryggestad, president and CEO of the *Christian Chronicle,* told me when we co-presented a workshop on Ukraine at a meeting of the Associated Church Press in May 2024. The *Chronicle* covers Churches of Christ, a fellowship of about 12,000 independent congregations in the United States with a combined membership of about 1.4 million. Missionaries from Churches of Christ began working in Ukraine just after independence in 1991.

"The church found fertile soil there, especially in the Donbas region," Erik told me. "At one point I think we had more church members in eastern Ukraine than in the rest of Europe put together."

That reality changed in 2014, when pro-Russian separatists started booting Churches of Christ and preacher-training schools from their buildings and using the facilities as barracks. Church of Christ members moved westward, to cities including Poltava, Kyiv, and Ivano-Frankivsk and strengthened congregations there.

The 2022 invasion pushed Churches of Christ farther west, into other European nations, and Erik said that Ukrainian Christians have revitalized churches and launched Ukrainian-language worship

services in Poland, Romania, and even the Netherlands. He calls it a "diaspora effect" with Ukrainians "on fire for the Lord."

In Warsaw, for example, a Church of Christ congregation was down to one family of three people before the war. Now it has more than 60 members—all Ukrainian refugees.

"God's been foiling Satan for some time, and we see that in Ukraine and among Ukrainians," Erik said. He believes that there is solidarity between Ukrainian and American Christians—even those in the U.S. who might oppose U.S. funding of Ukraine. When he relates the stories of Ukrainian church members struggling amid the full-scale invasion, Americans begin to see the power of Christian witness and that those experiencing the pain of Russian-led aggression "are those in our fellowship."

After returning to Kyiv, we had to say goodbye. With air-raid sirens in Kyiv blaring, we headed west on a 14-hour train journey to Warsaw. The trip required a stop the next morning along the Polish border for Ukrainian officials to query young Ukrainian men about their military eligibility. In a cramped sleeper car that dated from the Soviet era, I reflected about those we had met. I realized that none of them—sisters, a journalist, a priest, a teacher, an attorney, a translator, an army chaplain, humanitarian workers—would say they are in any way remarkable. Rather, they were simply doing their best in demanding, trying, and even absurd situations—a new normal. As we passed through stretches of stark, overcast landscapes, both in Ukraine and Poland, my thoughts strayed back to the early days of our assignment in Mukachevo. I recalled

what Sister Edita told me about meeting the displaced community in Serednje.

"We don't really have a collaboration with them yet," she said during our interview. "But I've been thinking since yesterday that maybe we can provide some pillows and dishes to help them."

I reminded Sr. Edita that she had brought a crate of oranges for the residents. "Yes," her face brightening at the memory. "It's always nice for children to have some fresh fruit." A small but thoughtful gesture. But in a country where war had become normalized, even that was an act of grace.

Life in Zaporizhzhia

A City Under Fire

As the winds drew closer to the southeastern Ukrainian village of Preobrarzenka on a clear, cloudless afternoon in February 2024, so did the sounds of artillery bombardments.

The noise, coming from Ukrainian forces on the front line about five miles from the village, did not faze the residents of the small community. They had grown accustomed to the steady din after two years of coping with the full-scale Russian invasion—two years marked by terror and resignation, displacement and loss.

"We can't plan anything," said Inna Sirinok, 52, a teacher who, along with her husband, Yurii, 55, lives with friends in another town because the couple's home was destroyed in a series of bombardments in 2023. "Now we live in fear, scared all of the time."

These are among the poorest of Ukrainians—rural folk who survive tending small plots of land and gardens, raising cows and chickens. Their roads are unpaved and muddy. They remain where they are because they see no alternative but to stay put and hope

for the best—that the war will end, that the sound of shelling and bombardments from the Russian side will stop.

"Oh, you get used to it," said Yurii. "We call it birds singing." Despite such expressions of irony—mordant humor is common in Ukraine right now—one of Inna's village neighbors, Tetiana Bilyk, 33, said the war has altered the village's view of life itself. "We've changed our understanding of the world—it is so difficult now," she said. "We value peace and quiet more than ever now." And yet, "with God's help we survive."

That source of hope is made tangible by the presence of the Sisters of the Order of St. Basil the Great who have continued visiting Preobrarzenka and other nearby villages at least once a month—though not as frequently now as during the first year of the war, when the sisters were flush with donated humanitarian aid they distributed. But the sisters, who live in the city of Zaporizhzhia, about 40 miles north of the village, remain a steady, welcome presence at a time when Ukrainians in poor villages like Preobrarzenka speak of the importance of not being ignored. Ukrainians of all locales, in small villages and large cities alike, are worried that the world at large—preoccupied by other global events, such as the war in Gaza—might be forgetting their cause.

"We're all tired of the war. Our first wish is to have peace," said Sr. Lucia Murashko, 49, who along with Sr. Romana Hutnyk, 54, delivered packages of detergent and cleaning items to the Preobrarzenka villagers. "But it doesn't mean we give up."

"Yes, we've become accustomed to war and that's very unnatural," Sr. Lucia said. "But we don't have a choice. We have to live to survive. If we live, it means a victory—victory over death." It also means a steely resolve about the Ukrainian cause that as one villager, Klavdia Paslavska, 67, put it: "All ours should be ours."

Even in poor, rural areas like this, where people are most directly affected by the war, this kind of determination is pervasive, permeating the consciousness of everyone, attesting to a determined Ukrainian spirit.

"We won't give up," said Diakova Lubov, 58, a cancer survivor displaced from a nearby village and who now lives in a dormitory residence for displaced persons in Zaporizhzhia and is also the recipient of other assistance from the St. Basil sisters. "We wait for victory."

Zaporizhzhia and villages like Preobrarzenka had been a destination since 2023, when I first spoke to Sr. Lucia about the possibility of visiting. As the superior of a three-sister convent in Zaporizhzhia, a city not far from the front lines and which has been shelled by Russian forces throughout the full-scale invasion, she said she would welcome a reporter's visit to highlight continued challenges and also as a sign of solidarity. But at the same time, she was reluctant to say yes in early 2023 because the situation in Zaporizhzhia was unsettled at best, and her convent was housing a number of displaced persons. Timing was also not good; Gregg and I had a very tight schedule in Lviv and Kyiv, and in the end, we decided we did not have the time to do justice to a visit to Zaporizhzhia.

But Sr. Lucia and I stayed in touch throughout 2023, and I contacted her in the summer for a story on yet another horrific turn in the war—flooding in southeastern Ukraine. Flooding on the Dnipro River caused by the collapsed Nova Kakhovka dam had demoralized residents who resided close to the war's front lines. Many of the villages close to the city of Kherson were "really suffering," she said.

What struck me about my June interview with Sr. Lucia, whose ministry in Zaporizhzhia was about 100 miles upstream from the

dam, was the frustration she expressed, acknowledging that the additional pressures for civilians in areas close to the front was taking a toll—people were simply worn out. She said that during the first year of the war, it was easy to raise money for humanitarian efforts within Ukraine, but that now, a year later, donor fatigue was setting in. "It's not easy," she told me. "Physically, financially, and spiritually, we are tired."

Sr. Lucia still believed Ukrainians would ultimately prevail in the war. But the pain in her voice was obvious and spoke volumes about the situation. She spoke candidly of how "it's hard to live in this pain" and that the "cost of ultimate victory and peace will be high." One of the reasons she knew this was because a soldier acquaintance had recently written her and said that in the ongoing Ukrainian counteroffensive, 55 soldiers in his unit had died and only 15 returned—after gaining less than a mile of territory. "It's a very high price," Sr. Lucia said, noting that hospitals near the front "are full of wounded soldiers."

More broadly, she told me, she thought that the war's reality was harder and graver than was being depicted on television news reports. On the overall situation of morale, Sr. Lucia said Ukrainians remain angry about the war, "but we can't do anything with our anger. The war provokes anger in our hearts, and that's very difficult."

At the same time, though, Sr. Lucia said she took heart in the efforts of a network of volunteers who were shepherding aid (food, water, clothes, diapers, generators, and health products) to flood-affected areas southwest of Zaporizhzhia, and for the financial and material support from sisters in other parts of Ukraine and in neighboring European countries, particularly Romania, as well as Italy and France.

In addition to financial support, Sr. Lucia said she and other sisters needed continued prayers for peace and for the sisters' work. "Any kind of support, including prayers, are important," she told me. "Any support, please do it. We want to be good people, good Christians. Help us in any way you can. It's very important. It gives us the strength to continue."

Sr. Lucia said she hoped to remain steadfast and continue her ministry in Zaporizhzhia. "I will not give up," she said. And that meant being focused on what she and the other sisters could control—which meant helping the flood survivors. Still, she acknowledged sadly that there was nothing that could help those living in the Russian-occupied side of the flooded areas—the Dnipro River separated the Russian and Ukrainian forces. "It's a desperate situation, and we're helpless to assist them," she said.

Yet despite those challenges, the sisters in Zaporizhzhia experienced moments of grace and recognition. In September 2023, the Chicago-based Catholic Extension Society announced that the Sisters of the Order of St. Basil the Great would receive the 2023–2024 Lumen Christi—or "Light of Christ"—Award, an annual honor awarded to those "who radiate and reveal the light of Christ present in the communities where they serve." The honor included a $25,000 financial award to support the sisters' ministry both in Ukraine and in the United States, including work in resettling Ukrainian refugees.

The announcement singled out in particular the sisters' monastery in Zaporizhzhia. "Despite the danger, the sisters felt called by God to minister near the war front, helping with evacuation efforts and regularly housing women and children, whose husbands and fathers are at war and whose homes and livelihoods have been destroyed," the announcement said. "They continue to provide comfort, food and

clothing to residents, particularly the elderly who remain in Ukraine, as well as provide pastoral care to battle-weary soldiers."

In response, Sr. Lucia said that they are determined to help the needy. "The source of our light is . . . Jesus, and He just works. You just have to follow Him." She then thanked everyone praying for her people and Ukraine. "Your prayers," she said, "are our protection."

At Zaporizhzhia's train station, after an overnight journey from Kyiv, Sr. Lucia warmly greeted me and Sr. Romana Hutnyk—another Basilian sister who would stay in the convent while Sr. Lucia traveled to the U.S. later in February. Lucia and I both were choked with emotion. We had finally met! But we had little time for pleasantries. My time in Zaporizhzhia—almost a week—had been carefully planned.

The first order of business was traveling to Preobrarzenka from Zaporizhzhia.

What was immediately clear was how much more militarized things felt in Zaporizhzhia than in Kyiv—more soldiers were visible. On the way to Preobrarzenka we had to stop at several check points, and while we had no trouble with the soldiers stopping us, Sr. Lucia and Sr. Romana laughed at the words of a woman we picked up along the road who needed a lift. "She said she had never traveled with sisters before," Sr. Lucia said. "People think we're not real nuns. They think nuns sit in a convent and pray"—a reference to the more usual tradition of cloistered Orthodox sisters. "We do what we need to do."

When we arrived at the village, people warmly greeted us and said our presence was in many ways more important than what the sisters had to distribute—bags of detergent and cleaning items. Though it

is difficult to interview people as a group, what I discovered was that people had opted to stay in their village out of a stubborn belief that that no one, not even Russian forces, would drive them out. Still, the numbers of those who had remained or in some cases had returned was small—there were perhaps 2,000 in the village before, but only a quarter of that remained. But that persistence was important: one resident told me. While always praying for peace and a return to normal life, "We were born here, and we want to die here."

Support for the war remained strong because, as another villager told me, "We cannot be sure there won't be more invasions by Russia in the future." Some 400 children, I was told, had left the village—their parents opting to move to other locales, such as Zaporizhzhia, for their children's safety. Others mentioned relatives fleeing to Germany— while others spoke of being traumatized and feeling physical effects from the chemical effects of a bombing.

I had not been so close to an actual war front line as I had been here, though at first the village seemed quiet enough. But in meeting with Inna and Yurii Sirinok, the couple coping with their heavily damaged home, I kept hearing rustling noises. The sounds became louder, and I realized I was hearing artillery fire—prompting Yurri's comment about the "birds singing." A few times the din got even louder and the shelling more apparent. Making a joke is hardly a surprise in such situations, and the Sirinoks tried to keep up a brave face when meeting me and Srs. Lucia and Romana. Inna pointed out to us the building's condition: ruined living areas, covered with shards of window glass and shattered furniture.

But it was hard not to see that Inna, speaking excitedly and nervously, was probably experiencing some kind of trauma: several times she confused the dates of the bombings and had to correct herself. She

spoke anxiously as she described the couple's plight. "We honestly don't have the strength to recover," she said, so considerable is the damage to the house. "We want to come back, but we don't know how or when."

"We have to start over," added Yurii. "We don't have the strength. We're elderly."

When I returned to Kyiv, I spoke to Tetiana of Caritas, who told me such heartbreak is widespread. Recall something mentioned earlier: Tetiana explained that in Ukraine, a cornerstone of a family's safety net is owning a home, whether in a city or a village like Preobrarzenka. There may be some two million homes destroyed in Ukraine now, she said. "That's a huge number of people whose security net has been somehow attacked or ripped out from under them."

Those are the physical costs. But there are other tolls—some of them unspeakably tragic—like the Sirinoks' neighbor who died after panicking and accidentally overdosing on antianxiety drugs.

"These stories are a piece of the horrors here," Inna said.

Such earthbound realities—of survival and fear—comingle with hope and thoughts that turn to God and eventual peace—as well as an embrace of some kind of normalcy. Inna's continued online teaching to first year students, including three special needs students, sustains her, as does the couple's love for each other and their belief in God—as well as the steadfast support of their neighbors. And in comfort from the regular encounters with the St. Basil sisters, whose hugs and embraces and *presence* mean so much. In such encounters, the burdens of life are lifted, if even for just a moment.

As it became windier that afternoon in Preobrarzenka, without a cloud in the sky, the bombardments got louder—but the villagers seemed to take it all in stride.

"We always pray," Inna told me, "and trust in God."

The next day, I accompanied Sr. Lucia to a distribution in Zaporizhzhia of donated backpacks, school supplies, hygiene items, blankets, and other household supplies outside of a dormitory that has been converted to residence for the displaced from villages like Preobrarzenka and from other locales in eastern Ukraine. The distribution to the group was orderly, and unlike the previous day, was brightened by the presence of children, who delighted in the backpacks Sr. Lucia handed them.

She met two women, Petrova Yevdokia, 80, and Diakova Lubov, 58, residents of the dormitory and regular recipients of the aid, and took them back to the convent for tea and to talk about their experiences. Both are courageous, brave, steadfast women who have had to endure physical challenges in their lives: Diakova is a cancer survivor and spoke with difficulty after a series of surgeries, including one that cut one of her vocal cords.

"I learned how to survive," she said. Meanwhile, because of an incident that occurred while she was fleeing bombardments, Petrova lost some front teeth, now replaced with gold crowns.

Diakova spoke first, noting that life in the dormitory is simple and spare, with shared quarters—but is certainly preferable to a life fleeing bombardments. She was once a resident of Preobrarzenka and worked as a postal worker—a job she enjoyed and remembers fondly because it afforded her dignity and some prestige. ("Every day I was greeted like a president, people saying 'Good morning.' I had such work!") But such memories have been eclipsed by recollections of Russian bombardments that began in March 2022 and continued

through October of that year, when she finally fled. Diakova opted to stay for seven months because, like those who still remain in the village, she did not want to leave. But it got to be too much: the sound of nighttime artillery shelling became hellish and the deaths of two village residents—two electrical workers—convinced her it was time to leave.

A widow, Diakova said she owes her life to one of her cats, Asia, who called her to a different room than her bedroom, in which windows were destroyed during an explosion. "That cat saved my life," she said. She had returned to the village just once to pick up some documents and to feed the cat, as well as another feline named Masian. Diakova hopes that Ukrainian soldiers who were now living in damaged residences might be taking care of the cats. (Pets are not allowed in the dormitory where Diakova is residing now.) Though she misses home, Diakova told me her current residence is supportive—residents help each other, share meals and the like, and Caritas has provided psychological help with trauma.

"We're like a family now," Diakova said.

Petrova was initially more measured in her comments. Like Diakova, she is a widow, and also like Diakova, she has endured hardship even before the war—her daughter died almost 10 years to the date before the full-scale invasion and she has been raising her granddaughter (17-year-old Diana) since then. The two are from the eastern city of Mariupol—a major site of battle during the initial months of the full-scale invasion, and one that fell to Russian forces in May 2022.

Petrova's memories of that experience are searing: she and more than a dozen others—10 adults and 7 children—took shelter in an apartment basement and stayed there for 20 days with little food or water with shelling all around them; one person got the courage to

leave briefly to retrieve some bread; those in the shelter shared it—a moment of holy symbolism.

"The danger gathered us together," she said.

(I later heard a similar story about a Protestant church in Bucha that had housed as many as 170 people—all of different faiths—for three weeks during the Russian occupation there.)

On the twenty-first day, the group learned a humanitarian corridor was being formed that allowed them to leave the building, go to another site by bus, and ultimately to a hospital building. Petrova teared up when talking about the loss of her teeth—she fell on a pavement—but also in recalling seeing bodies outside as the group ran to buses for safety. "In a situation like that, you don't know who is shooting," she said, crying.

The evacuees briefly came upon a group of Russian soldiers who offered them some food—meat and bread. For that they were grateful. But that was a brief encounter in an otherwise chaotic moment: "We ran and ran but we didn't know where to run," Petrova said. Eventually the group arrived at the hospital, where they stayed for two days. She and Diana had enough cash to pay several drivers to take them to Zaporizhzhia—they had to go through 20 checkpoints to do so and arrived at a converted shopping center like the ones on the Polish border I had visited. Petrova said she was at a loss—with no money, no fresh clothing, and then, for a time, becoming separated from her granddaughter.

After staying briefly with a woman who offered her help, Petrova settled in the Zaporizhzhia dormitory but said she was desperate to find her granddaughter; eventually soldiers who investigated available records of displaced persons located Diana—much to Petrova's relief. "I had become so sick and didn't have any further strength. I

needed help," the grateful grandmother said. Of her reunion with her granddaughter, Petrova added, "Of course we were so happy." Life had settled some; though the two women remain dependent on humanitarian aid, Diana was now in school, learning computer technology and also sewing. She hopes to become a photographer.

Petrova still has two daughters in Mariupol and a son in Belgium. I asked Petrova if she would want to return to Mariupol or live with her son. She said no, particularly to the idea of returning to Mariupol, saying she doesn't like the idea of reliving bad memories. But she, like Diakova and so many of her compatriots, remained confident of Ukraine's ultimate victory. "We will win," she said assuredly.

I asked both Petrova and Diakova if they felt they could forgive the Russians for what had happened. Petrova said it was true that Russian soldiers had, for a moment, helped her and others fleeing. But she felt confusion about who she could ultimately trust. "When I lay in my bed and think about what I went through, I think it would be difficult to forgive," she remarked as we spoke in the small but brightly adorned chapel space in the sisters' convent. Diakova was more unequivocal. She joked that her surname is similar to the Ukrainian word for love—but in the end, she said, "I can't forgive."

Though these comments hinted of bitterness, Petrova acknowledged the blessings she and others had experienced because of the humanitarian work of Catholic sisters. "We're very happy that the sisters are still remembering us when others are no longer giving aid."

Tired of War but Not Giving Up

Sr. Lucia calls her early-morning hours in the convent "coffee with Jesus," and I was honored to be invited in the small convent kitchen to

join her in that time for coffee, tea, and rolls. Mornings are a special time for Sr. Lucia—time to reflect, ponder, pray, and prepare—but she said that even for a sister, a group known for their strict work ethic, there are days when she needs to devote herself fully to rest and sleep.

By American standards, Sr. Lucia is relatively young for a sister—49, entering the convent in 1994 and taking vows in 2001. She remembers the exact date in 1994—February 7—because that was 30 years to the date when we visited the villages on our small humanitarian mission.

I told her it was a privilege to share that anniversary with her; she smiled but was philosophical when I asked her about what she had told me the previous summer of Ukrainians feeling frustrated and exhausted. Sr. Lucia said that remained true and that "we're all tired of the war, and our first wish is that we want to have a peace. However, it doesn't mean we give up." She further acknowledged that she and her fellow citizens had all become accustomed to the war and said it is still a "very unnatural state." But, she added, "We don't have a choice. We have to live to survive. If I live today, it means a victory—it's a victory over death."

How does Sr. Lucia make it through the day? "To see the positive things, to see the ray of light amid the darkness. That gives us hope today and tomorrow." She paused, reflecting on the rhythms of her vocation. "God works better in our situation than we do. He wants us to live in peace with ourselves. But the responsibility is ours, to choose what we want to see, to see his presence in the everyday." People will say, in the midst of this situation, "That there's no God. I understand that feeling. But I know God is with those who are suffering and with those who are doing something good. I know God cries with the people who cry. I see a God who has suffered, and I know a God

who stays with those who are protecting us. I know God is on the side of those who choose to do good."

The good is all around Sr. Lucia; she and her fellow sisters radiate goodness, but the goodness is now highlighted against real challenges. The worst days came after Ukrainian forces destroyed a well-known bridge in the east, prompting intense Russian bombardments.

"We were being bombarded every night," she recalled, shaking her head, her usually relaxed body tensing at the memory.

One time, Zaporizhzhia was hit 16 times by the Russians.

"We couldn't sleep normally," she said. "Zaporizhzhia is so close to the front lines. You don't feel comfortable or ever totally rested." That takes a toll.

While visiting her congregation's monastery in Lviv, Sr. Lucia recalled that even hearing a door slam alarmed her. Luckily, there had not been a bombardment over Zaporizhzhia since January—though there was at least one a week after I left the city, in February. (More followed in March, but through a text message, Sr. Lucia told me the sisters at the convent were fine.) Of the sirens, she commented, "You start to ignore them. If you go to the basement, you start to think that you have to live there," she said of earlier experiences. Now, she declared, "We just live and hope God protects us. Our only protection is Him."

Sr. Lucia said that in the first year of the war she was constantly busy delivering and organizing aid shipments. The convent was overrun with aid. "We worked so hard that we couldn't believe we did it," she said. But she now suffers from a bad back, an occupational hazard. Though Sr. Lucia said it can be frustrating not to have the same amount of material assistance as before, it also means that she and

her fellow sisters are not as stressed or overwhelmed with work. The convent has become less crowded now. In the early days, displaced persons would come for a night or two, "to wash, to sleep, to eat. We helped them get further . . . we helped them get to Poland, especially people with physical needs."

The small convent kitchen remained quiet as we spoke, and light began to emerge, though it was obscured behind a cloud-filled sky. The morning stillness, Sr. Lucia remarked, contrasted with the days when bombardments rocked Zaporizhzhia, disturbing the peace of the city—and the convent.

Sr. Lucia's focus now is on fundraising to help efforts for the soldiers—"We need to support those protecting us," she said in the immediate weeks before her US fundraising tour. "Here, we are in the hands of those who have a generous heart."

I said that some Americans might be puzzled by sisters needing to so strongly support soldiers. She replied that such a ministry to those protecting the country is an important piece of what she and the others are doing—whether that means collecting food and clothing ("They were cold," she said when asked why this was a priority) or being a sounding board and caring ear for them. Of that, and based on her own experience, she said non-soldiers need to take their cues from the soldiers and not ask them tough or blunt things. "If they want to discuss it, fine—whatever happens it's a good result if you can talk, and a soldier remains whole. But the soldier has to do it," she said. "If he starts to cry, you have to be able to help him remain whole."

Soldiers are not strangers to the convent—it has become a temporary residence and place of respite and rest for them, as well as volunteers, journalists, and other visitors. But the welcome to the soldiers

is particularly important—they come to visit relatives, rest, reflect, confess. "We even celebrated a wedding of a soldier. We are close to the personal stories." She paused, smiling at the memory. "Soldiers can eat [as if they are at] home, at a table, and on plates. Maybe the food is not totally like family, but the atmosphere is like family."

"Wanting to Be an Island of Light"

A convent is a place of peace, rest, and renewal, but with a chapel adorned with iconography and crucifixes, it is difficult not to be aware of the reality of death—and life. That awareness underpins "how we save Ukraine. It unites us, and it makes more active in our religious life," Sr. Lucia said. "Some people who arrived here are now parishioners, and they're receiving spiritual bread."

Some who have experienced the occupation or seek an experience free of any Russian influence have come to the parish and according to Sr. Lucia have been made to feel welcome—"to make them feel like family. In the last two years we've welcomed more people than we have in the last 20 years." In that way, Ukrainians want to stand together—"not to feel alone in this terrible war"—and that those fleeing from the occupied areas want to feel that "people have not forgotten us." In a sense, she said, it's a feeling of solidarity—that "I understand what you've been living through, and I want to stand with you." It made her and other sisters feel that they were not alone in their efforts.

Sr. Lucia thanked the global community, particularly in Poland, Italy, Japan, and Australia, for their support and said it was due to them that they were able to "share everything with those who are in need."

She added: "We're not a rich community." She further said that the assistance—such as food—they received from Caritas helped them in assisting those who had fled.

She said staying in Zaporizhzhia was a conscious choice. "It was scary at the beginning, and we weren't sure if the war would come here," she said, recalling that she and other sisters were invited to return to their provincial house in Lviv if they thought that would be more secure. They did send some documents to the provincial house and prepared suitcases in case they needed to depart quickly. But they opted to stay. "We felt we were needed, that it was important for us to stay here. Of course we were scared. But thanks to God, Zaporizhzhia was not occupied."

Sr. Lucia believes she and the sisters did the right thing in remaining in Zaporizhzhia—"we opened our door to people, and we opened our hearts, the way we could serve as best as we could." She added it was all an example of the Gospel mandate—of Jesus's command to share with others. Sr. Lucia thinks the outpouring was not their doing but of God's. "Every day we ask God in our prayers, 'What can you do for us today?'"

Sr. Lucia also said that if no one had come to the convent, "We'd have wondered if we should have stayed. But people kept coming, and so that's why we stayed." She acknowledged it took a toll—by the summer of 2022, she was tired and spent. "Sometimes it was too much. It was physically exhausting. But people kept coming." As did humanitarian assistance. "I never learned to say, 'We don't need this.'"

As sisters, Sr. Lucia continued, "hospitality is in our constitution"—monasteries and convents are supposed to show hospitality. And sisters are to show hospitality in their work—which is why the sisters opted to continue working in the small villages. It is important, Lucia told

me, for people to have some kind of stability in their lives since they have lost everything. "For those people, everything has changed. People talk about what they had. 'I had a house. We had cows.' They felt they would have a tomorrow." They continue to pray that they can return home. "But the war seems to continue, and we don't know how it will go." For such survivors, happiness is in the tiny gestures, like a prayer with a sister. "They are so happy. It's a small thing. Even if I just pray with them, that's enough."

I asked Sr. Lucia how many people she felt she and the other sisters had served. Thousands, she replied—and while the shipments of aid have slowed, the demand for needs has continued. "The life has to continue," she remarked. "That's what we have to see—the light, and not just the darkness. For us here, we know all about destruction and death . . . but it's important to celebrate life." She concluded, "We want to be an island of life, where people receive a little bit of faith and hope and go back to their communities, their daily life."

In other words, a sign of victory over death.

For Mothers and Women, a Need for Prayer and Fellowship

Part of seeing the signs of life is the connection beyond the monastery and the immediate humanitarian needs. It is important for women, and mothers in particular, to keep meeting amid all of the hardships. So, one of the days I spent with Sr. Lucia and the sisters was to venture to the city of Kamianske, about 70 miles northwest from Zaporizhzhia, to join them for a day of community and prayer. "The war is a good lesson for who we are and want to be," she said,

"and prayer has always been important but more than ever, people realize how important it is now."

It was a cold, overcast, snowy day, and the sight of often worn-down, beat-up residences from the Soviet era did not bring much cheer. But the prayers and singing were affirming, as was the welcome by Auxiliary Bishop Maksym Ryabukha. He praised Sr. Lucia "as one of our angels" and also spoke of their prayers being united with the prayers of those outside of Ukraine during the past two years. It was important for the women, he said, to pray for those in the occupied areas—"that we are one and united with them," he said, noting that the Greek Catholic churches in the occupied areas had been closed.

One of those joining the service was Olha Vakalo, 53, a local Zaporizhzhia television journalist and radio host. She felt a strong need to pray because it is a "nervous, anxious time," and so the fellowship with others is a needed balm. It is refreshing, she said, "to be with others, even those I don't know personally." As a godmother of six, and concerned about the fate of the country, Olha said, "I've been praying more since the war started . . . through our spirit we'll reach victory. By the power of the spirit—history shows this," she said. "I'm sure of it." And she is equally certain that Zaporizhzhia was not occupied because of the prayers of dozens of monks and the pilgrimage just as the full-scale invasion began. She and others walked down an avenue called Peace Street. "We saw a rainbow and saw that as a sign."

Prayer remains central, of course. A Mass celebrated in the convent on the Sunday I joined the sisters drew about 30 people, and encouragingly, about a third of them were young people and children. Like the Ukrainian Masses I attended in Poland, there is a stirring sense of otherworldliness and mystery with much of the service devoted

to chanting. One of those glad to be steeped in such holiness was Rostislav Kiviluk, 41, an army medical driver from the western city of Ternopil, whose work had stationed him in and around Zaporizhzhia. A tall, bearded, friendly bear of a man, Rostislav worked at the "second line"—about 24 miles from the front line. Without getting into details—I sensed this was a sensitive subject—he described his and others' experiences as "very hard" as they did not have adequate supplies or enough vehicles to properly do their work.

"It's a terrible situation on this front line. We've lost a lot of good soldiers from bad tourniquets. It's a hard time for Ukrainians," he said after lighting several candles following the service. A practicing Catholic, Rostislav carried his burdens confidently but said attending Mass at the convent "helps me. It gives me energy for my job. Being here with the sisters for a couple of hours, I'm at home."

Eleven

Stories of Displacement

New Home, Same Hope

*S*eventeen-year-old Ivan Cherychenko, and his friend, fourteen-year-old Alisa Rengevch, were a constant presence when I stayed in the Zaporizhzhia convent. They had found a safe haven with the sisters, and though the sisters sponsored social gatherings with local teens, Ivan and Alisa became part of the sisters' life, enjoying daily meals and catching up on news and storytelling with them.

This was encouraging, especially since the full-scale invasion has greatly affected Ukrainian children and young people. A United Nations survey conducted in late 2022 of 2,064 respondents between the ages of 14 and 34 found that 82 percent said they had experienced some kind of loss since the invasion; 27 percent expressed worries about their physical safety; and 40 percent reported they did not have regular access to food and were having difficulties in covering basic needs.[*]

[*] United Nations Development Programme, "Impact of War on Youth in UKkraine: Findings and Recommendations," 2023, https://www.undp.org/sites/g/files/zskgke326/files/2023-06/undp-ua-impact-war-youth-eng-findings-recommendations.pdf.

While those problems did not seem to be immediate concerns for Ivan and Alisa, I soon found that, in Ivan's case, these were not distant worries or experiences. Alisa, though not a shy girl, was never enthusiastic about being interviewed. But Ivan, a fun-loving teen with long cropped hair parted in the middle and who enjoyed a good laugh, was not shy about sharing his experiences leaving the Russian-occupied area of his small village, Komysh-Zorya, located in the Pology region of the wider Zaporizhzhia Oblast—about 50 miles from the city of Zaporizhzhia. Ivan told me that, before the war, the village had about 5,000 residents but now only had a fraction of that. As is the case with Preobrarzenka, its residents were now older and did not want to leave.

The Russian occupation of the village began a little after a week of the full-scale invasion, and the village was encircled by Russian tanks. However, unlike in other nearby villages, residents of Ivan's village resisted for some time, their forces shooting back at the Russian shelling. The presence of a sole Ukrainian tank gave the Russian forces the idea that there was more resistance than there actually was.

The situation for Ivan and his family became perilous. Ivan's parents, an older brother and five others joined Ivan in hiding in the family basement. A grandmother, suffering dementia, stayed in an adjoining residence; an older sister had moved to Zaporizhzhia. "We were lucky to hide right away," Ivan said, adding that while the worst shelling and shooting occurred on the other side of the village, it remained tense—though luckily the worst was over in a full 24 hours. Still, "it wasn't a good sleep that night," he recalled. From the basement the family and neighbors said they could eventually determine the frequency of shelling, and one of the party went to the garage to find tools in case the house collapsed and also grabbed water and some

food. The family home was spared serious damage—though other homes and the village school sustained damage. Even so, the village was without light or electricity or phone service for several weeks. In that time, Ivan said, the town found itself in a kind of surreal limbo.

The family was divided over what happened. Ivan said that in the subsequent months, his father, 48, a tractor operator doing road repair, opted to stay in the village "and bought into the Russian propaganda." Ivan said it was a "pretty typical scenario"—his father was a product of the "USSR time" and thought the Russian presence in the village might "bring it all back"—a time of some security, perhaps, but Ivan wonders why this is so, as the stories he has heard of the era—like of long lines and scarce goods—is hardly ennobling.

Ivan, who was 15 and a tenth grader at the time, said his father's reaction was startling to him because once the occupation began, Russian troops started looking for Ukrainian patriots and began killing people—"clearing the village of the Nazis" was the official reason given. "That's when the horrors began," Ivan recalled, saying the Russian forces were keen on finding anyone who had served in the military since 2014, as well as local government officials. Reports began circulating of people being tortured and interrogated and of killings of a prominent family who owned a local grocery store. Ivan also heard stories of women being raped and even of residents being run over by Russian tanks. The official word, heard over radio broadcasts, was "We're not harming civilians," but that is patently untrue, Ivan said. As the Ukrainian army retreated, there was no one to protect civilians. Eventually, he added, the Russians brought in their own authorities—police and guards—to oversee the village.

Ivan said this chaos continued through 2023 and said a lot of collaborators began reporting on their neighbors to the new local

authorities. "I think people were scared and would say anything to protect themselves," the teen said, adding that it was known that troops were looking for women and girls to rape. Abductions became common—people disappeared.

"I still don't know who is alive and who isn't," he said.

Ivan even heard of one man who was able to escape from Russian custody and weighed 100 pounds, down from 250. "He was desperate," Ivan said.

In telling me these things, calmly and objectively, at the convent's dining room table, Ivan seemed to change some: his once-sunny demeanor disappeared, and he became quiet, serious, and reflective. He said that while his family's experience was not nearly as bad as others', "a lot of people went through worse. There was never a moment of peace." He added: "Everything they're doing is being done to create chaos."

The experience further sowed division within his family: his father began to drink heavily and declared that Russia was "here to stay" and that people should become accustomed to it. "If it weren't for America," his father said. "Ukraine would be totally under Russian rule." Ivan decided it best to avoid his father and try not to get into arguments with him. In that respect, Ivan was in some ways siding with his mother, who told her husband, "You've lost your job, your life, your house. Why do you agree with them?" And there was yet another reason for the division: Ivan's uncle died while serving in the war and was killed on June 16, his mother's birthday—a day she said she will never celebrate again. She was mourning—and wanted to get out.

Ivan said he did not think about leaving without his mother, who stayed to take care of her mother. But when the older woman died in November 2022, and after a mourning period, the mother

began thinking it was time to go. But unfortunately, a "humanitarian corridor"—a safe transportation to leave—had just ended.

"We missed that," Ivan said regretfully, but also recalled hoping that somehow Ukrainian forces might still retake the village. When that did not happen—and when the 2023 Ukrainian counteroffensive against the Russians did not develop as well as had been hoped, Ivan and his mother decided it was time to leave.

"I was always saying, 'Let's move, let's move.'" One reason for that, Ivan said, was because school had closed, and he felt "like we were just existing. It was constant terror, and you never knew what to expect."

Though worried about stories of Ukrainians leaving the occupied territories and being interrogated by the Russians—cell phones with pro-Ukrainian photos were particularly worrisome—the family was able to assemble enough money to leave and did so—though the brother opted to stay. Ivan worries about his brother and others left behind.

Ivan and his mother left on November 15, 2023, and were held up at the border for three days and then ended up taking a roundabout route to get into nonoccupied Ukraine, including time in Russia, which took two days by bus. The family spent a day at a refugee center. "When I got here my emotions were numb," he said, "but I was happy and finally relieved."

In Zaporizhzhia, Ivan feels grounded—he joined a local Scout troop that has ties with the monastery and has been regularly attending services at the monastery chapel. Though baptized Orthodox, he now feels he is Catholic. He finds the convent a welcoming place—like a second home—and that the church gives him a sense of community and safety, security, and welcome. "They make it very much like family," he said.

Ivan's schooling will continue in the fall of 2024, he hopes, noting that he had been studying online but that that was risky—as he did it in Ukrainian and not Russian. He used a second phone to transfer homework to his instructor. Another teacher, given five days' notice before deportation, was told she could go to the frontier and was then on her own. "I still don't know what happened to her." Not that things went well for the other teacher, whose car was the target of a Russian shooting spree. Why? "There's no logic to it," he said.

As for his own life, Ivan once dreamed of becoming an actor but is not sure how realistic that is right now. "I feel lost," he told me, his eyes downcast. He said he is not yet worried about being conscripted into the armed forces as he becomes older but realizes it hovers as a possibility. His mother is still in touch with Ivan's father, but she steadfastly refuses to return to occupied Ukraine. As does Ivan, who harbors resentment over his father that predates the war, saying his father was "distant and selfish" and that he was not given proper attention as a son. But, he said, "Maybe that will change with time."

I asked Ivan what he would like to see Ukraine become. "Independent and free," he said, and added he wants to be free of any feeling of hatred and to, someday and somehow, help rebuild his village if he could. I asked him if Ukraine should tilt toward East or West. "It's obvious—the West," he said, meaning Europe. "There's no question. No person would want to be part of something that is so horrible."

For a Ukrainian Cleric, an Almost Cinematic Journey

Ivan's account is not singular. Echoes of it resonated in the experiences of Fr. Aleksandr Bohomoz, 35, whom I had met on the mission to the triage center and who had previously worked in Melitopol. A native of

the Kherson region, Fr. Aleksandr was part of a group of Ukrainian Catholic clergy who found a welcome in the east and saw the number of churches increase before the full-scale invasion. Whereas there was only one Ukrainian Catholic priest in the region in 2010, there were five or six by 2022, and each took care of three to four parishes. In all, there were six priests who remained in the occupied areas: two were eventually imprisoned, two escaped, and two were forcibly deported, Fr. Aleksandr being one of them.

Like Ivan, Fr. Aleksandr spoke of his experiences calmly, in a somewhat matter-of-fact tone. We talked at the same table where I had interviewed Ivan a few days earlier. Over a meal of cheese pizza that the sisters had ordered in, he told me that he had spoken of his experiences to Ukrainian journalists, and so the narrative came easily to him. His body language did not betray much emotion at first. But as he spoke of what was a remarkable experience—almost cinematic—his pace of speaking picked up some.

Fr. Aleksandr told me that though Russian tanks rolled into Melitopol on February 25, 2022, he was able to stay nine months before being deported—an experience he said that could have been far worse. Unlike another priest, for example, he was not beaten. But still, the experience was unnerving. In all, he was interrogated seven times over the course of nine months, and each time he resisted what he was told was the "proper way" to practice his faith. What resulted in the final expulsion was his refusal to divulge confessions, and ultimately his interrogators took personal items and documents and seized his car. During this time, someone armed with a machine gun watched after him. As a founder of a local Knights of Columbus chapter, Fr. Aleksandr and the Knights were accused of being American spies. Yet, he was still spared being imprisoned or beaten.

"There's no explanation for it," he said, repeating what Ivan had said of a teacher whose car was shot at. It's not rational. "I'm lucky to be alive. . . . It's a miracle."

But it is a miracle also given his final experiences in the occupied areas: On December 1, 2022, on a cold, cloudless day, Fr. Aleksandr was dropped off at the so-called gray zone and told he had to walk nine miles to the Ukrainian side—all while shelling erupted. He walked along a highway, with rockets soaring over his head, and ran into a group of Russian soldiers who asked what he was doing. Wearing his clerical garb, he said he was headed toward Zaporizhzhia, garnering laughs from the Russians.

"I didn't explain that I was deported," he said, figuring that telling the story would complicate things.

Fr. Aleksandr knew the area a bit and knew of a small bridge he might cross. However, he found that that bridge had been blown up. Along the way, he met an elderly woman who warned him about land mines ahead. "She said, 'Don't go there.'" He recalled, "If I hadn't been told that, I might have died. That was another miracle I experienced."

Fr. Aleksandr recited the rosary throughout the ordeal and knew there were people who were praying for him. "I believe faith and constant prayer guided me." So did a sense of urgency—he walked quickly, almost running, and though it was cold, took off his jacket due to the rapid pace, adrenaline rush, and anxiety he felt. "I almost flew there," he recounted.

He later experienced another miracle. At the border, "someone screamed my name." It was a young soldier who had been a member of one of his parishes. He did not recognize the young man at first, Fr. Aleksandr admitted. "I was confused."

The front line is as long as 600 miles, so the chances of seeing this young man were minimal at best. "He ran to me with a bulletproof vest—I hugged him so hard," he said, recalling tearing up.

This all happened in one day, he marveled. He was arrested at nine thirty in the morning and arrived in a safe zone by five in the afternoon. The sun was just setting—and it was cold. What came next? "I wasn't sure where I'd spend the night," but the young soldier took Fr. Aleksandr to his commander, and he was able to get a lift to a nearby police station, where he told his story to authorities, told them he was fine, and eventually arrived in Zaporizhzhia.

"The way things came together, I was blessed." Still, Fr. Aleksandr's initial feelings focused on fears that he had let his parishioners down. "I felt I left my people there and felt lost, a bit of guilt," he said.

Fr. Aleksandr has made his peace, though, serving in Zaporizhzhia, but is still eager to return to Melitopol. He said Zaporizhzhia "has become dear to me" and praises Sr. Lucia and the sisters for welcoming him. He now works in four parishes in the Zaporizhzhia area, but he feels it is a temporary dwelling. His two real homes, he said, are in heaven and in Melitopol.

Fr. Aleksandr shared that he has forgiven "the guys who pursued me, the Russians," but added that he feels sorry for the Russian people. Given the horrors he experienced, he believes, using biblical imagery, that they are possessed by demons and "led by the devil."

"I pray for them every day and pray for their conversion," he told me. "I try not to think about it, though I do feel a lot of pain and grievance. I do think about close friends of mine who have died. I have lots of pain, but no, I don't feel hatred for them."

That sense of hard-earned benevolence comes through in his work as a cleric. In addition to seeing Fr. Aleksandr work with Sr. Lucia

during our visit to the military triage center in Velykomykhajlivka, I had also seen him preside at Mass at the convent. He was centered, assured, and even happy. Fr. Aleksandr had escaped from a kind of hell—but being fortunate to have touched the light, had affirmed the promise of faith.

The Question of Peace

"Everyone Wants to Be Free"

I have covered enough humanitarian crises to know that absolutes of any kind—political ideologies, religious beliefs, the rigidity of entrenched positions—can be perilous. Life is too messy in crisis situations to easily conform to established ideological boundaries, and perhaps no more so than with issues of war and peace, when people's lived experiences can clash with aspirational ideals, like pacifism. Such ideals and the traditions they represent—while to be wholly admired—can seem naive in the face of something as tragic and egregious as an unnecessary war and outright naked aggression.

Here I acknowledge my debt to the thought of Reinhold Niebuhr, the mid-century American theologian and ethicist. In his later years, Niebuhr became a critic of the American-led war in Vietnam and was always keen to point out the perils of imperial hubris. But with the rise of Nazism and American involvement in World War II loomed in the early 1940s, Niebuhr argued forcefully against pacifism.

In his 1940 essay "Why the Christian Church Is Not Pacifist," he argued that "Christianity is a religion which measures the total dimension of human existence not only in terms of the final norm of human conduct, which is pressed in the law of love, but also in terms of the fact of sin. . . . It believes, in other words, that though Christ is the true norm ('The second Adam') for every man, every man is also in some way a crucifer of Christ."[*]

Put another way: "Christianity measures the full seriousness of sin as a permanent factor in human history."[†] Niebuhr added: "The good news of the gospel is not the law that we ought to love one another. The good news of the gospel is that there is a resource of divine mercy which is able to overcome a contradiction within our own souls, which we cannot ourselves overcome." Niebuhr said it was impossible for humans to achieve "the full measure of Christ. . . . In that sense Christ is the impossible possibility." Loyalty to Christ, Niebuhr argued, "means realization in intention but does not actually mean the full realization of the measure of Christ."[‡]

I admire Niebuhr's thought because I think it is realistic about the presence of tragedy and imperfection in human life—something I thought of repeatedly in my reporting experiences in Ukraine. For in fact, a visitor to Ukraine quickly learns that the issue of peace is not to be discussed glibly. Though clerics and sisters I met were open to a visitor's questions of how to end the war, and all reiterated the war's tragic toll and damage to the country, the possibility of a negotiated

[*] Reinhold Niebuhr, "Why the Christian Church Is Not Pacifist," *Christianity and Power Politics* (New York: Charles Scribner's Sons, 1940), 2.

[†] Ibid., 3.

[‡] Ibid.

settlement with Russia was always politely but firmly dismissed and rejected.

"That would be a compromise with evil," Dominican Fr. Petro Balog, who heads the Institute of Religious Sciences of St. Thomas Aquinas in Kyiv, told me in February 2023 in his book-lined office. "It's not Christian to compromise with evil."

Like other religious, Fr. Petro framed the situation in biblical terms: Ukraine's calvary, he told me, began with the February 2014 annexation of Crimea and the war in the Donbas region that began a few months later. Peace—which Balog compared to the resurrection—will be marked "when death is defeated, and the threat of death will linger as long as Putin's imperial and [Soviet-like] Russia exists." He added: "Our task is not an agreement with death, not a compromise, but to overcome it, and that is final. I think with God's help, it is possible."

Similarly, Sr. Veronika Yaniv of the Sisters Catechists of St. Anne told me in February 2023: "We can't be in peace until we have freedom. Everyone wants to be free. That will be our peace."

These beliefs reflect a resolve and determination that is evident even when shorn of religious language. When I covered the March 2023 meetings of the United Nations Commission on the Status of Women, a session on how Ukraine and Ukrainian women were faring a year after the full-scale invasion proved instructive. The mood in the room was by turns celebratory—a feeling of women's solidarity was palpable—but also, given the subject, a bit somber. Toward the end of the session, an American peace activist asked what Ukrainian women were doing to promote peace in Ukraine. It was a well-meaning question that in American peace circles was hardly a surprise—who does not support peace, after all? But in a room filled

with Ukrainian women, many of them in exile, it hit a nerve and caused some murmurs, because the question implied that that the responsibility for peace rested at least equally with Ukraine, and not just Russia. The assembled women responded much as I had heard back in Ukraine—that a "compromise peace" that accedes to even some of the Russian territorial gains would be no peace at all. Anna Olsen, a senior combat medic with the Ukrainian marines, and a former Ukrainian prisoner of war held in captivity by the Russians, declared, "Freedom is not free," and that Russian forces "are trying to break us as a nation." What is happening in Ukraine, she added, "is a fight for the whole world."

Notions like that can sometimes sound to an outsider like evocations from a different, less-cynical era. But the depth of earnest feeling expressed by Ukrainians cannot be understated—which is why Ukrainian Catholic clerics and sisters, no matter how horrified they are by the human cost of war, are committed to Ukrainian victory.

Sr. Anna Andrusiv, one of the youngest members of the congregation of the Sisters of the Order of St. Basil the Great, told me in Lviv that a peace that locks in Russian gains is not a true peace.

"Putin and Russia will not give us peace," she said. If they "give us two years of 'peace,' they will come back again."

Another member of her congregation based in Kyiv agreed. "From the first day, I have believed we will win and that it will be a victory for the whole world," said Sr. Yanuariya Isyk. "It's a fight with evil," she told me in a February 2023 interview. "And the truth will win out."

At the same time, though, the wages of war are never free of complexity, irony, or tragedy. While I came to agree fully with my hosts about the need for defending Ukraine, and the need to protect democratic values in the face of outright naked military

aggression, I always reserved some measure of caution—like the streak of nonbelief that animates my own religious faith. There is always the worry that this war—as any war—could end badly in its aftermath, with an authoritarian government emerging. I find no reason to doubt the commitment of President Zelensky to the cause of democratic institutions, and, to an outsider, Zelensky seems refreshingly free of hubris. But history tells us we have to approach political leaders—even the best ones—and their use of power with caution, weariness, and even suspicion. (As I completed work on this book, one of my interviewees in Ukraine told me by email of worries about Ukrainian government policies toward freedom of expression. "There is censorship in our country and I cannot write or tell much due to objective reasons," the interviewee said. "Only after the end of the war.")*

And then there is the issue of the waging of war itself: the Biden administration's July 2023 decision to provide Ukraine with cluster bombs, even as a temporary, stopgap measure, was understandable and maybe even justified. But it was a reminder of the brutal, ugly nature of war, and should leave even the supporters of Ukraine's war of self-defense, as it did me, anxious and uneasy. In a war, even solidarity and mercy are twined with tragedy.

But the sisters and clerics I met are all too aware of these complexities—they have spent time with soldiers and their families and know what the wages of war are like. Sr. Lucia told me that soldiers

* Martial law was imposed in Ukraine as the full-scale invasion began, and President Zelensky has postponed elections indefinitely, citing the pressures of the war. In early 2024, journalist Masha Gessen wrote a fair and comprehensive assessment of the challenges facing Ukrainian democracy for *The New Yorker*. See: Masha Gessen, "Ukraine's Democracy in Darkness," *New Yorker*, January 29, 2024, https://www.newyorker.com/magazine/2024/02/05/ukraines-democracy-in-darkness.

she has met are constantly grappling with the many layers involved in killing. "God says don't kill," they have told her. She told them that, yes, they are killing and must recognize and acknowledge that fact. But killing others who are invading one's country—"because you love your family, your land—this is not killing because you want to kill. You're killing people because they came to our lands." In this, Sr. Lucia and other sisters are providing spiritual comfort and guidance. Their support helps Ukrainian soldiers continue to fight for their land—a reminder that the sisters' work is crucial not only to humanitarian efforts but to the war effort as a whole.

Similarly, when asked about sin, Lucia told the soldiers, "Sin is something you do against God's will. However, if you love someone or protect them, and there is no other way to stop the enemy, you're not intentionally killing. You didn't choose such a thing, you were *forced* to do such a thing. If you're happy to kill them, that's one thing, but if you love your family and land, that's bigger than the hated of the enemy. Would these soldiers be the first to just kill Russians if there was no war? No."

In all things, Sr. Lucia said, an understanding of the many complexities is needed, as is a sense of humility—of what it means to be human in a tragic situation. In offering solace to soldiers, she must realize that "I'm not perfect as a sister, as a Christian, as a human being." She paused. "We are humans and right now, our pain is big." Sr. Lucia doesn't think God is judging Ukraine for fighting back against an invading force. At the same time, Sr. Lucia said, she is mindful of a larger meaning of what is happening. "I don't hate Putin or judge him. That's up to God, not me."

In saying this, Sr. Lucia is aware of the Church's teaching on war. In an online primer, the Justice and Peace Office of the Catholic

Church in Australia noted that the church "is emphatically for peace in all places and for all people, and has time and again advocated vocally for the prevention or cessation of war and supports the long tradition of pacifism in the church." But, it said, under certain circumstances, the church also believes that "war is morally permissible perhaps even necessary."

"Built on centuries of tradition and scholarship the Church uses the just war theory as the basis upon which it discerns the permissibility of a war and the morality of its conduct." The Church also believes, the primer said, that a state "has a right to defend itself, and its peoples, from an act of aggression, though the manner in which it does so will still need to be bound by certain principles." The conditions to wage war include just cause, meaning the right intention, legitimate authority, proportionality, and probability of success.

In the case of the Ukrainian context, what Sr. Lucia declared coincides with church teachings, as does the ministry she and others have offered for the Ukrainian soldiers who continue to fight for their country.

Sr. Lucia told me she discussed some of these complexities with a delegation of American and Japanese peace activists who visited Zaporizhzhia in 2023 to try to help diffuse the tense standoff at the nearby Zaporizhzhia nuclear power plant where Russian forces took control. While she welcomed the opportunity to meet with those with good intentions, the experience proved frustrating at times because the activists and Ukrainians were sometimes at cross purposes.

"I was honored to show them our reality," Sr. Lucia told me, but said she was taken aback when asked if there might be some advantage to Ukraine not fighting at all. She was uneasy with the

question because she and other Catholics would be targets of Russian aggression. She reiterated to them what she told me: that the soldiers were not fighting because they want to fight, but because "they are protecting their homes, their families, and their country."

Would it not be better, she was asked, if Ukraine had not responded to aggression in the hopes that the Russians might eventually leave? Put another way, the visitors asked, "Why were we fighting?"

"I was upset," Sr. Lucia said, "and said only people who don't understand us would ask that question." She added that she realized the group had virtuous aims but still asked the group members, "Would you be willing to give up your home in the face of aggression?"

The sister continued that it was difficult to convey the Ukrainian context to them and felt that, in their intentions to talk peace, the activists were in a way disrespecting Ukrainian reality. "I can free myself from hatreds, but they can't see what it's like to lose your family. . . . It's like a priest who wants to help soldiers and assures them of 'how brave they are.' But the soldiers rightly reply, 'Father, you're not one of us. You have to live like us.'"

While Sr. Lucia said she respects any Christian trying to adhere to the Gospel, and also respects the aspirational traditions of nonviolence, she is not sure the activists she met fully understood "what we're living through."

Encouraging People for the Cause of Peace

After returning home following my early 2024 assignment, I spoke to one of the visiting activists, lifelong Mennonite John Fairfield, the author of the book *The Healer Messiah*. He said the mission was an outgrowth of work by an international peace organization called

World Beyond War, "made up of people working to end war because they see the futility of war."

The tensions and threat posed by the Zaporizhzhia nuclear plant prompted activists to try to find people "who had relatives and friends in the occupied areas and who were still in communication with them and could perhaps form the basis of the beginning of a conversation about negotiation." In towns on both sides of the fence, Fairfield said, "There are people who would prefer the other side. There are, on the Ukrainian side of the front, some Ukrainians who would prefer a Russian takeover. And in the area under Russian control there are Ukrainian nationalists who would prefer that Ukraine be wholly victorious. Could we get people within those communities to begin to talk to each other?" He added: "At the moment, everybody's got their heads down, both sides. They don't want to talk. They're scared stiff of being labelled traitors. So, we were looking to encourage people."

Fairfield later told Sr. Lucia that the mission had effectively failed because communities on both sides of the conflict were extremely polarized. He and other activists were not able to identify those willing to take the risks of a conversation. Fairfield made clear he and the groups were not preaching reconciliation—that is something that would take generations—but rather preaching negotiation.

I told Fairfield of my numerous encounters with Ukrainian clergy, sisters, and laity who all said discussions of negotiation with an enemy who people cannot trust would be difficult now. He said he understood those impressions, but doubled down on negotiation. He firmly believed that "you don't negotiate with a friend, you negotiate with an enemy."

He added: "We were trying to find a way to start that negotiation through civil society. It's going to start. It's got to start. I mean, right

now, dancing in the streets would be better than what they're doing. The losses on both sides are horrible, as is the destruction of whole cities."

Fairfield resists the term "pacifist" because it sounds passive, and instead favors the term "nonviolent resistance" and that a nonviolent movement "needs to be able to demonstrate that it can deal with a totalitarian state from within, that the 'beloved community' knows how to defend itself, nonviolently, but effectively." And if that were the case, he said, Ukrainians would have some hope, and be able to dare winding down the war.

"The psychology of war," he told me, "and certainly the psychology of propaganda on both sides is to dehumanize the enemy so that you can kill them. We need to stop dehumanizing. To engage an enemy, we must believe in and respect the human in them, to inspire them to, in turn, accept us as humans."

Fairfield speculated on what would have happened had Ukrainians not engaged in armed resistance to the Russians. Russia would not have had to fire a shot, he told me. Yes, they would have "corrupted Ukrainian politics. They'd have gotten a leader or a government elected that was favorable to Russia. Ukrainians would not be free. They would live under leadership that was collaborating with the Russians." Fairfield's point was that it is difficult to negotiate with an incoming artillery round, whereas it is possible to negotiate with a collaborator. "I can awaken the humanity of a collaborator."

Fairfield acknowledged that many are reluctant to believe nonviolent resistance may be more effective than armed resistance. But he believes there is enough evidence to show that armed defense has failed again and again at defending communities. "Nonviolent engagement doesn't have to be a hundred percent effective," he

said. "It just has to be more effective than armed engagement. It's a low bar."

I asked Fairfield about the armed defense of the capital of Kyiv, which *did* work and *was* effective. Fairfield said he is not suggesting that that armed engagement never works. "It certainly does, sometimes," he told me. "I'm sure that there are cases where armed engagement would work and nonviolent engagement would not. But the success rate of armed resistance is abysmal. Nonviolent engagement is more effective, on average, in the long run, than violent engagement."

I mentioned what sisters like Sr. Lucia and others had told me—that giving Russia the territory it had captured since 2014 would be acquiescing to evil. He responded: "If there's a dog chomping up your leg, all you can think of is *Get it off, get it off, get it off.* So I have every sympathy with their fear and their reaction," Fairfield acknowledged. "I mean, that's a very normal human reaction. Of course, they have a right to defend themselves. It's not a matter of right. We're not talking right here, we're talking which is more effective? To me, it's not even a matter of morality. It's a matter of being effective."

Fairfield spoke of an observation I had in covering Ukraine: That once war begins—"as bullets fly," he said—nations "settle into a war culture, an insane mindset of mutual slaughter that goes on and on," Fairfield argued. Once that logic sets in, he said it is "really hard to pull out of it, but the cost of it eventually wears people down. It is as if nothing will break us out of that, save the blood loss. And at the end, we finally stagger towards what we should have done all along. Negotiation. So yes, I have every sympathy with the situation. It's a very human situation. We just need to learn to be more effective."

Fairfield took an even broader and expansive view of this all, saying that humans are finite, and that "even when we dance together, we step

on each other's toes. We're offenders, we offend each other. And that's part of being human. You've got a point of view, you've got a history, you've got a past, you've got an identity. And it rubs the wrong way against other people's perspectives and identities." As a result, he said, it is important to create "healthy societies"—societies in which offense does not lead to violence, but rather leads to increased engagement with each other.

"Health is life together in tension," he said. "The attempt to muddle through together is wiser than any ideology."

Through this lens, Fairfield said, a Christian perspective would say that Jesus is a healer messiah—"not a messiah on the order of David, who was a warrior messiah. Jesus himself was confronted and castigated for accepting the hospitality of collaborators with the Roman occupation—the tax collectors, the prostitutes. That was a phrase that referred perhaps to the sexual kind, but most emphatically to the political kind. He accepted their hospitality. And in so doing, he called them to account."

Fairfield said the difficult business of negotiating with each other is never easy. It is costly on both sides. "But we have to accept that," he told me. "We'd be so much better off if we could accept the cost of working through relationships now rather than waiting until people start shooting each other."

Fairfield concluded by citing the Apostle Paul, who in Romans 12:20–21 said that "if your enemies are hungry, feed them; if they are thirsty, give them something to drink, for by doing this you will heap burning coals on their heads. Do not be overcome by evil, but overcome evil with good." That story "tells us to ignite the fire of the Holy Spirit in our enemies," Fairfield argued.

"It is an attempt to heal the enemy into their true self, which is an embodiment, an incarnation of the spirit of God. And what

is God's spirit like? Throughout the entire Bible, God is trying to create a relationship with God's offenders, God is trying to create a covenant, a marriage with Israel who has offended and is offending and will offend. That's the spirit of God. God accepts us while we are yet offenders."

That insight deserves reflection. John Fairfield's thoughtful, earnest, and faithful arguments as an American adherent of nonviolence cannot be dismissed. They remind us all of the perils of war and a resulting culture of violence that can poison everything it touches. We should always be on guard about such perils. But at the same time, I came pretty quickly to agree with the arguments of Sr. Lucia and the other Ukrainians I met because they stem from a particular Ukrainian position and experience—of a people facing an aggressor waging an unjustified war. Moreover, I agree with Reinhold Niebuhr that part of being human, and part of being a Christian, is to face and respond to evil in ways that we may not necessarily like or embrace outside the context of war. The Ukrainians I met knew this in their bones.

Survival, Tyranny, and the Power of Identity

From the start, the full-scale invasion became a global crisis, with President Putin threatening that their interference in the war would "lead you to such consequences that you have never encountered in your history." He was speaking, of course, about the threat of a nuclear event of some sort—perhaps all-out war or using a tactical nuclear weapon on the Ukraine battlefield. Though neither have materialized in the two years since the invasion, the threat has never disappeared and has spurred new concerns about the need for nuclear disarmament—something of great concern to disarmament advocates,

including Catholic sisters whose advocacy work is based at the United Nations in New York.

One of them is Sr. Kathleen Kanet, a longtime peace and justice educator, a member of the Religious of the Sacred Heart of Mary and one of several sisters who attended a September 12, 2022, prayer service at Holy Family Catholic Church near the United Nations the day before the start of the UN's 77th General Assembly.

The prayer service focused on the nuclear issue—and for good reason. The tensions between Russia and the United States had worsened, and in Ukraine, there were worries about Russian control of the Zaporizhzhia Nuclear Power Plant.

Advocates like Sr. Kathleen had prominent allies. At the prayer service, Archbishop John Wester of Santa Fe, New Mexico, the author of a pastoral letter on nuclear disarmament, said, "If we care about humanity, if we care about our planet, if we care about the God of peace and human conscience, then we must start a public conservation on these urgent questions and find a new path toward nuclear disarmament." And earlier, UN secretary-general António Guterres, who spoke in August during ceremonies marking the seventy-seventh anniversary of the atomic bombing in Hiroshima, Japan, called for nuclear disarmament in the wake of the Russian American tensions. "Take the nuclear option off the table—for good," Guterres said. "It's time to proliferate peace."

With Russian advances in the war, and with Putin making fewer threats about nuclear war, some of those tensions had decreased by 2024—though such tensions are never fully eased, with Sr. Kathleen continuing her advocacy against ever-present nuclear threats. "I think the question about the possible use of it is very relevant, and the dangers of it are even more horrid than, of course, what had happened

in Hiroshima and Nagasaki way back in 1945," she said. "So yes, I think it's relevant and the threat is there, and we have to deal with it."

When I returned to New York after my 2024 assignment, I asked Sr. Kathleen how she views the Russo-Ukrainian conflict. She said there is a moral claim for supporting the Zelensky government. But she added it would be good to hear more about any negotiations "that are going on because there has to be people who are trying to negotiate the ceasefire, trying to stop the terrible violence." There is also "a hopelessness in continuing to create and send weapons"—in other words, US support for the war "is only helping arms manufacturers."

I asked Sr. Kathleen about the core belief I heard repeated and repeated in Ukraine: that the Ukrainian response to the Russian invasion is justified as a response to evil. Though making clear that she is not an expert on the current conflict, Sr. Kathleen asked, "Does it have to be as violent as it is? And if the focus is on belief that the weapons are going to be the answer, then I say weapons are not the answer. I am totally committed to nonviolence." The idea that armed violence is the only answer, she said, goes against ongoing ideas "toward nonviolence and of alternative ways of confronting reality and of making changes is a field that's growing and it exists. . . . How do we change the thinking process of enough of us to say that this is not the answer?"

Respecting her dedication to nonviolence, I asked Sr. Kathleen how, as a peace activist, she would frame the current conflict. Like John Fairfield, she said that she always looks for the chances for dialogue: "Any activity that gives me energy is when I participate or share or see or celebrate when people who are in conflict with one another, countries that are in conflict for one another are focusing on how can we be human beings together with this danger before

us. It's growing. I think that the nonviolent movement is growing. I hope that we have enough time." She added: "More and more people understand that violence is not the way, and that violence leads to more violence."

I repeated my observation that the Ukrainians I met feel that dialogue with Putin and the Russian government was simply not possible now—and possibly ever.

"I would guess I would disagree with that," Sr. Kathleen told me. "Isn't there always hope until the last moment? I mean, I pray for Putin every day. You're not a lost cause until you die."

Does the idea of a lost cause also apply to the need for forgiveness? We know it can take generations to heal from the wounds of war, and though they are on opposite sides of many questions, Fairfield and Sr. Lucia agree that any thought about forgiveness now is too soon for most people, as is any idea of reconciliation.

When I drove back with Fr. Aleksandr and Sr. Lucia from the triage center near the front during my early 2024 assignment—which began this book—Sr. Lucia mentioned Petrova and Diakova, the two women we had met in the convent. Both said they simply could not forgive the Russians for what they had done to their communities—and indeed their lives.

"Forgiveness is a process," Sr. Lucia said. "The women we met are not bad people but because of the pain they have experienced, it is hard for them to forgive right now."

She paused. "The work continues—we can start thinking of forgiveness when the bad things are over, when the war is finished—but now you have to collect your thoughts for protection—forgiveness is for later on and we will think of how to free our heads from hatred later on."

Sr. Lucia later told me she had thought more about this and said that Petrova and Diakova were to be commended for at least considering the problem and asking the question of whether it is right to simply not speak of forgiveness at all. "We are in solidarity with them," she said. "If you know the person, you can ask them to go towards a deeper life with God. We know God doesn't love hatred, and we know those hatreds can confine us like a prison. Maybe someday we can leave that prison. But now we just need the energy to survive."

Questions of Ukrainian survival always engaged two observers whose judgment I trust: former US Rep. David Bonior and Fr. Peter Daly, both of whom visited Ukraine in 2023 and have a passionate interest in the country. David is a board member of *National Catholic Reporter,* and Peter is an *NCR* contributor.

When I interviewed them after returning from my February 2024 assignment, the two men said they were concerned about the unfolding situation and even of Ukrainians losing heart given the challenges the country faced. Peter told a story of a Ukrainian American college student he met while holding Mass in Washington, DC—part of a group participating in a volunteer service week.

"He was saying, it is time for peace in Ukraine," with perhaps the east being ceded to Russia and the west remaining Ukrainian. But the student also pointed out that his mother, a Russian speaker and a barber in a Russian-speaking community in New Jersey, refuses to cut the hair of anybody who supports Putin. In a way, the mother and son's positions crystallized the current situation—people tired of war and yet also resolved to win it.

"They've had a tough year," David said of the Ukrainians, noting they had been let down by the United States and to some extent the European Union, though he felt that ultimately American aid would be forthcoming—and it was, in April 2024—even though to some extent "the rules of the game have been stacked against them." But, David added, "one thing Ukrainians are very good at is being resilient—ask the Russians, and they'll tell you that, ask the Hapsburgs, they'll tell you that, too. They're very resilient and they're tough and they're smart. And the younger Ukrainians, at least in our last visit there, showed a lot of desire to stand with their president in this battle to save their country." He said a passage from Galatians 6:9 is apt here: "And let us not grow weary while doing good, for in due season we shall reap if we do not lose heart."

"So, I am not pessimistic. I mean, I couldn't do this if I didn't have any hope," he said of his Ukrainian advocacy work. "You've got to have some sense that things are going to get better, and you're going to work toward making it better. And I think that's how a lot of Ukrainians feel as well. And since I'm part Ukrainian, I guess I inherited something along the way."

Peter agreed, saying that the Ukrainians "are dedicated to this fight" and that after disasters like US support for governments in Afghanistan, as well as Vietnam and Iraq, "Ukrainians are the dream partner that the United States could have. These are the people who really do want to do the fighting, they want to do the training, they share our goals, and they have identified the enemy as Russia. I think we're crazy if we don't support them. Now we finally have a good partner who actually wants to do similar policy objectives from an American standpoint."

But beyond that, he said, from a "Christian standpoint," the United States cannot abandon people "to their destruction." He added: "This

is a survival war. This is about whether the country will exist or not in the future for a hundred years into the future."

I told my colleagues about my discussions with Sr. Lucia and John Fairfield and asked whether both men—David, as a former congressman known for being more of a dove than hawk, and Peter as a Catholic priest—continued to believe that the Ukrainian response was just and whether US support for Ukraine was just.

Peter said that, from the Ukrainian standpoint, it has been "a just war in its inception," but also because the cause is self-defense. "We don't deny that to people on a personal level to defend yourself if you're assaulted. And we don't deny that to countries. And I think that if anybody doesn't see Russia as the aggressor, they're not looking at the facts." He said arguments from the American left and by some prominent political scientists like John Mearsheimer at the University of Chicago that Russian aggression was provoked by NATO expansion were "ridiculous."

Peter told a telling anecdote as to why. He recalled years ago, in the 1990s, while visiting a US diplomat friend in Romania that Romanians told Peter that Romania actually sought NATO bases on their territory because they did not want Romania to be under the dominance of Russia again. Eventually, Peter said, Romania was accepted into NATO almost immediately. "These are autonomous countries, these are independent countries," Peter said, "and they're determined that they're not going to be subservient to the Soviet or the Russian boot again."

In other words, this was not strategic expansion by the United States, but something sought internally by the countries themselves. "Every country that is a member of NATO had to be approved by every member of NATO and by their own parliaments, by their own

decision," Peter told me. "They had to petition for membership. And some of them had to wait for years, but they all want to be in it."

As someone who graduated from college in the early 1980s and who was leery of Cold War militancy by both the United States (in Central America) and the Soviet Union (in Afghanistan), I had instinctively believed in a foreign policy that was moderate and eschewed intervention. Yet, as I thought about the understandable response of Ukrainians to possibly joining NATO, given 10 years of war waged on Ukrainian soil by Russia, I better understand Peter's anecdote—an anecdote that I believe would not have surprised Sr. Lucia and other Ukrainians.

Nor would they have been surprised by Peter's view that the response from the Ukrainian side had been just because "the Ukrainians have been proportional in their responses. They have not attacked civilian targets. They've attacked military targets within Russia, but that's a legitimate target. They have not engaged in the kind of wholesale destruction of cities that the Russians have done in places like Mariupol," he said, believing Ukraine's response has been proportional"—a cornerstone of the just war theory.

Peter noted that in just war theory, "you're not allowed in a just war to do acts, which will live on after the war"—which, of course, means the use of nuclear weapons. "They're not going to irradiate some area of Russia, but it might be the other way around." On the issue of territory, he said that under international law, Ukrainians have a right to declare "that this is our territory, and we are not going to give it away." Peter added: "Ukraine has conducted itself morally up to this point. And it has every right to insist on a resolution of this war, which will be a just resolution, which is to retain its territory."

David agreed, saying while "you have to differentiate in war." Ukrainians have adhered justifiably "to defending themselves. Absolutely." And with virtually no navy nor air force for that matter, "the Ukrainians have fought the Russians to basically a draw, actually getting some of their own territory back. . . . That's how committed they are."

Peter noted something I had long thought: that even if there was some kind of peaceful resolution to the conflict—if there is an unjust resolution, if Ukraine is asked to sacrifice, say 20 percent of its territory—it might resemble the Versailles Treaty after World War I. It could be unstable.

"There won't really be peace," Peter speculated. "There will be a truce between the warring parties—but people will come to resent the Russian presence." He added that Russia may not stop at Ukraine—that Putin has said he wants Transnistria, a disputed area in Moldova. Given that, "can you imagine a Russian occupation of Ukraine, which is a huge country with all of this hostile people around him?" It would end up, he said, with a similar situation the United States faced in Iraq or Vietnam, or for that matter what both the Soviet Union and the United States faced in Afghanistan.

David said from a strategic standpoint the Russian-led invasion had also been a failure—Putin has now helped expand NATO with the addition of Finland and Sweden. "And it's been a failure in terms of the loss of lives," he added, noting they have incurred 350,000 deaths, casualties, and wounded, and that's what they started the war with. "It's an incredible story when you think about that. Those numbers are just so grotesque. And you understand why 300,000 Russians decided to hit the road and go to Kazakhstan and other places."

Peter picked up on the theme of the NATO expanding to Finland and Sweden, saying the two countries would not have joined NATO had it not been for the Russian invasion. "And I think there's no doubt among the people in the Baltic states that they would've been invaded too had they not been members of NATO. I mean, what is little Estonia going to do against Russia? It wouldn't survive."

David said, "The experience of the Soviet Union and its satellite states was pretty gruesome, rough, and horrific for a lot of people. And of course it was for the church. We know that, and nobody wants to go back to that. The opportunity to get up from underneath the boot for the Ukrainians who have been colonized by the Russians and the Soviets for hundreds of years, it's significant. And so that's the side to be on."

Peter added, "We all want to be on the side of peace." He was an opponent of the war in Vietnam, and the second Iraq war. He opposed the United States going into Afghanistan "other than to go after Bin Laden." But in Ukraine, he said a hope that a truce or acceding to Russian demands would not guarantee peace. "Even if there was a truce, I don't think there would be peace."

The Question of the Pope, Ukraine, and Peace

No discussion about the complex dynamics of peace can be completed without some mention of Pope Francis, who condemned the full-scale invasion from the start and has shown empathy for the war's victims. But he has also made statements about peace that, among Ukrainians, are often seen as murky or ambiguous. I am an admirer of Francis—with caveats—but I understand why, even Catholics share some dissatisfaction with the pope. In my travels, I broached

the subject carefully, and the response from Ukrainian clerics and sisters was always cautious—at the very least, they said that Francis did not appear to understand the Ukrainian context.

When I spoke to David and Peter upon my return, they both said they agreed with Ukrainian discontent on this issue, which became more public in March 2024, when, in an interview, Francis spoke of the possible need for peace talks between Russia and Ukraine. He said, "I think that the strongest one is the one who looks at the situation, thinks about the people and has the courage of the white flag, and negotiates." The white flag image was a particular hurdle—the Vatican later said it was meant to suggest negotiations, not a Ukrainian surrender.

But the imagery prompted David, who has largely supported Francis's pontificate, to say that he was both disappointed and "taken aback but not surprised" by the remarks. As he explained, he believes that the pontiff has "never really been that strong of supporter of Ukraine, although he has, when he's been challenged, backtracked, and become stronger. But something isn't there, and it's really troublesome."

Peter, who is also largely supportive of Francis, said that what was particularly troubling, was that the pontiff did not seem to fully appreciate the Catholic tradition within Ukraine that "almost 400 years ago decided to come back to Rome." According to Peter, the Ukrainian Greek Catholic Church "is the heir to that decision" and a way to separate themselves from Moscow. "Peter added that it is not likely that the late John Paul II "would have made that mistake." He noted: "I think he would've understood almost instinctively, because obviously he grew up just a few miles away."

The Ukrainian Greek Catholic Church reacted to Francis's remarks in several ways. Church officials pointed out that Francis spoke both

of the war in Ukraine and the Israel-Gaza conflict, and noted that, as a rule, globally, "Pope Francis calls for negotiated settlements of armed conflicts."

Even so, the synod said it would not reflect directly on the pope's statement but did say that it was important "to understand the position of most Ukrainians," a people it said in a statement "were wounded yet unbroken, tired yet resilient."

The statement was pointed: "Ukrainians cannot surrender because surrender means death." It means death because Ukrainian identity is at stake. "In Putin's mind," the statement said, "there is no such thing as Ukraine, Ukrainian history, language, and independent Ukrainian church life. All matters Ukrainian are ideological constructs, fit to be eradicated. Ukraine is not a reality but a mere 'ideology'"—and ideology that the statement noted is cloaked with the false description of Nazism. And by doing that, Putin has dehumanized Ukrainians. He has done exactly what the Nazis did—saying that Ukrainians "have no right to exist" and so need to be "annihilated, killed." The war crimes committed by the Russians, the statement said, in locales like Bucha, Irpin, Borodyanka, Izium "have illustrated for Ukrainians (and to all people of goodwill) the clear purpose of this war: to eliminate Ukraine and Ukrainians." And, there is a religious component, too: Every Russian occupation of Ukrainian territory "leads to the eradication of the Ukrainian Catholic Church, any independent Ukrainian Orthodox Church, and to the suppression of other religions and all institutions and cultural expressions that do not support Russian hegemony."

Is it any surprise, then, that "Ukrainians will continue to defend themselves. They feel they have no choice." The statement went on to say that in the past quarter century, "that with Putin there will be no

true negotiations." It noted that Ukraine negotiated away its nuclear arsenal in 1994, at the time the third largest in the world. "In return, Ukraine received security guarantees regarding its territorial integrity (including Crimea) and independence, which Putin was obliged to respect." He did not. A 1994 memorandum signed by Russia, the United Stares, and the United Kingdom "is not worth the paper on which it was written. So it will be with any agreement negotiated with Putin's Russia." Given this history, the statement said, and notwithstanding "the suggestions for need for negotiations coming from representatives of different countries, including the Holy Father himself, Ukrainians will continue to defend freedom and dignity to achieve a peace that is just. They believe in freedom and God-given human dignity. They believe in truth, God's truth. They are convinced that God's truth will prevail."

This was a formal crystallization of everything I had heard on the ground in my two years of reporting on Ukraine, and it was further amplified later in 2024. Archbishop Borys Gudziak, one of the signatories of the statement, has emphasized that Pope Francis has spoken out in defense of Ukraine as a victim repeatedly—in fact, more than 300 times. No global leader has spoken so often about Ukraine's torment, he said. It is important that the pope's constant advocacy for the "tortured people of Ukraine" is heard in the global south where Ukrainian voices are rarely heard. But, he said, "a few of the Holy Father's expressions have been ambiguous." He told my *National Catholic Reporter* colleagues Joshua J. McElwee and Christopher White in a March 19, 2024, podcast that the pontiff's "white flag" remarks were "very problematic," and that Ukrainians "were really knocked off balance" by them.

Archbishop Borys said he believes "the Holy Father really cares for the people of Ukraine, and he cares for the suffering people of the

world." But he said that on this occasion Francis's choice of words "was very unfortunate," continuing, that for Ukrainians, "Negotiating with Russia and [President] Putin today is a no-go," adding that Ukrainians had tried negotiations before the full-scale invasion but see the Russian president as "a relentless killer."

"Ukrainians are convinced that he is a disingenuous and completely unreliable interlocutor in negotiations. He has lied at every step of the way. Observers from afar are often hoodwinked. Those who have endured tragic experiences have clarity about Putin and historical and contemporary Russian imperialism," he told me.

"I think even the Holy Father has difficulty understanding who the world is dealing with, who Ukraine is dealing with," Archbishop Borys said. "For Ukrainians, Putin's explicit words and heinous actions leave no ambiguities."

Even those aligned with activist movements in Ukraine and who do not identify with the Church in Ukraine have spoken similarly. Tamara Zlobina, head of the feminist activist group Gender in Detail, has asked why it is so difficult for the West to understand the Ukrainian context. In a December 2023 reflection, Zlobina argued that peace is only possible based on a sense of justice for Ukrainians—and that a lesson from Ukraine to the world is that "peace and democracy are not a given, but a result of political action."* The absence of war, she argued, "does not necessarily equate to peace," and that concrete, active measures are needed to protect those harmed by the Russian invasion and to establish justice for the afflicted.

* Tamara Zlobina, "Peace Is Only Possible Based on Justice," *New Eastern Europe*, December 7, 2023, https://neweasterneurope.eu/2023/12/07/peace-is-only-possible-based -on-justice/.

Zlobina writes that she did not sense such understanding from the West in early 2022. Instead she saw abstract, amorphous statements such as "'We are against war, both sides should stop,' and 'A bad peace is better than a good war.'" From such well-meaning slogans, Zlobina said, "demands emerged not to provide weapons to Ukraine because, supposedly, weapons would escalate the conflict." This position, she writes, "caused irreparable harm to the people in Ukraine." Ukrainians, she said, "had to spend months convincing other countries of their right to self-defense, begging and waiting for the weapons needed for self-defense." This led to "deaths, the capture of significant territories, and terror against the occupied population," she argued.

Abstract pacifism in the West "surprised and saddened everyone in Ukraine," Zlobina wrote, adding that a war initiated "by an aggressive invader will not stop because of a beautiful slogan on a poster. Just like in the case of a criminal who attacks with the intent to rob in the street, a polite remark like 'Excuse me, sir, but I believe you are doing something wrong,' will not stop the robbery."

Zlobina said she recognizes that in today's media-driven world, "public sentiment, which influences the actions of politicians, is highly dependent on media images. War photos are horrifying, and there may be a temptation to say that anything is better than this." Yet, she said, context is all important—context that takes into account the lived experiences of real human beings. Zlobina recalled overhearing a conversation between strangers who asked, "if Ukraine really wanted peace, it should give the occupied territories to Russia."

She reflected: "However, the territories are not just empty land; they are inhabited by people"—something we know from the testimonies of those I spoke to about their experiences under Russian occupation. "What is happening to these people under occupation is

horrifying. Structural violence is much less visible than a bombed-out building," Zlobina said. "Incidents of rape, torture, abductions, forced erasure of identity, child abductions, and lawlessness are rampant on the occupied territories."

Put another way, she argued elsewhere, peace does not come *after* war. Peace comes after one of the parties has won the war. And *who* wins the war—be it Ukraine or Russia—is critical.

In this, as well as in the statements of the Ukrainian Catholic bishops, I once again hear echoes of Reinhold Niebuhr's thought. Niebuhr acknowledged that the taking of human life is a "terrible thing" and that the "conflict between man and man and nation and nation is tragic." But he said, in words that seem particularly applicable to Ukraine: "Tyranny is not war," Niebuhr argued. "It is peace, but it is a peace which has nothing to do with the peace of the Kingdom of God. It is a peace which results from one will establishing a complete dominion over other wills and reducing them to acquiescence."*

Ukrainians of varying backgrounds know something of the hard, embittering realities of acquiescence and political power and force by an outside power—which is why their resistance has been so strong, so deep, and so heartfelt.

* Niebuhr, "Why the Christian Church Is Not Pacifist," 16.

Blue Skies and a Yellow Sun

The Future of Ukraine

After leaving Zaporizhzhia, I spent a week in Kyiv interviewing several of those I had seen the year before, and they reflected on what had been, by nearly all accounts, a challenging year for Ukraine. The counteroffensive had stalled, and Russia had made steady military advances. President Zelensky's government faced new challenges and was under fire for, among other things, charges of corruption but also complaints of how the war was being conducted. And many expressed anxiety about US political realities: despite pleas from President Joe Biden (and President Zelensky), the Republican-led US House of Representatives resisted providing more military aid to Ukraine, taking their cues from presumptive Republican nominee Donald Trump. (Eventually, though, the aid package was approved.) In short, the hope still prevalent in early 2023 that Ukraine could defeat the Russian forces and even recapture the 1991 borders it shared with Russia after the fall of the Soviet Union were tempered, even dashed.

Ukrainians recognized that, despite an initial poor showing by Russia in early 2022, the Russian military remained a formidable and powerful force.

"It's been a difficult year," reflected Dominican Fr. Petro Balog, who heads the Institute of Religious Sciences of St. Thomas Aquinas in Kyiv, the Catholic think tank I had visited a year earlier. "I think many people—not all, but many—are feeling pessimistic right now." Fr. Petro said he still believes "in miracles" and thinks ultimately Ukraine will prevail against Russian domination—though it may take years. But he acknowledged things looked far more optimistic at the start of 2023. "A year ago we believed we'd be victorious after three months and that we'd be in Crimea."

The first thing Fr. Petro mentioned to me was the wide-spread worry about former President Trump and Ukrainian puzzlement as to why the Republican Party—which had once been so fiercely opposed to the Soviet Union—had so swiftly changed course on viewing Russia as a threat. (I agreed with him, saying it was confounding.) He said without Western support, Ukraine's defenses would, in all likelihood, collapse within a few months. He struck a philosophical, if fatalistic, tone: "It's all in the hands of God." He repeated what he said earlier—that history had shown that Russia could not be trusted with peace agreements—and cited a 1994 memorandum between Russia and Ukraine that he said simply became a piece of paper for Russia. But he still felt that, at its core, Ukrainian resolve remained strong.

"We can't imagine a future without victory," he told me. That is because, given the evidence of Russia's actions since 2014, Ukrainians worry about the potential for "a new kind of genocide," Fr. Petro said. This is based on fears of Russia wanting to eliminate Ukrainian

culture and language. "After victory, Russia will still exist, and Russia will still be our neighbor. It still has imperialistic ideas."

Still, there were also the internal problems: Growing complaints about government corruption were a worry, as was confusion about the government changing military leadership and tactics. Fr. Petro said while President Zelensky still had a significant percentage of the population behind him, he wondered if the president's daily appearances on YouTube promising victory were becoming tiring. Fr. Petro also wondered if Putin had "read" Zelensky better than people realized, thinking the former comic and actor was an untested figure, making it easier to eventually launch a full-scale invasion of Ukraine. "I think it was a mistake to elect an actor as president," Fr. Petro told me. "I knew after the 2019 election war was coming. He [Zelensky] had no political experience. He was naive, and Putin knew it."

I asked about the Church's humanitarian response in the last two years. Fr. Petro said the Church had done well, fulfilling its humanitarian mission and ministries in numerous efforts. He added that such efforts would have to continue into the future, given the support that will be needed to deal with the trauma of separated families. "Families are in crisis," with so many women abroad and men remaining in Ukraine, he noted—and returning soldiers will be needing assistance, too. He also hopes a new nation—and one that belongs to the EU (and possibly NATO)—will emerge. "We must become a new society," he said, "not the old one of (Soviet-style) corruption."

What about the theological significance of the war? Fr. Petro criticized something said by some Ukrainian Protestants that the war represented the "wrath of God" against Ukraine because of perceived past sins. Fr. Petro finds that comparison too rooted in a wrathful

Old Testament God and instead finds hope in the image of a New Testament God, comparing Ukrainians to the body of Christ—the Christ who was crucified and then resurrected.

"I'm sometimes asked where was God in Bucha?" Fr. Petro said, alluding to the site of Russian war crimes against Ukrainian civilians. "I say God was there with us on the cross. He is a suffering God, a god who suffers with the people, for people, and from people, and then is resurrected."

"This war has put a huge hole in everybody's hearts," said Sr. Yanuariya Isyk, the St. Basil sister I saw on my last day in the Kyiv, in the small but cheerful apartment that continued to serve as an urban monastery. As she had done the year before, Sr. Yanuariya served me homemade sweets and tea and seemed eager to reconnect. Like Fr. Petro, she acknowledged many of the same problems the past year posed—the military stalemate, changes in the military leadership, corruption—and said that "people are disappointed," though remained committed to a peace based on a return of the country's former borders.

"We'll never give up; after ten years of the first invasion and two years after the second, we remember everything"—a reference to the Soviet era. "We still remember that."

As for her own ministry, Sr. Yanuariya continued her work in coordinating volunteer-led efforts to send supplies to soldiers and to children living near the front lines in eastern Ukraine. But she worried that the country may be losing sight of its spiritual bearings as the war dragged on. Sr. Yanuariya said people were more "deeply prayerful" in the first year of the war. She is disappointed that that

discipline seems to be waning among many Ukrainians. Sr. Yanuariya has observed less interest in a prayer group she leads, with attendance down. "I wish people would come back to God," she said.

Yet, in saying that, Sr. Yanuariya acknowledged that she and others remain committed to humanitarian work and hope to continue it with the future in mind—a future that all hope will be brighter and more secure than it is now.

Feminism, Faith, and the Ukrainian Fight

Some are already taking that initiative but also asking questions about what a postwar Ukraine might look like—and where it fits into a world still dominated by large countries like the United States, Russia, China, and India. One of those is Nina Potarska, 40, the Ukraine national coordinator for the Women's International League for Peace and Freedom. In the past two years she has lived in the Czech Republic, Poland, and Canada. She was one of the speakers at the United Nations Commission on the Status of Women (CSW) in March 2024, leading a session on Ukraine's future, which I attended.

In an interview following the two weeks of meetings, Nina told me of some of the frustrations she and other Ukrainian feminists face right now—caught between different visions and different worlds. On the one hand, Nina is mindful of global solidarity with other feminists who oppose war and are suspicious of bodies like NATO, which, they believe, are part of structures that can escalate war.

"It's a big challenge because on the one hand we understand that we are living in a global world with the global rules, with the security system, which involves a big fight between different countries and empires"—in this case the United States and Russia.

At the same time, Nina said Ukrainians have to ask, "Where is a place for our country?"—a country that has a right to resist a Russian invasion but is also caught in a bind because of the threat of a possible nuclear war—what Nina calls the nuclear paradox.

"I'm from Ukraine, and I'm Ukrainian, and I would like to save my space and save the people who are living around me," she said. "I have a right to resist my space and resist my existence because I don't want to live under the Russia occupation."

And yet, Nina worries about the current dynamics of dependence on assistance from Western partners "who are feeding us with a small spoon. And after two years, it's clear that nobody is going to die for Ukraine except Ukrainians," she said. As a result, Nina said she and other Ukrainian feminists have to "continue discussion with the American, Canadian, and some European feminists who are against the war," and try to find some "common ground and be able to hear each other."

That is one set of challenges. Another is how to affirm a feminist vision of a reconstructed Ukraine—how to help a country with an exhausted population and needing a boost in education, health, and social care systems and the like.

What this all means is that Ukraine looks toward eventual reconstruction. "We just need [to try] to convince everybody that we need to pay attention to maintain our social infrastructure system and social care system because it's a main thing for women and feminists, a way to support ourselves and renew and rebuild our society from inside," Nina said. In other words, a kind of "feminist peace" in which women have an active role in politics and decisions about economic policies—policies that reject neo-liberal models and "are more focused on the human being and the human needs and human security."

Like others who spoke at CSW, Nina said Ukraine is dealing with a multitude of narratives right now—one is that all Ukrainians have had to endure a lot in the war, making people resilient. But that narrative about resilience somewhat overlooks the challenges that women had to face *before* the war—and women in rural areas in particular, who often don't have immediate access to medical facilities, for example. "All of these challenges just multiplied with the 'war effect,'" she said, noting that women have had to keep working, care for households, and care for children, many of whom are now studying online.

"It's difficult, especially for small kids studying online. It's impossible. You need to tutor your kids; at the same time, you have to organize everything at the home. I mean buying food, taking care of other stuff. And sometimes it's taking more than ten hours, twelve hours per day. It is exhausting labor."

The pressure on women is just one kind of challenge. There are others—and some in society are working to heal the many wounds caused by the war.

In Kyiv, Healing the Wounds of the Wounded

Mykola Vouchenko, a therapist and psychologist, heads a Kyiv-based organization that helps returning veterans with PTSD and makes the adjustment to civilian life. He said that such work will expand in coming years with greater number of veterans returning to their former lives. He further noted that Ukrainian society has a chance "to build a better country" by welcoming former combatants "back from hell" and create an atmosphere so that they can become well-adjusted citizens.

"The soldier's part of the contract was to protect the country," he said. "Our part of the contract, the second part, is to help them with their transformation to become people of wisdom."

In doing that, he said, veterans can "help us create a great, great country."

Similarly, Sr. Anna Andrusiv, whose ministry as a Sister of the Order of St. Basil the Great moved in 2023 from the western city of Lviv to the capital of Kyiv, noted that her congregation recently purchased a three-story residence in northwest Kyiv in hopes of turning it into a monastery for the sisters but also a rehabilitation center for wounded soldiers and their families, especially children. It will be open to all seeking spiritual solace. "We already know there is a need for this for everyone suffering trauma," she said.

That is a large swath of the country, said Tetiana Stawnychy of Caritas, who cited a United Nations report noting that as many as 15 million, or roughly 40 percent of Ukrainians, still need some kind of humanitarian assistance. Those most affected, of course, are those who were vulnerable before the full-scale invasion began. While "everyone is carrying the consequence of the war on different levels," she told me during a February 17, 2024, Zoom interview, those who were vulnerable most before have borne the brunt of the tragedy:

> [I]t is usually elderly, it's usually people with somebody in the family with disability, it's single mothers with children. There were a lot of cases where people didn't move because they had someone who was bedridden in the home, and they just didn't see how they could possibly go anywhere.[*]

* Interview with Tetiana Stawnychy, February 17, 2024.

Tetiana recalled a project Caritas initiated in providing modular homes to those whose houses had been totally destroyed—those who had "no hope of rebuilding that home or fixing it. Rather than trying to get them to move somewhere, she said, if they have a plot of land where they already have access to water and electricity and maybe sometimes gas, Caritas would offer to put up a modular home on their plot of land so that they would stay inside of their community.

"They would have that comfort of being somewhere familiar," she said. "They would stay near their home." One family, she recalled, decided that the modular home was a way "to kickstart" their dreams of rebuilding a destroyed home, a project of some 10 years. But for the father of the family's mother, who had been helping them rebuild this home, the whole experience became traumatic.

"When we were talking with him, he was weeping. And then he was also grateful, but there was something about how the elderly or people with some kind of vulnerability are affected, because they're holding on by a thread anyway."

In holding on to a thread, such people are the special beneficiaries of succor—a version of the church's preferential option for the poor—but they are only part of the process of solidarity. When I spoke to Tetiana about the working title of this book, her face brightened—especially the use of the word "solidarity." She said:

> It's like rings of solidarity, and it's solidarity between people, between communities inside of Ukraine, and then outside, this solidarity we've had from the outside. I cannot even begin to speak what it meant to us and means to us to this day as to have solidarity from outside the country of people who see us, who recognize what's happening, and who are accompanying us to respond. It is like a chain.

In the course of her work, Tetiana spoke in the summer of 2023 to Caritas members in Switzerland, telling them about, in a very poignant moment, the Caritas center that had been struck by a missile. The next day, she said, Caritas staff "were already on location, registering people for window repair and helping with psychological support."

> And I remember I was standing in front of these people in Switzerland, and I was saying, "You know what? You were there. You were there that next morning after the missile attack, because it was your project that helped us." And so, it was kind of understanding that in a way, through that solidarity, our staff on the ground are the hands, the feet, the heart that's on the ground, but it carries all of our intentions down to that last mile. And that's a really powerful moment that I think everyone needs to hear and understand and own, that they're a part of that beauty of what happens at this last mile.

As for the word "mercy," Tetiana said she thinks it has more to do with "practical love in action" and used similar language as she had when we first spoke in March 2022:

> I feel like the people who receive and the people who give, there's mercy on both sides somehow. I can't explain that there's something life-giving between both in receiving the aid from someone, but there's something really life-giving in the person who's giving it. And you can feel it in the people who are active in. . . . I imagine it's for the whole humanitarian community, when you really help someone in need, it's a very powerful moment. It makes you more human. So, you're not just restoring the humanity for the person in need, you're restoring the humanity in yourself.

Put another way, it's the idea of restoring the world—or at least a small portion of it. Archbishop Borys alluded to this when he told me that the 2014 street protests were sometimes called the Revolution of Dignity, adding that Dignity, Solidarity, Subsidiarity, and the Common Good are the four main points of Catholic social doctrine.

> Our church, since the time of Pope Leo XIII, has been enunciating that in various ways. It would take too long to explain how it happened. But President Zelensky, unbeknownst to himself, is a student in the school of Catholic social doctrine, as are millions of Ukrainians. So, the life of the Church, the body of Christ, has received a promise. The gates of hell will not prevail over it. And we're seeing real hell, but we're seeing that hell is not prevailing, and it will not prevail. It can cover things up for a while, as it did in the twentieth century, but the body of Christ will rise.

It is certainly alive in the work of the humanitarians I met in two years of travel in Ukraine and Poland, from those I met initially along the border, to the NGO workers in various locales, the priests and, of course, many sisters in numerous locales, in Ukraine, Poland and the United States.

With God, Feeling Boundless Love in a War Zone

We started this journey with the mission of Dominican Sr. Lydia Timkova, who in agreeing to be interviewed by me in early 2023, said—and this is very characteristic of Catholic sisters—that the experiences of the war's victims, and not responders like herself, deserve the most attention.

Yet Sr. Lydia acknowledged that in her travels with Katarína Pajerská, who coordinates the Slovak mission of Caritas in Ukraine, that the two women faced risks. Their physical courage is something I deeply admire: when I spoke to her in mid-May 2023, Sr. Lydia acknowledged that "it was very hard when we came under fire this time last week," speaking of experiences she had and Katarina had had in Torske, in the war-torn Donetsk region, about two miles from the Russian occupiers. "On the way we saw bombs falling, explosions, fire, and smoke in several places."

It was considerably calmer during the earlier interview in February as snow fell outside the convent she shares with another sister and regular visiting sisters in the western city of Mukachevo. Even then, Sr. Lydia acknowledged the dangers of traveling to the east. But she said that she and others are "going where no one else wants to go."

How does she do it? I asked. "With God, I feel boundless love for the people I meet. Even if I am in a dangerous place, I ask, 'Why should I be afraid?'"

At that moment, Sr. Lydia caught her breath, began tearing up, and then made a cutting motion with her hand. "When I meet people in a war zone, they are happy to see what little I can do for them. I listen to their stories—terrible stories. I listen to them, and I can't tell them that everything will be okay. All I can do is hear them and embrace them."

She said the stories were searing—of women being forced by Russian soldiers to eat sand, of girls being raped, of neighbors tortured by having their fingernails pulled out. Given those realities, Sr. Lydia said it is an imperative and a duty for those able to help to do so in the current environment.

Sr. Lydia does not take undue risks—she always travels with others, for example. And her time of "encounter" with those she assists is often brief, leaving shortly after arriving with a shipment to avoid potential complications and problems. The entirety of the visits takes about a week—the spring visits were spent for several days each in Kharkiv, Mykolaiv, and then in villages around Mykolaiv.

"We distribute it in different ways, either directly to the people or to the village headman, who passes it on to the people," Sr. Lydia said. The assistance—such as food and household supplies—were donated by Slovakians and collected in churches and monasteries for later shipment in a van across the border into Ukraine.

Once at a designated front line village, where there is always the risk of artillery shelling or coming upon land mines, Sr. Lydia and a travel companion, such as Katarína of Caritas, are always accompanied by a local resident who helps them navigate the on-the-ground challenges. Katarína, who I also interviewed in the convent, sees the work as helping right a grievous wrong. "Nobody has the right to take the home of another people," Katarína said of the Russian invasion. "And in the east, people have lost everything."

Those kinds of ever-present realities make humanitarian work daunting for those like Sr. Lydia and Katarína. But Katarína finds the long days of journeying with Sr. Lydia invigorating because prayer—rather than music blaring from a radio—becomes the calming rhythmic hum of travel across Ukraine's sprawling countryside. "It's very nice to have a travel partner, but when I'm with Sr. Lydia, I feel especially that the road is blessed," Katarína said. "And it's not just about the aid, it's about belief—it's about God. I really have felt that God wants us to be there."

Katarína recalled visiting one village in the Kharkiv region in 2022, where the two came upon a partly destroyed home and found a wounded elderly man who needed assistance. "If Sr. Lydia and I hadn't found him, he'd have died."

At another locale, they met a struggling grandmother who, upon seeing the two visitors, looked to the sky and exclaimed, "Thank you, God."

With experiences like that, Katarína said, "I have felt like we were on the right way. It's not just about the aid, but about giving people hope." Katarína said while traveling within a war zone it is helpful to travel with a sister. "When I'm with Sr. Lydia, people are more open. They can trust us," she said. As one example: "The soldiers are more friendly."

For her part, Sr. Lydia downplayed any idea that she, or what she does, is special. She told me that her real work remains as a teacher in Mukachevo, which has not felt the brunt of war like urban areas in the east and in Kyiv.

"I always come back here," she said of Mukachevo. "Here is my soul, my heart, my kids."

Sr. Lydia's path to avowed religious life was not easy—a common experience for sisters from Eastern Europe who grew up under communist rule. Born in the village of Bystré in the east of Slovakia, about 270 miles from Bratislava, now the capital of Slovakia, she felt a calling as a teenager, deciding to enter the novitiate at age 19, and eventually took vows in 1993. But the period of formation was challenging because of the still-extant fear of communist rule. Not even her family knew of her aspirations, and it took years—and the end of communism—before she would don her habit. "The advice I got was be among the people. Go to the movies, go to the opera—all

to hide the fact of my real calling." She added: "I would get up at five in the morning to meditate, go to work [at a children's rehabilitation center] and hide my calling, my 'blessed life,'" she told me. She recalled that all the sisters worried "about slipping—it was stressful. We were afraid." With the fall of communist rule, "we felt freedom and it was liberating to wear the habit," she said.

From the start, working with children—from newborns at a hospital to orphans to eventually teaching—felt like her calling. Sr. Lydia's resulting ministry has spanned across countries—she first worked in Ukraine in 1994, returned to Slovakia for a time, then left Europe to work as a teacher in Cameroon. She returned to Ukraine in 2018 and has now lived and worked there for more than 15 years. Upon her return, she felt the country had changed some—the Russian invasion and annexation of Crimea in 2014 marked a turning point, she told me.

"I noticed that people spoke more and more about freedom," she said. "People felt the pain of that invasion. They spoke of losing something they had."

Even with that history, Sr. Lydia said the news of the 2022 full-scale invasion remained a shock. She and other sisters still didn't believe it would happen. "We prayed the rosary all day," she said, fingering her rosary beads, recalling the memory.

Since the full-scale invasion began, she and others have prayed the rosary to the divine mercy daily at 3:00 p.m.—the time of Jesus's death.

"People are uniting—prayer is a way to unite people," she said.

In Mukachevo, Sr. Lydia teaches catechism to teenagers and Christian education to adults and seniors. She hears and encounters the pain of families who have families in the east, as well as the

experiences of those who have lost soldier relatives. She knew one soldier herself—dead and buried in November 2022.

Eleven residents from Kyiv, Kharkiv, and Chernihiv who fled the war lived with the Dominican sisters in the Mukachevo convent for much of 2022. But by September of that year they had returned home. For the first two weeks of war, "everything stopped," Sr. Lydia recalled—schools, markets, "normal life." Some sense of normalcy has returned, though not fully: the seeming quiet of Mukachevo can be interrupted at any time by air-raid sirens.

"We have hospitals here. What do you do with patients?" she said. "It means they are always in danger. It's hard."

It *is* hard. It is difficult. The challenges facing a country at war are as immense and as sprawling as the Ukrainian countryside. And they are daunting to everyone—sisters included. But Sr. Lydia believes her work is part of a plan that, at its core, remains an ineffable mystery. She can't always fully comprehend it herself—but it must be respected and made tangible. "I've dedicated my life to God, to helping people," she said. "And now I am feeling the living God. He gives me power."

Helping people. Living God. Power. Let those be the final words here.

Afterword

*I*n two years of travel to central and eastern Europe I saw some of the best and worst in humanity—and some of the worst had little to do directly with the Ukrainian war. Personal visits to Holocaust memorial sites in Ukraine, Poland, Germany, the Czech Republic, and Croatia could not help but reinforce a certain pessimism about the human condition. And yet, a simple statement by Holocaust survivor Halina Birenbaum, which I saw during my second visit to Auschwitz-Birkenau, crystalized what I had seen and experienced in Ukraine. "Even if evil triumphs at times," Birenbaum said, "goodness does not cease to exist."

I saw plenty of examples of this—on the Ukrainian-Polish border; in convents in Ukraine, Poland, Croatia, and the United States; in the towns outside of Kyiv and in the villages near Zaporizhzhia. But as we close this book, I think we should always be a bit cautious about the word "goodness"—it can prevail, as the Gospels suggest, but it is also often hard-earned, something that Beatitude Sviatoslav in his March 2024 sermon at Saint Patrick's Cathedral noted, citing examples of those in Ukraine have suffered for the truth: "To the man in Bucha who was shot with his hands tied behind his back in March 2022, to the mother killed a week ago in Odesa by a Russian drone while

holding her four-month-old son in her embrace, to helpless prisoners of war and those who were tortured to death, to you and to me."

The image of torture is arresting, and it takes me back to the thought of one of my professors at Union Theological Seminary, the renowned Black theologian James H. Cone. I thought of Professor Cone a number of times in my travels, recalling how he would remind his students that theology—how we speak about our relationship with God—is always contextual, born from personal and communal experiences and histories. I always affirmed that in my experiences with Ukrainians, though as a white liberal American Christian, sometimes I struggled a bit with the resurrection narrative I heard in Ukraine, given the current context of worries about Christian nationalism in the United States—the comingling of religion and nationalism. I say this gently—the United States is a triumphal country with overwhelming power in the world; Ukraine is an invaded country struggling—really struggling—to protect itself. And I mean that literally. In talking to soldiers both in person in Ukraine and online since returning home in early 2024, I have been struck by a continued theme: how undersupplied they are with the basics, like clothing and shoes and other necessities. And yet they fight on, with uncommon courage, fortitude, and commitment. Though soldiers are woefully underpaid, one young man, Yevhen, texted me, "This is our life. Because of what has happened to Ukraine, my country cannot be abandoned."

I asked my American colleagues David Bonior and Peter Daly about this topic of religion and nationalism and both had reasonable and reassuring responses: David said the real concern should be Christian nationalism in Russia, "showing itself in a very nondemocratic way, with church and state blended together."

Peter agreed, saying: "If you want to see Christian nationalism on steroids, look at Russia." Peter also noted that Patriarch Kirill, the primate of Russian Orthodox Church, "is at every speech that Putin gives, and he is blessing the troops as they go off to war. He's told them that if they die in this conflict, they have prescriptive entry into the kingdom of heaven, which is total nonsense."

Peter calls Ukraine "a different landscape" than Russia. Officially it was atheist until 1990, he said, and "a lot of people in power never really had a religious background at all. Although quietly in the homes, religion was still practiced. Of course, it is much more diverse than Russia." Both men recall attending a gathering of religious leaders from Ukraine who represented a multitude of faiths—Jewish, Muslim, Catholic, and Protestant, both evangelical and unevangelical. I heard the same from a group of religious representatives and physicians of different faiths who visited Ukraine in 2023. Both experiences spoke of a diversity of religious traditions being respected and honored in Ukraine.

"The fact that there is a large Greek Catholic community in union with Rome, liturgically Eastern, but in union with Rome has always given Ukraine a kind of international outlook," said Peter. He also noted that a lot of those clergy were trained in Rome and elsewhere.

"That's not true in Russia. And they've always had a sense that they looked outward. And part of the reason is that since the seventeenth century, they wanted to look outward as an alternative to Moscow. So, I think they don't have Christian nationalism in Ukraine like they do in Russia or like we do here." He noted that Ukraine has a Jewish president, and "if they were Christian nationalists, they would probably be electing some kind of ultra-Orthodox figure."

Peter added, "I don't think there's much danger of Christian nationalism there."

Of course, it is true, Peter said, that you "do have to be cautious about theological justifications for your political decisions." He continued, "it's very dangerous to think that God is on your side, and this is when religion becomes destructive." But when Ukrainians use resurrection language when speaking of victory, they're seeing a kind of metaphor of Ukraine surviving, and "coming back and rising from the dead," Peter said.

That is a reasonable, wise, and sound observation—one that returns me to the thought of my late professor, James H. Cone. In one of his last theological projects, Cone wrote of the relationship between the cross and the African American experience of lynching, a particularly egregious type of torture. I need to be extremely cautious here about equating lynching with Ukraine's challenges. They are born from quite particular and very different tragedies and injustices. Brutal acts of American racism and the violent assault on a sovereign country are obviously quite different types of oppression. Yet I remember Professor Cone as an eloquent champion of anyone denied their basic humanity. Moreover, Cone was keenly aware of how Christian salvation is, as he said, "available *only* through our solidarity with the crucified people in our midst,"* and that it is impossible to embrace the cross "unless one is standing with those who are powerless."†

Surely the refugees I met in Poland could be called powerless, at least as they began their journeys. And most certainly this would be

* James H. Cone, *The Cross and the Lynching Tree* (Maryknoll, NY: Orbis, 2011), 160.
† Ibid., 162.

true of the residents of the villages near Zaporizhzhia, whose homes had been destroyed and were living by a thread. I think Sr. Lucia was thinking of them when, as noted before, she was convinced that "God is with those who are suffering and with those who are doing something good. I know God cries with the people who cry. I see a God who has suffered, and I know a God who stays with those who are protecting us. I know God is on the side of those who choose to do good."

That resonates deeply as I reflect on the many times I heard Ukrianians evoking the experience of the cross. Despite differences in race, culture, and nationality, I think they might appreciate Professor Cone's understanding of the cross as a living symbol of "death and defeat"—but also hope. In Cone's words, God turned the cross into a

> a sign of liberation and new life. The cross is the most empowering symbol of God's loving solidarity with the "least of these," the unwanted in society who suffer daily from great injustices. Christians must face the cross as the terrible tragedy it was and discover in it, through faith and repentance, the liberating joy of eternal salvation.[*]

It is this idea of God granting "eternal life to all who suffer for the truth" that Beatitude Sviatoslav spoke of so eloquently in his sermon at St. Patrick's Cathedral in New York, as he also did about hope, which he called "a theological virtue."[†]

[*] Cone, *The Cross*, 156.
[†] "His Beatitude Sviatoslav's Sermon at St. Patrick's Cathedral in New York," Ukrainian Greek Catholic Church, March 11, 2024, https://ugcc.ua/en/data/his -beatitude-sviatoslavs-sermon-at-st-patricks-cathedral-in-new-york-954/.

It means placing our trust in Christ's promises and relying not on our own strength, but on the help of the grace of the Holy Spirit. Hope is our weapon, hope is our shield.

The Ukrainian soldiers defending the innocent in Chasiv Yar, Robotyno, Kupiansk at this very moment "put on the breastplate of faith and charity, and for a helmet, the hope of salvation."

In its essence, hope is utterly practical. To flourish hope needs us—our hands, voices, prayer, and effort. I ask you to do everything in your power, and believe me, you can do a lot, to invoke God's power to intercede for the people of Ukraine, for peace and justice.[*]

In a detail that James Cone would have appreciated, Sviatoslav ended his sermon by evoking the life and example of Martin Luther King Jr., whom he called a "visionary American." King, the Ukrainian prelate said, "Stated that no one is free until we are all free. No one is at peace until we are all at peace. There is no justice if someone continues to suffer from injustice."

In a way that is what Ukrainians had been telling the world for two years: that theirs was a fight for liberty and freedom against a modern form of occupation and tyranny—a cause rooted in Ukrainian history and experience, but whose ideals, of course, are not singularly Ukraine's. Recall what Anna Olsen, a senior combat medic with the Ukrainian marines, and a former Ukrainian prisoner of war held in captivity by the Russians, declared at the United Nations in March of 2023: "Freedom is not free," she said, and that Russian forces "are trying to break us as a nation."

[*] "His Beatitude Sviatoslav's Sermon at St. Patrick's Cathedral in New York," Ukrainian Greek Catholic Church, March 11, 2024, https://ugcc.ua/en/data/his -beatitude-sviatoslavs-sermon-at-st-patricks-cathedral-in-new-york-954/.

What is happening in Ukraine, Olsen added, "is a fight for the whole world." That may sound uncommonly idealistic and noble in an ignoble era of authoritarian and antidemocratic leaders. But it is true. In taking a stand against tyranny and what my soldier acquaintance Yevhen called "the whims of a despot," Ukrainians are doing the world's work, as Yale University historian Timothy Snyder has argued:[*]

> The Ukrainians are defending the legal order established after the Second World War. They have performed the entire NATO mission of absorbing and reversing an attack by Russia with a tiny percentage of NATO military budgets and zero losses from NATO members. Ukrainians are making a war in the Pacific much less likely by demonstrating to China that offensive operations are harder than they seem. They have made nuclear war less likely by demonstrating that nuclear blackmail need not work. Ukraine is also fighting to restore its grain exports to Africa and Asia, where millions of people have been put at risk by Russia's attack on the Ukrainian economy. Last but not least, Ukrainians are demonstrating that a democracy can defend itself.[†]

A European democracy defending itself in the year 2024—imagine! At times, it still startles and amazes that a European land war is being fought in the twenty-first century. By all lights, a Russian imperial invasion was never supposed to happen again after the downfall of the Soviet Union. But it is the persistent memory of the oppression Ukraine experienced as a Russian-Soviet state that has animated and galvanized a people.

[*] Timothy Snyder, "The State of the War," *Thinking About* (blog), September 7, 2023, https://snyder.substack.com/p/the-state-of-the-war.
[†] Ibid.

When I saw Sr. Urszula Krajewska of Jesuit Refugee Service again in late February 2024 in Warsaw, we discussed that fact in the context of Halina Birenbaum's quote about goodness not ceasing to exist. She said the sentiment was true—and that ministries to help the survivors of the Ukraine war were proof of that. But she also expressed a word of caution: After the fall of the Soviet Union, she said, it became popular to talk about the "end of history"—that with the perceived victory of political and economic liberalism, the world had entered a more optimistic era, perhaps free from tyranny. But Sr. Urszula said the idea "wasn't true then and it isn't true now." Wars and resulting humanitarian crises like those in Ukraine—where millions migrate—happen all the time. "I thought at the beginning of [the] Ukrainian crisis that it was something special. It's not. It's all too common."

And that is true—as we spoke, a war in Gaza raged, as did in conflicts in Sudan and Myanmar, among other locales. Humanity's dance with war and with death persists. That is a constant in our lives as humans. Sr. Urszula recalled meeting a Syrian refugee who said every day she thought the war in her country would finally end, and it never did. Reaching back into the examples of the Holocaust and subsequent genocides, "the idea that none of us can be harmed—well, we can see that's not true. Experiences like Auschwitz expose that."

They do. The last two years have allowed Sr. Urszula to reflect on her journey of faith and the meaning of suffering. For herself, that experience has brought her into deeper relationship with Christ, saying she knew "intellectually" she was saved by Christ, but that it wasn't always easy to accept the implications of that experience. "He's the savior, I'm not the savior."

Yet, at the same time, she said, the charism and spirituality of her congregation—the *very name* of her congregation—the Society

of the Sacred Heart of Jesus—is "to enter the heart of Christ and go out into the world with love." Still, the experiences of Ukraine, or Auschwitz, or other catastrophes will always prompt the question, "Why does God allow suffering?"

To that, Sr. Urszula said, "It's not in God's plans to allow suffering." Rather, the better question is, "Where is there hope? And where is there love?"

Here is a partial answer. The day after Easter in 2024, I asked Sr. Tesa Fitzgerald, the president of the Sisters of St. Joseph of Brentwood, New York, about the congregation's decision to welcome refugees from Ukraine—as well as those from other countries—to their large Long Island campus. She told me that the sisters "always pray and listen to the heartbeat of the world"—especially where need is paramount.

"If we really say we are attentive to those in front of us, we need to be giving." In this case, she said, the sisters were responding to an obvious immediate need—refugees requiring safe space after fleeing wars and conflicts and then trying to find their ways in a strange country.

I framed the question as one of "welcoming the stranger," an oft-used phrase in church circles. But Sr. Tesa said the word "stranger" had quickly lost its meaning as the refugees become integrated into the St. Joseph community—living and working on campus, for example. "They're no longer 'strangers,'" she said. "The stranger becomes neighbor, then friend"—helping to expand the sisters' own sense of community and widening their vision of the world. The refugees "being here has opened our hearts."

In response to the war in Ukraine, the evidence of opening hearts, of acting with a sense of succor and unity, in the hope of miracle and resurrection, of *solidarity and mercy,* in a broken and polarized world, is all around us.

I completed the very final stages of this book while making a short trip to Kyiv in July 2024. Except for occasional air-raid sirens, it was quiet in Kyiv—up until the final day. At midmorning on July 8, Russia launched a barrage of missile attacks across Ukraine, killing at least 40 people. The explosions shook the Ukrainian capital; they were the first rocket attacks I heard while in Kyiv and they were terrifying. They pierced the heart and shook the soul.

One of the buildings destroyed was the Okhmatdyt children's hospital, the nation's largest such facility. Dozens of emergency personnel and volunteers gathered to assist in rescue efforts—luckily, children at the hospital had been evacuated before the attack after air-raid sirens sounded.

The Russian military, not surprisingly, denied responsibility, saying the hospital attack (improbably) was caused by a Ukrainian antiaircraft missile. But United Nations personnel in Kyiv said that the evidence pointed to Russia's culpability. Ukrainian officials said the case should go to the International Criminal Court, which is already seeking to prosecute Russian leaders, including President Putin, for alleged war crimes, such as forcibly deporting Ukrainian children to Russia.

My friend Sr. Anna Andrusiv was not in Kyiv at the time—she had joined other sisters of St. Basil the Great at a retreat in western Ukraine. We exchanged texts. Despite everything Sr. Anna had told me about the brutal nature of Russia's war against Ukraine, she said that "even this was something unbelievable for all of us."

I asked Sr. Anna if she felt resurrection was far off now. Yes, she replied. But did she also believe that Ukrainians continue living in hope? "Yes, we do."

An Interview with Archbishop Borys Gudziak

An edited transcript of a February 23, 2024, Zoom interview with Archbishop Borys Gudziak, the Metropolitan-Archbishop of Philadelphia of the Ukrainian Catholic Church

HERLINGER: Archbishop Borys, what are your thoughts as we enter the third year of the full-scale invasion of Ukraine?

GUDZIAK: Well, my thoughts and feelings are based not only on these last two years, but they're based on history. I'm a son of Ukrainian war refugees who actually lived through a much worse war. The casualties now are in the hundreds of thousands. My parents were victims, and my family, they were victims of a war in which seven million inhabitants of Ukrainian lands were killed, including at least 1.5 million Jews during the Holocaust. So, the bottom-line conviction is that a culture, a country, a church, a nation can survive incredible challenges and great devastation. What it can't survive is a total genocide. It can't survive if its freedom and God-given dignity is completely crushed. It can't survive, it will no longer be itself, if it is forced to be something else, particularly if that something else is counterfactual and an inversion of one's identity.

And I think this reflects what Ukrainians say. A million people volunteered to defend the country during this war. If you talk to many soldiers and probe their motivation, they will not tell you that they're protecting the Zelensky government, that they are ready to sacrifice their life for a political system. They say, we have been dealing with Russian imperialism for centuries. Our whole nation, the people, our families are in mortal danger. We will defend them. The stories of devastation at the hands of Russians have been a part of my family history and of virtually every Ukrainian family for generations. This has been passed on from generation to generation, this fear of the Russians, the persecution at the hands of the Russians. We do not want to pass this on to our children and grandchildren, and for that we're willing to die. And that is kind of the rock on which Ukrainian resistance stands. Ukrainians want to put a stop to Russian colonialism once and for all.

It's very important to emphasize to Americans that it's been actually ten years of the war, including the last two years of a full-scale invasion. The decade of war and the relentless brutality of the last two years have clearly exhausted people. People are exhausted, deeply traumatized. And most people, over 60 percent, of Ukrainian young people, after high school go on to some further studies. People are educated: they have an awareness of what is happening with them, to them. They understand concepts like post-traumatic stress disorder which previous generations didn't understand. They understand that their children now have been deprived for four years of normal education, two years of COVID, and two years of the full-scale invasion. So, they're not naive, but they know Russian occupation means genocide. They know it because it's happened in the past and it's happening now.

The population is fully aware of the incredible devastation, the suffering, the torture. What people have undergone and continue to endure is blood-curdling. The $1 trillion worth of infrastructure damage, the 14 million people that were displaced from their homes. This is very shattering, exhausting, traumatizing. But the people understand that they need to be resilient, because otherwise they won't exist. That is something that is not understood on the outside.

HERLINGER: So many people I have met have told me stories about their families, particularly in relation to the events of the 1930s. And there has also been much controversy about that word genocide in the context of the Israeli-Gaza situation, so I think we all have to be very specific and clear about that term *genocide.* How would the word genocide apply here, do you think? I'm assuming you're saying Russia wants to destroy Ukraine and the Ukrainian people, Ukrainian culture.

GUDZIAK: Putin basically says there is no Ukraine. It's a fake. The Ukrainian language is just a dialect of Russian, he says. The Ukrainian religious communities—the Orthodox Church of Ukraine, Protestant churches, our Ukrainian Catholic Church—they're persecuted wherever there is Russian occupation. In the twentieth century, they were destroyed. The independent Ukrainian Orthodox Church was destroyed within a few years of Russian Soviet rule, by 1930. The Ukrainian Catholic Church was rendered illegal within basically 16 months of Soviet rule in Western Ukraine. And in the Zaporizhzhia Oblast—60 percent of the area is now occupied—our church is already illegal, in the occupied part.

So, whether it's in the past or now, whether it's the elimination of churches, the burning of Ukrainian textbooks, the prohibition of teaching in Ukrainian in schools, the abduction of children from Ukraine, and then brainwashing them and raising them as Ukraine haters. You see, Putin is not only negating Ukraine, he's hating Ukraine. He's creating in Russia a hatred for things Ukrainian, an identification of everything Ukrainian with, for example, Nazism, calling the Ukrainian Jewish president a Nazi. A Nazi is a monster that needs to be killed, needs to be annihilated.

And the definition of genocide is actions leading or intended to lead to the destruction of a whole or part of an ethnic group. Whether it's in Bucha or Irpin or in the other places that were liberated from Russian occupation, we can see the ferocity with which the Russian soldiers just killed regular citizens. A lady riding a bicycle, a man going out for bread, just shot on the street. The world saw them lying on the streets. The Russians just left them lying there for weeks. In April 2022, we saw the mass graves. And that has great precedent in history. So, Putin says, this is nothing, you are nothing, which is a negation—it's historically genocidal. It's factually genocidal. Most importantly, it's ideologically genocidal, because the ideology leads to the actions.

HERLINGER: How would you frame the last two years in light of Catholic faith, Christian symbolism? People of course will always ask the theodicy question, "Where's God?" I asked this of several people I met in Ukraine and the answer was, "God has been with us. God has been with us on the cross, and this is a moment of a suffering people."

GUDZIAK: Again, I return to my experience of history in my family, or in my historical studies, because as a scholar, I was trained

as a historian and worked as one doing research and publishing. We're going tomorrow to Washington for a rally on the occasion of the second anniversary. And I remember going on these rallies 40 years ago when I was in college, when I was a PhD student. For example, the first big major Holodomor rally in Washington was in 1983 for the fiftieth anniversary of the Holodomor, of the genocide famine. And we were rallying, praying, marching for Ukraine's freedom, for the freedom of our Ukrainian Catholic Church, which then was illegal. It was the biggest illegal church in the world between 1946 and 1989. Did we really believe that the Church would be liberated? We thought it should happen, that it is right for it to happen. But did we believe that within a few years, the whole Soviet Union would fall apart, that the second biggest nuclear superpower would just crumble?

For me personally, I've seen too many miracles not to believe that God is working in history, despite human sin, despite human evil. The prototype of sin is the "grab." God gives to Adam and Eve everything, and we're reflecting on this right now in Lent, and God says, just don't take the fruit off this tree because it will lead to your death. But because of passions or falling to temptation, Adam and Eve take this fruit, and they begin the grabbing. What Putin is doing is the "mega-grab." Russia has 28 times the territory of Ukraine. Why does it need a 29th piece? It covers 11 time zones. Live in your land and enjoy. Live the gift. But no, we're going to grab for more. Adam and Eve had the whole garden of Eden, but they had to grab that fruit despite being told that this will lead to their death. This is the prototype of sin. At the heart of our faith is that Jesus comes into our world, or life, our very sin. He conquers sin and its consequence—death. and gives people the strength to resist evil.

HERLINGER: And that strength was demonstrated early on.

GUDZIAK: Two years ago today, as we speak, all the pundits, all the analysts, all the experts were saying, Ukraine will fall in three days, a week maybe two. In this all western leaders were in agreement with the thoughts of Putin. The war is going to begin in a day or two, and Ukraine is going to fall. The capital is going to fall in a week or two. It's miraculous how this relatively poor country with a very small army a few years ago has stood up and, in many places, defeated the Russian army. I think it's a miracle. It's something that is superhuman. And so, seeing the miracles of the past, seeing the desire—the Soviet Union had immeasurable resources to crush the Ukrainian Catholic Church, and it thought it had accomplished this goal. The Soviets reduced the number of priests in the underground from 3,000 in 1939 to 300 aged priests in 1985, the average age of whom was greater than the life expectancy of males. That cohort was going to die out, and it was going to be all over. Yet the Lord brought us back from Hades, from the tomb, to a new life. How do you explain that? I don't explain that other than the grace and the faithfulness of martyrs, of people who were ridiculed.

The number of our faithful that could be serviced by those 300 priests, those 300 priests served no more than 100 people each. But that's like the top number. Let's take that number as the maximum. That means there were 30,000 people in the underground that had some regular connection with the church. Of course, there were people that, through their families, through the memory, associated themselves, but they couldn't get to the underground, because the control was totalitarian. That's 30,000 is out of four million people that had been members of that church in 1939. It was a tiny number—less

than 1 percent was left; 99 percent of the activity of the church was stamped out. And today it is a major leader, moral leader. Catholic social doctrine, enunciated by the Ukrainian Greek Catholic Church, characterizes Ukrainian society.

God-given dignity. That is what people seek. The revolution was called the Revolution of Dignity, Solidarity, Subsidiarity, and the Common Good. Those are the four main points of Catholic social doctrine. And our church, since the time of Pope Leo XIII, has been enunciating that in various ways. It would take too long to explain how it happened. But Zelensky, unbeknownst to himself, is a student in the school of Catholic social doctrine, as are millions of Ukrainians. So, the life of the church, the body of Christ, has received a promise. The gates of Hell will not prevail over it. And we're seeing real Hell, but we're seeing that Hell is not prevailing, and it will not prevail. It can cover things up for a while, as it did in the twentieth century, but the body of Christ will rise.

HERLINGER: What you're telling me resonates with everything that I saw and heard when I was there. I think we do have to acknowledge, this particular moment two years later, this isn't the best moment. I mean, I did sense, talking to people I met last year, it's been a frustrating year. They're still determined. They still believe Ukraine will prevail. But it is a frustrating moment right now, isn't it?

GUDZIAK: Well, people are exhausted. People are traumatized. Thousands of people have been killed. Fourteen million people were forced from their homes. That's pretty bad. But it can get blacker, and it has been blacker, and the light has shined even in a pitch blackness in Ukrainian history. I've seen it. My family's lived it. My church

has lived it. And I think that is consciously or subconsciously in the minds of millions of Ukrainians. And while they are exhausted and traumatized, deep inside there's a conviction that there is God's truth. There is eternity. Even if I'm killed, that's not a total negation of my being. And there are things bigger than my body, my little life, my little chronology. And we see injured soldiers, you've probably heard of this, the sisters talk about it, the soldiers are injured, and then they have a bit of a recovery, and they say, we're going back.

HERLINGER: I discussed the issue of pacifism with a number of people in Ukraine, which we know is part of the Christian tradition. But people were skeptical. Have you, in the last ten years, but particularly in the last two years, have you had to make the argument against pacifism with those who have asked you that question about the pacifist vision?

GUDZIAK: Well, my patron saints are Saints Borys and Hlib. They were the sons of Volodymyr the Great who brought Christianity to modern-day Ukraine, Belarus, and Russia. And when their father died in 1015, there was a struggle for the succession to the Kyivan throne. And an older brother, fearing them as rivals, marched against them. And first Borys and Hlib said, "We will not raise our sword against our brother." And 900 years before Gandhi, Martin Luther King, Nelson Mandela, Dorothy Day, they basically took a pacifist stance, and one might say it's a Christ-like stance, in the face of military physical violence.

However, there's a difference between Borys and Hlib sacrificing themselves and someone standing by and seeing children sacrificed, family members and other people sacrificed. And that is the kind of

pacifism that Ukrainians don't buy. I would like to see these pacifists that come with "a high pulpit" and watch their own children being killed and massacred, and I would like to see them not defend them. If I'm in a subway and a criminal jumps a little old lady, I'm going to go defend her. Most people won't go, not out of pacifism, but because they're afraid for themselves. But I think that little old lady deserves to be defended. As do fellow citizens, members of one's family.

HERLINGER: I liked the introduction you wrote for the Ukrainian diary of Henri Nouwen from 1993 and 1994, and I thought it, and the diary itself, were very stirring and very helpful for understanding Ukrainian history. Is there anything further about that book you'd like to say?

GUDZIAK: Henri had a great gift for spiritual insight and had great psychological awareness. I don't know if there's more than three or four weeks recorded in that diary, but it's two snapshots, two different summers. But at the early point of Ukraine's emergence from the totalitarian Soviet trauma, Soviet totalitarian trauma, it really is a snapshot of what Ukrainians want to leave behind. The grayness, the dullness, the sadness that piled up, because of wave after wave of genocidal history.

Ukrainians want to live; they want to be free. They want to cross the border into Western Europe. They want to be citizens of the world. They want to continue growing wheat and feeding 400 million people. Most people don't realize Ukraine feeds 10 times the number of its citizens. North Africa or the Middle East will starve if Ukrainian food, Ukrainian agriculture production, is blocked from arriving there.

So that book, which was not published for almost 30 years, it had great insight, and it was like a photograph, a documentation of the state of the Ukrainian soul at that point. And in it also Henri, who was a great peace activist, said, "I'm really worried what the Russians are going to do." It was prophetic.

Ukraine was giving up its nuclear arsenal. It had the third biggest nuclear arsenal in the world after the US and Russia. It had more nuclear arms than England, France, and China put together. And it was giving that arsenal up. Very few pacifists and peace activists today recognize that Ukraine did a Christ-like act.

HERLINGER: One last question, given the two-year anniversary of the full-scale invasion. What's the state of the Ukrainian soul today?

GUDZIAK: It's tortured, it's beat up, but at its core, there's a resilience which combines both decisive resistance, but also flexibility, because somebody that is resilient is creative. Not brittle.

Selected Bibliography

Author's Global Sisters Report Articles

Herlinger, Chris. "Arduous journey leads Ukrainian mother and daughter to shelter at Polish convent," Global Sisters Report, March 24, 2022, https://www.globalsistersreport.org/news/news/news/fleeing-war -ukrainian-mother-and-daughter-find-rest-polish-convent.

Herlinger, Chris. "As 2 years of war in Ukraine take a toll, sisters remain a steady, welcome presence," Global Sisters Report, February 22, 2024, https://www.globalsistersreport.org/news/2-years-war-ukraine-take -toll-sisters-remain-steady-welcome-presence.

Herlinger, Chris. "As Easter approaches, life in Lviv, Ukraine, includes 'never-ending' pressure." Global Sisters Report, April 6, 2023, https://www.globalsistersreport.org/news/easter-approaches-life-lviv -ukraine-includes-never-ending-pressure.

Herlinger, Chris. "For Ukrainians in Poland, joy of the season is mixed with heartache," Global Sisters Report, December 15, 2022, https://www.globalsistersreport.org/news/ukrainians-poland-joy -season-mixed-heartache.

Herlinger, Chris. "Increased nuclear threat may renew interest in disarmament, advocates say," Global Sisters Report, September 22, 2022, https://www.globalsistersreport.org/news/social-justice/increased -nuclear-threat-may-renew-interest-disarmament-advocates-say.

Herlinger, Chris. "In spite of a year of war, Ukrainians endure and religious ministry continues," Global Sisters Report, February

23, 2023, https://www.globalsistersreport.org/news/spite-year-war
-ukrainians-endure-and-religious-ministry-continues.

Herlinger, Chris. "In Ukraine, 'a mission for light' illuminates daily life
far from the fighting," Global Sisters Report, December 8, 2022,
https://www.globalsistersreport.org/news/ukraine-mission-light
-illuminates-daily-life-far-fighting.

Herlinger, Chris. "Long Island sisters open their doors, and their hearts,
to refugees," Global Sisters Report, September 21, 2023, https://www
.globalsistersreport.org/news/long-island-sisters-open-their-doors-and
-their-hearts-refugees.

Herlinger, Chris. "Monday Starter: War in Ukraine contributes to
growing global hunger," Global Sisters Report, April 18, 2022,
https://www.globalsistersreport.org/news/news/news/monday-starter
-war-ukraine-contributes-growing-global-hunger.

Herlinger, Chris. "On World Refugee Day, celebrate Ukrainian women
for their resilience, strength and hope," Global Sisters Report, June
19, 2023, https://www.globalsistersreport.org/news/world-refugee-day
-celebrate-ukrainian-women-their-resilience-strength-and-hope.

Herlinger, Chris. "Reporter's notebook: Activists fight to end sexual
violence in war," Global Sisters Report, June 19, 2023, https://www
.globalsistersreport.org/news/reporters-notebook-activists-fight-end
-sexual-violence-war.

Herlinger, Chris. "Reporter's notebook from Ukraine: What life is like
when war becomes normal," Global Sisters Report, April 6, 2023,
https://www.globalsistersreport.org/news/reporters-notebook-ukraine
-what-life-when-war-becomes-normal.

Herlinger, Chris. "There are moments of grace, but Ukraine war's trauma
seeps into people's souls," Global Sisters Report, March 9, 2023,
https://www.globalsistersreport.org/news/there-are-moments-grace
-ukraine-wars-trauma-seeps-peoples-souls.

Herlinger, Chris. "UISG begins $1 million grant distribution to sisters
serving Ukraine refugees," Global Sisters Report, May 4, 2022,

https://www.globalsistersreport.org/news/ministry/news/uisg-begins-1
-million-grant-distribution-sisters-serving-ukraine-refugees.

Herlinger, Chris. "Ukrainians praise warmth of Polish welcome after
long, difficult journey," Global Sisters Report, March 11, 2022,
https://www.globalsistersreport.org/news/news/news/ukrainians-praise
-warmth-polish-welcome-after-long-difficult-journey.

Herlinger, Chris. "Ukrainians fleeing terror at home find solace in
Polish church," Global Sisters Report, March 31, 2022, https://www
.globalsistersreport.org/news/ministry/news/ukrainians-fleeing-terror
-home-find-solace-polish-church.

Herlinger, Chris. "War, climate change, inflation: Multiple crises have
led to a boom in global hunger," Global Sisters Report, October 13,
2022, https://www.globalsistersreport.org/news/ministry/war-climate
-change-inflation-multiple-crises-have-led-boom-global-hunger.

Herlinger, Chris. "'We are afraid, but we are also strong': Stunned sisters
worldwide watch as Russia invades Ukraine," Global Sisters Report,
February 24, 2022, https://www.globalsistersreport.org/news/religious
-life/news/we-are-afraid-we-are-also-strong-stunned-sisters-worldwide
-watch-russia.

Herlinger, Chris. "With flooding, Ukrainian villages near war's front
lines 'are really suffering,'" Global Sisters Report, June 16, 2023,
https://www.globalsistersreport.org/news/flooding-ukrainian-villages
-near-wars-front-lines-are-really-suffering.

Herlinger, Chris. "With Ukraine under siege, sister shepherds supplies
cross-country to civilians," Global Sisters Report, May 25, 2023,
https://www.globalsistersreport.org/news/ukraine-under-siege-sister
-shepherds-supplies-cross-country-civilians.

Herlinger, Chris, and Dan Stockman. "Sisters in Ukraine navigate 'a
time full of terror' as Russian invasion continues," Global Sisters
Report, March 4, 2022, https://www.globalsistersreport.org/news
/news/news/sisters-ukraine-navigate-time-full-terror-russian-invasion
-continues.

Author's *National Catholic Reporter* Articles

Herlinger, Chris. "Catholic scholars call for Russia, US to calm rhetoric about use of nuclear arms," *National Catholic Reporter,* November 9, 2022, https://www.ncronline.org/news/catholic-scholars-call-russia-us -calm-rhetoric-about-use-of-nuclear-arms.

Herlinger, Chris. "An Easter journey of mourning Holocaust victims who shared my name," *National Catholic Reporter,* April 14, 2023, https://www.ncronline.org/opinion/ncr-voices/easter-journey -mourning-holocaust-victims-who-shared-my-name.

Herlinger, Chris. "Four Ukrainian refugees share testimony: War's tragedy, people's kindness, holiday memories," *National Catholic Reporter,* December 28, 2022, https://www.ncronline.org/news/four -ukrainian-refugees-share-testimony-wars-tragedy-peoples-kindness -holiday-memories.

Herlinger, Chris. "A Good Friday reflection from a Europe at war (again)," *National Catholic Reporter,* April 15, 2022, https://www.ncronline.org /news/opinion/good-friday-reflection-europe-war-again.

Herlinger, Chris. "On Polish border, Ukraine refugees ache for home while facing uncertain future," *National Catholic Reporter,* March 17, 2022, https://www.ncronline.org/news/people/polish-border-ukraine -refugees-ache-home-while-facing-uncertain-future.

Other Online Articles

Balog, Amy. "Ukraine: Families still enduring constant psychological torture," Aid to the Church in Need, February 16, 2024, https://acnuk.org/news/ukraine-families-still-enduring-constant -psychological-torture/.

"His Beatitude Sviatoslav's Sermon at St. Patrick's Cathedral in New York," Ukrainian Greek Catholic Church, March 11, 2024, https:// ugcc.ua/en/data/his-beatitude-sviatoslavs-sermon-at-st-patricks -cathedral-in-new-york-954/.

Houston, Aidan. "The Role of Religion in Russia's War on Ukraine," United States Institute of Peace, March 17, 2022, https://www.usip .org/publications/2022/03/role-religion-russias-war-ukraine.

"Impact of war on youth in Ukraine," United Nations report, 2023. https://ukraine.unfpa.org/sites/default/files/pub-pdf/undp-ua-impact -war-youth-eng-findings-recommendations.pdf.

Kyiv International Institute of Sociology. "Dynamics of Religious Self-Identification of the Population of Ukraine: Results of a Telephone Survey Conducted on July 6–20, 2022," press release, August 5, 2022, https://www.kiis.com.ua/?lang=eng&cat=reports&id=1129 &page=1.

McElwee, Joshua J., and Christopher White. "Ukrainian archbishop: Pope Francis doesn't understand Putin," *National Catholic Reporter*, March 20, 2024, https://www.ncronline.org/vatican/vatican-news/ukrainian -archbishop-pope-francis-doesnt-understand-putin.

Noe, Nicholas, and Hardin Lang. "Breaking the cycle: localizing humanitarian aid in Ukraine." *Forced Migration Review* 72 (September 2023), https://www.fmreview.org/ukraine/noe-lang.

Oxfam International. "Ukraine: 42 civilian casualties every day in two years of war," press release, February 22, 2024, https://www.oxfam .org/en/press-releases/ukraine-42-civilian-causalities-every-day-two -years-war#:~:text=As%20of%2022%20February%202024,the%20 conflict%2C%20including%20587%20children.

Rios, Loreto. "Aid to the Church in Need launches campaign to help Ukraine," Aid to the Church in Need, February 20, 2024, https://omnesmag.com/en/newsroom/acn-bell-ukraine/.

"Seven Themes of Catholic Social Teaching," United States Conference of Catholic Bishops. accessed March 22, 2024, https://www.usccb.org /beliefs-and-teachings/what-we-believe/catholic-social-teaching/seven -themes-of-catholic-social-teaching#:~:text=The%20Catholic%20 tradition%20teaches%20that,things%20required%20for%20 human%20decency.

Smith, Peter. "Ukraine's parliament advances bill seen as targeting Orthodox church with historic ties to Moscow," *National Catholic Reporter,* October 20, 2023, https://www.ncronline.org/news/ukraines -parliament-advances-bill-seen-targeting-orthodox-church-historic-ties -moscow.

Snyder, Timothy. "The State of the War: Thoughts from Kyiv," *Thinking About* . . . (blog), September 7, 2023, https://snyder.substack.com/p /the-state-of-the-war.

UN News. "Nearly 2,000 children killed in Ukraine war: UNICEF." https://news.un.org/en/story/2024/05/1149661, May 13, 2024.

"Volhynian Massacre," European Network Remembrance Solidarity, accessed March 22, 2024, https://enrs.eu/news/volhynian-massacre.

Online Interviews

Zoom interviews in February and March 2024 with David Bonior and Peter Daly, John Fairfield, Archbishop Borys Gudziak, Sr. Kathleen Kanet, Nina Potarska, and Tetiana Stawnychy.

Books

Applebaum, Anne. *Red Famine: Stalin's War on Ukraine.* New York: Anchor Books, 2018.

Cone, James H. *The Cross and the Lynching Tree.* Maryknoll, NY: Orbis, 2011.

Forché, Carolyn, and Ilya Kaminsky, editors. *In the Hour of War: Poetry from Ukraine.* Medford, MA: Arrowsmith, 2023.

Niebuhr, Reinhold. "Why the Christian Church Is Not Pacifist," *Christianity and Power Politics.* New York: Charles Scribner's Sons, 1940.

Nouwen, Henri J. M. *Ukraine Diary.* Maryknoll, NY: Orbis, 2023.

Plokhy, Serhii. *The Russo-Ukrainian War: The Return of History.* New York: W. W. Norton, 2023.

Snyder, Timothy. *Bloodlands: Europe Between Hitler and Stalin.* New York: Basic Books, 2010.